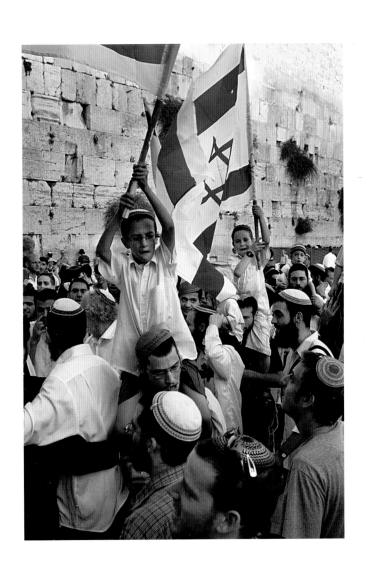

WHITE STAR PUBLISHERS

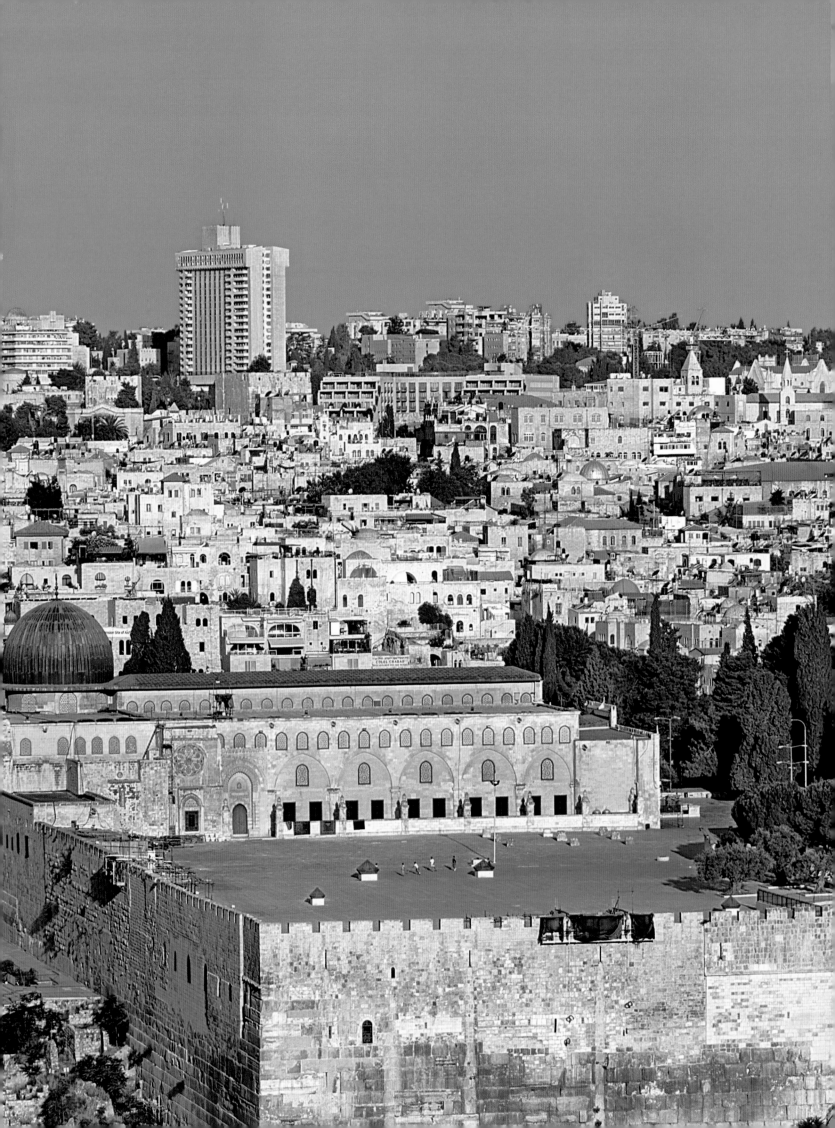

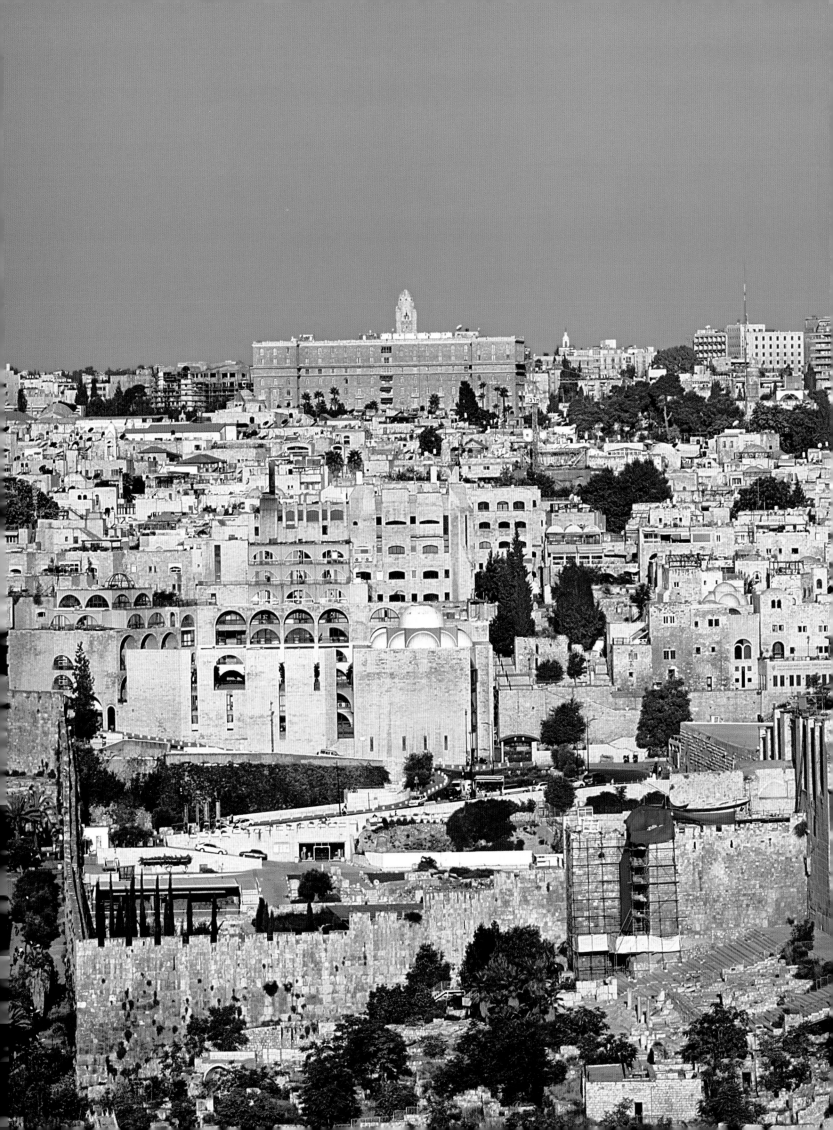

CONTENTS

1 In addition to being a religious symbol, the Wailing Wall is also a national monument. The Wall is used as a setting for patriotic observances, state ceremonies, concerts, political demonstrations and military parades.

2-7 The Scottish artist David Roberts, who painted the most famous 19th century views of the Holy Land, in 1839 depicted the profound chasm of the Pool of Bethesda where Jesus performed the first of his miracles in Jerusalem, with the Temple Mount and mosques in the background.

3-6 The Old City covers an area of less than half a square mile (1 sq km), including the Temple Mount – a small piece of land on which the destiny of the entire Middle East depends.

JERUSALEM

PLACES AND HISTORY

Text by Roberto Copello

Graphic design
Maria Cucchi

© 2008 White Star S.p.A.
Via Candido Sassone, 22/24
13100 Vercelli, Italy
www.whitestar.it

TRANSLATION:
KARLA DONNELLY

ISBN 978-88-544-0378-9

REPRINT:
1 2 3 4 5 6 12 11 10 09 08

Color separation: Fotomec, Turin
Printed in Indonesia

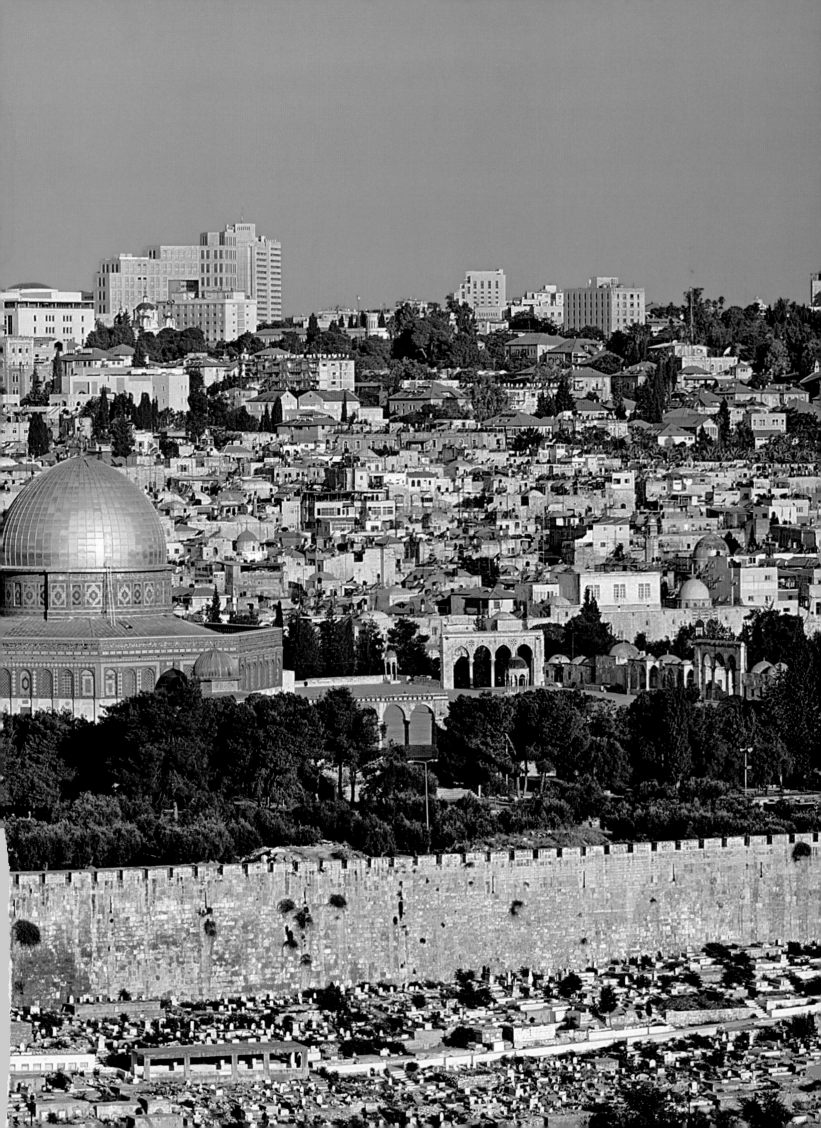

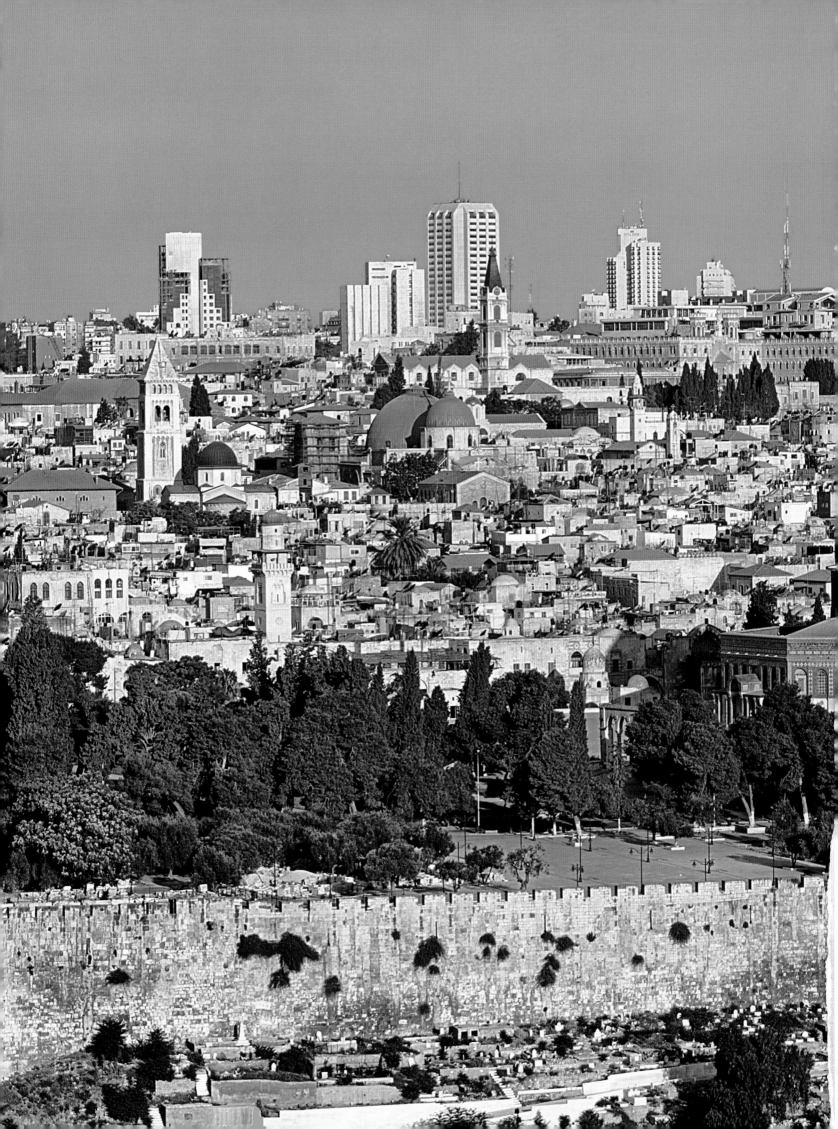

8 top The great square in front of the Wailing Wall, cleared in 1967 by Israeli bulldozers, is divided into two areas – the men stay on the left side, while the right side is reserved for women.

8-9 A rocky promontory located far from the sea at the edge of the arid Judea Desert; here rose, more than five thousand years ago, Jerusalem, the city that would become sacred to three religions.

9 Despite changes made by the Ottomans, the Citadel still offers a glimpse of its former grandeur as the palace from which Herod the Great, who built Masada, ruled the city.

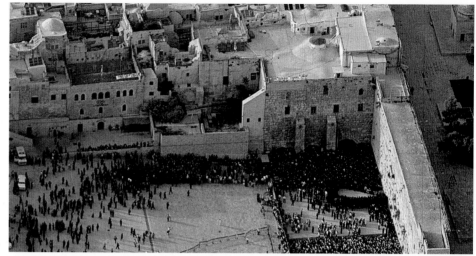

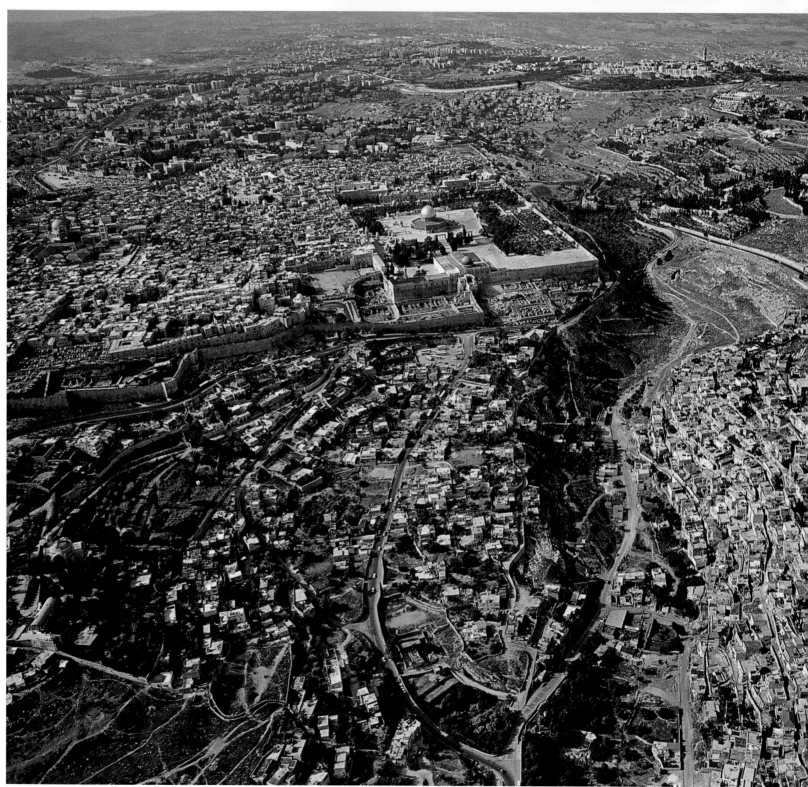

INTRODUCTION

It is written in the Talmud (Kiddushim 49b) that God divided Beauty into ten parts, allocating nine parts to Jerusalem and one part to the rest of the world.

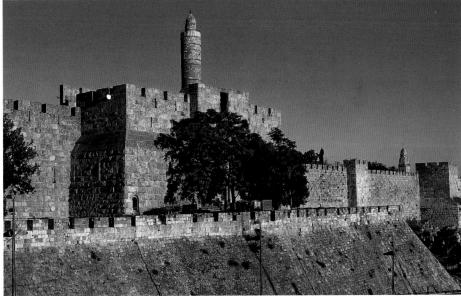

He then separated Science into ten parts, and again gave nine parts to Jerusalem. Then finally, however, He divided Sorrow into ten parts, assigning in the same manner nine parts to Jerusalem and one part to the rest of the world. No other parable so aptly captures both the dramatic mystery and bitter allure of a city that for over 3000 years has aroused such deep passion, an infinite love leading to the most extreme of excesses which it is somehow still capable of justifying. Less than a square mile of land that so many have tried to destroy but which someone has always rebuilt, often completely differently than before, and often providing the city with a new name: David's Zion; the YRSLM of biblical texts; the Yerushalaym of the Jews; the Aelia Capitolina of Emperor Hadrian; Al-Quds, the Sacred Place, of Arabs; Montjoie for the medieval Catholic pilgrims. . . .

It is futile, therefore, to continue believing in the old, and untrue etymology, which has since been refuted, that the name Jerusalem has its roots in the word *shalom*, and is therefore by definition the "City of Peace": a mere wish, rather than a fact. A mere wish because no other land has been so soaked in blood and tears as Jerusalem. Egyptians, Canaanites, Jews, Assyrians, Babylonians, Macedonians, Romans, Persians, Arabs, Crusaders, Kurds, Khwarezmians, Mamluks, Ottomans, Britons, Jordanians, Israelis, and Palestinians have all fought both beneath and within the city walls. David, Sennacherib, Nebuchadnezzar, Alexander the Great, Antiochus IV, Judah Maccabeus, Pompey, Herod the Great, Titus, Khosrau II, Heraclius, Caliph Omar, Godfrey of Bouillon, Saladin, Selim I, Ibrahim Pasha, General Allenby, Moshe Dayan – at least twenty great leaders have attacked the city. . . .

10 top *The Artists' House is located in the historic building that once housed the first Academy of Art in Jerusalem, the Bezalel School of Arts and Crafts.*

10 bottom *The university campus on Mount Scopus is home to the Faculty of Humanities of the Hebrew University of Jerusalem, which was inaugurated in 1925 with the support of Einstein and Freud.*

11 *Mamilla Quarter is located to the northwest of the Old City. Between Mamilla and the city walls a tunnel reduces the traffic from the Jaffa Gate to the New Gate.*

14-15 *In 1967, when the entire city of Jerusalem was occupied by Israel, there were 286,000 inhabitants. Today, there are 700,000 inhabitants, 450,000 of whom are Jewish, 200,000 Muslim, and 14,000 Christian.*

16-17 *Since David attacked the stronghold of the Jebusites three thousand years ago, Jerusalem has almost always been encircled by walls; the current walls were built by Suleiman between 1536 and 1542.*

18-19 *On Friday evenings at sunset there is always a large crowd in front of the Western Wall to celebrate the beginning of the Sabbath. The immense square can hold up to 100,000 people.*

Enigmatic, indecipherable, far from the sea and close to the desert, ancient but also surprisingly modern, Jerusalem is the place where, it has been said, one feels most strongly the breath of God. No other city on Earth has been thought to be the center of the universe, the place where the end of the world will occur, the imperfect model for the longed for perfect city – the Celestial Jerusalem. No other city contains, within a distance of a few hundred yards, sacred areas and splendid religious buildings that make Jerusalem the spiritual and religious center for two-thirds of humanity. This city is in fact the capital of the three great monotheistic religions, the city cherished by Jews, Muslims, and Christians, all sons of Abraham and followers of the One True God; this One God, however, never overlaps with the One God of the other religions. In Jerusalem even the rocks are divided, and each religion has its own sacred stones: the Jews have the stones that form the *ha-Kotel*, or the Western Wall improperly known as the Wailing Wall; the Christians have the stones of the Church of the Holy Sepulcher where the body of Jesus Christ was placed after His death on the cross and before His Resurrection; the Muslims, beneath the gilded Dome of the Rock, have the stone from which Muhammad ascended to heaven (and that, long before, was also sacred to the Jews, for other reasons).

Thus Jerusalem, halfway between the Orient and the Occident, where it is possible to capture in the same photograph a minaret, a bell tower and a synagogue, rather than becoming a melting pot, has remained a mosaic in which cultures and religions mix yet never combine, each remaining as distinct as possible from the others. Jerusalem is a city holy to three religions, which has been so divided and disputed in the name of God that the official religion has been changed eleven times. It is an irresistibly fascinating city that everyone, believer or non-believer, should visit once in their lifetime. To the Jews, wherever they might be, who have not yet visited Jerusalem, is directed the following Passover wish: "Next year in Jerusalem." It would be better to say: "Next year in peace in Jerusalem," realizing that there cannot be peace in Israel, in Cisjordan or in the Middle East until the "question" of Jerusalem is resolved.

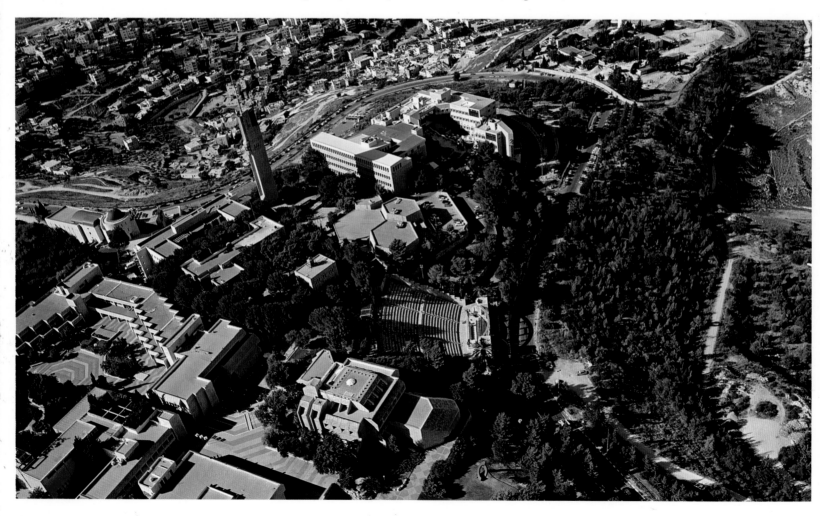

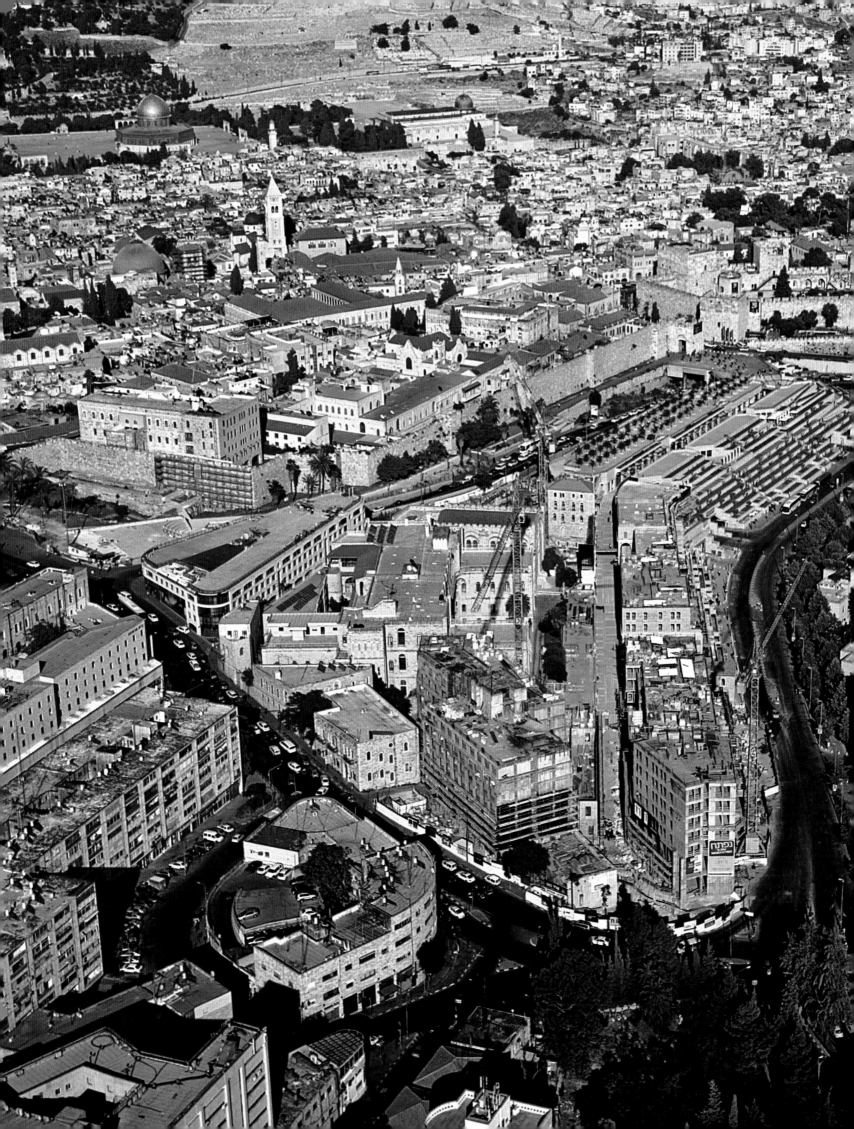

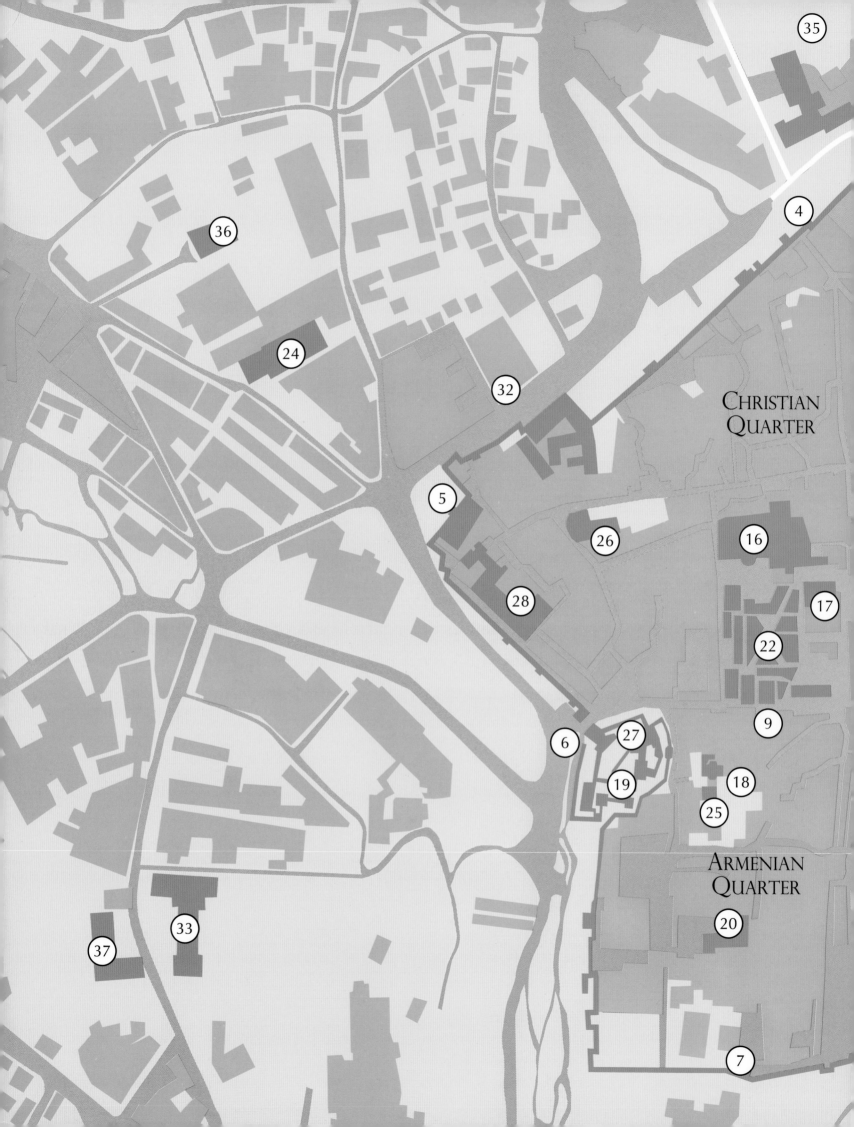

CHRISTIAN
QUARTER

ARMENIAN
QUARTER

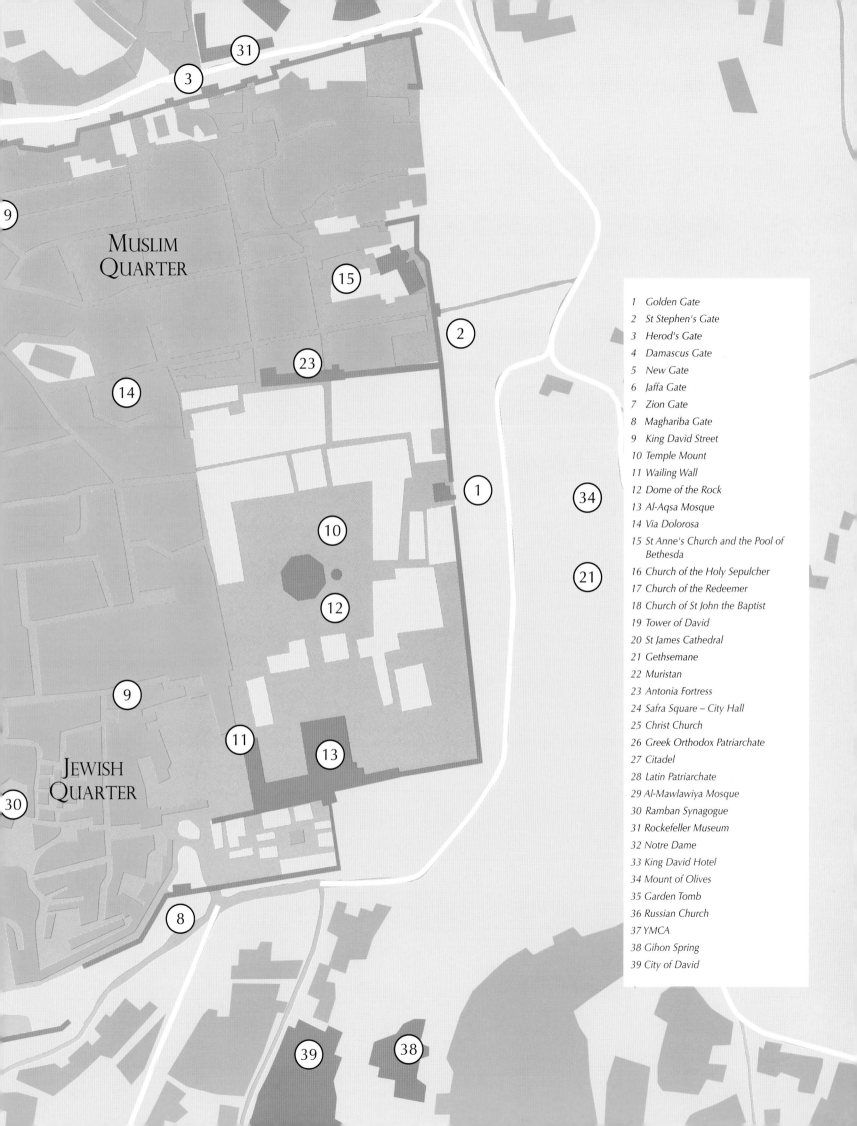

MUSLIM
QUARTER

JEWISH
QUARTER

1 Golden Gate
2 St Stephen's Gate
3 Herod's Gate
4 Damascus Gate
5 New Gate
6 Jaffa Gate
7 Zion Gate
8 Maghariba Gate
9 King David Street
10 Temple Mount
11 Wailing Wall
12 Dome of the Rock
13 Al-Aqsa Mosque
14 Via Dolorosa
15 St Anne's Church and the Pool of
 Bethesda
16 Church of the Holy Sepulcher
17 Church of the Redeemer
18 Church of St John the Baptist
19 Tower of David
20 St James Cathedral
21 Gethsemane
22 Muristan
23 Antonia Fortress
24 Safra Square – City Hall
25 Christ Church
26 Greek Orthodox Patriarchate
27 Citadel
28 Latin Patriarchate
29 Al-Mawlawiya Mosque
30 Ramban Synagogue
31 Rockefeller Museum
32 Notre Dame
33 King David Hotel
34 Mount of Olives
35 Garden Tomb
36 Russian Church
37 YMCA
38 Gihon Spring
39 City of David

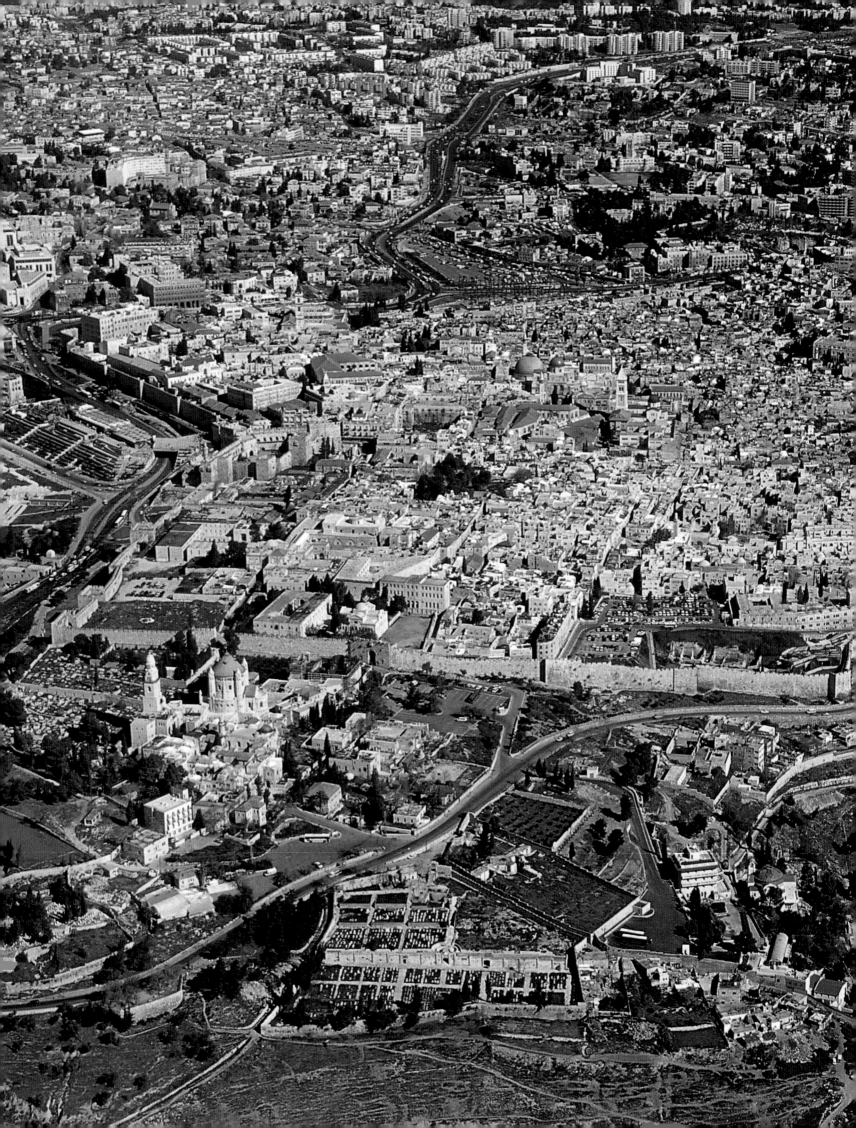

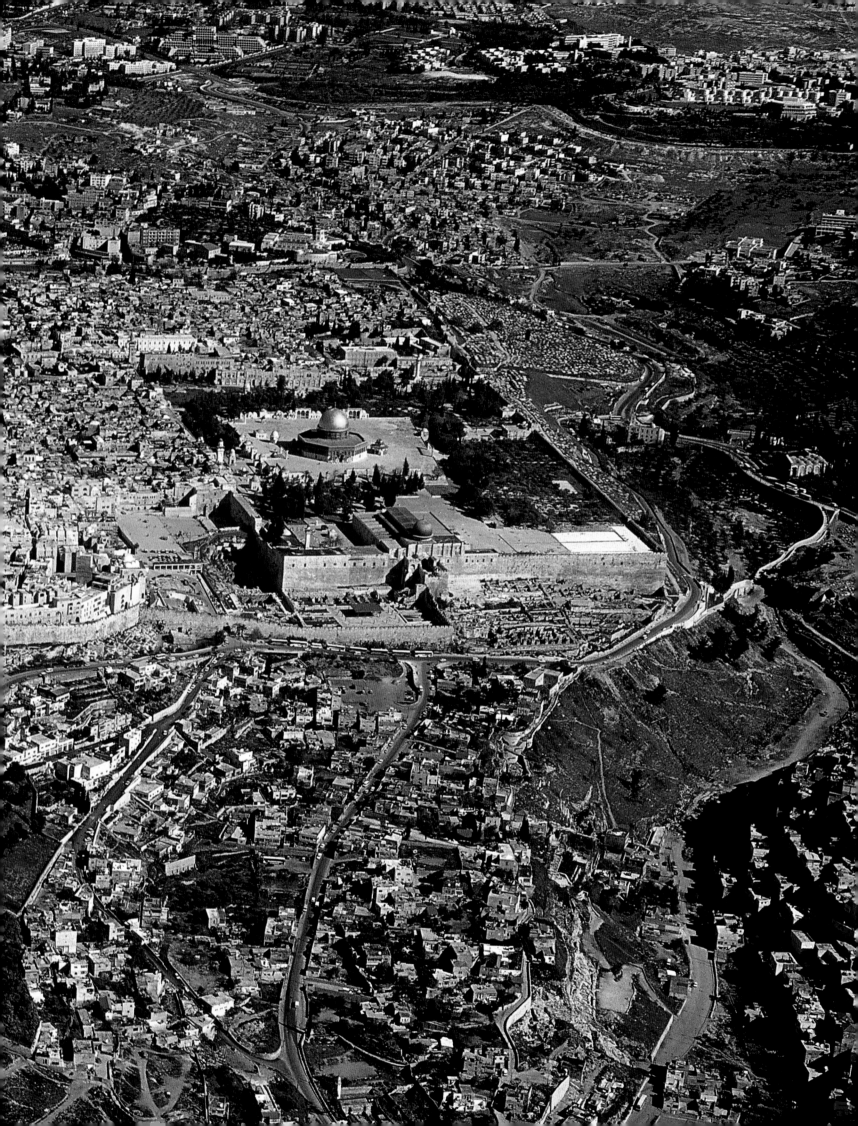

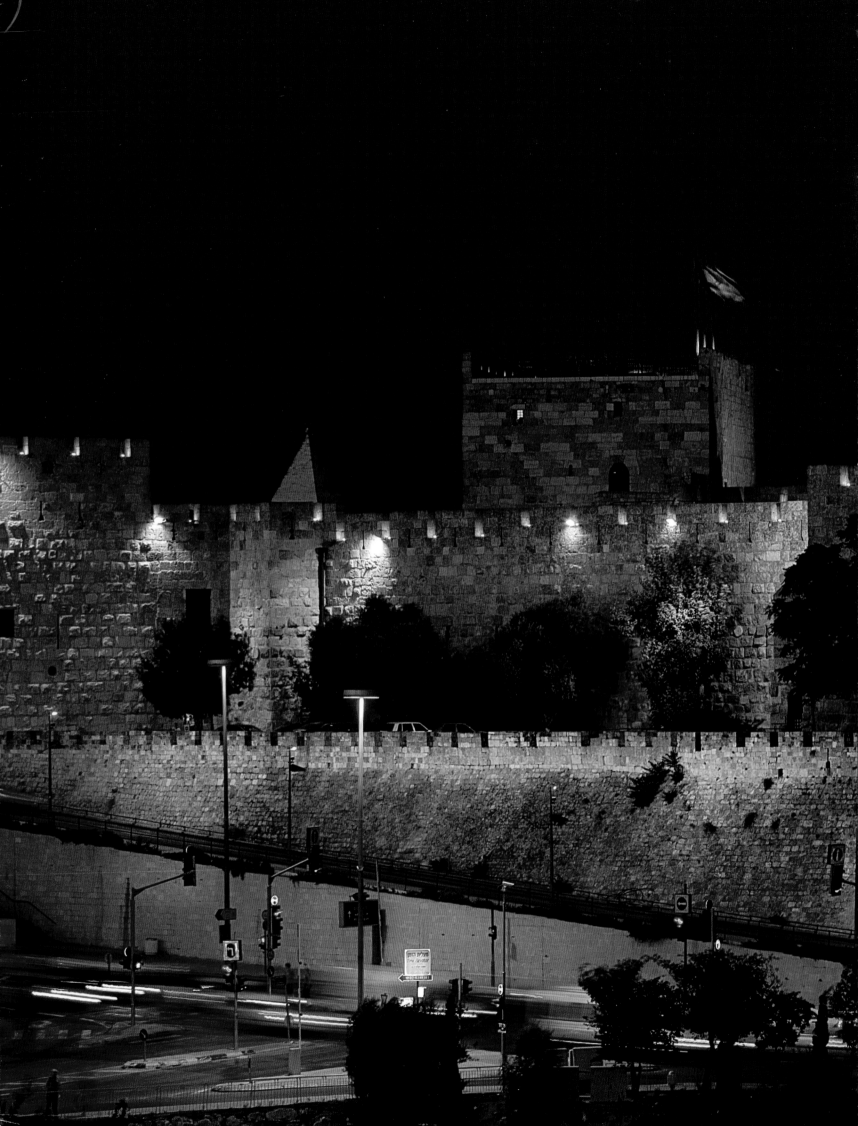

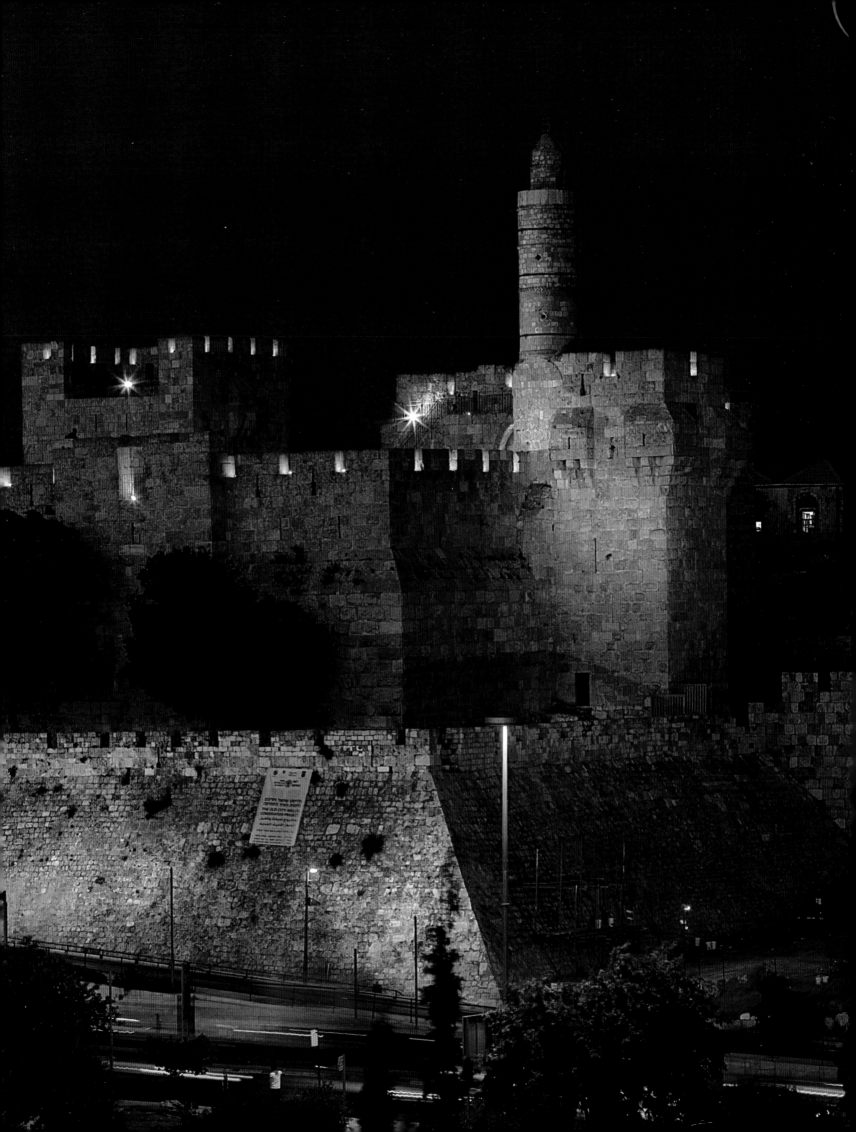

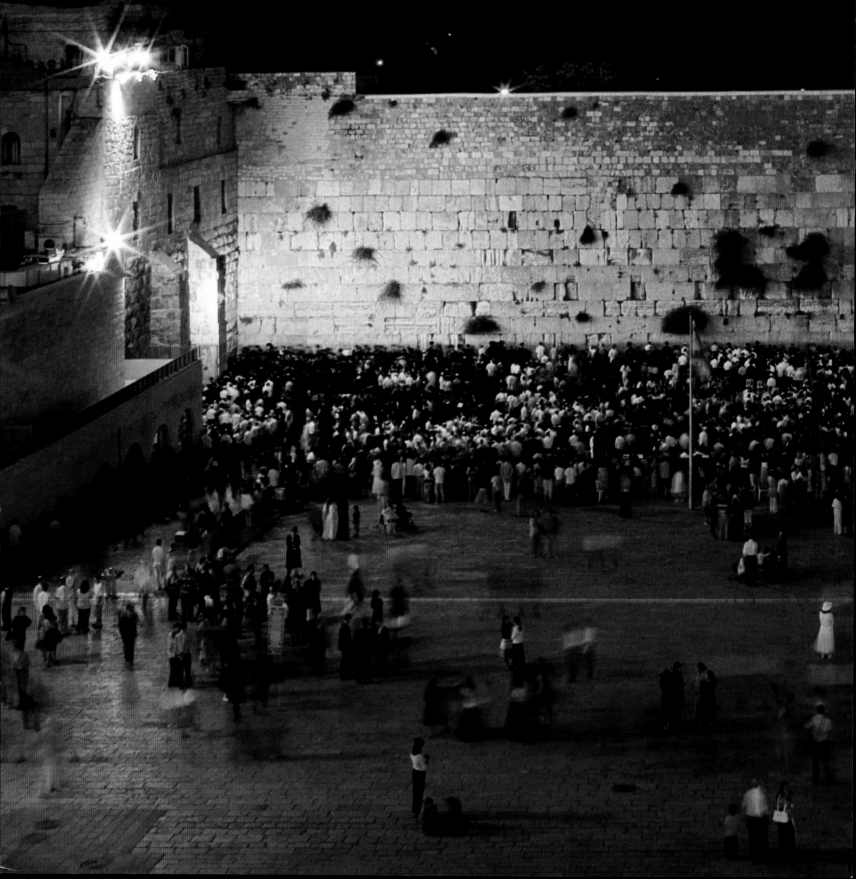

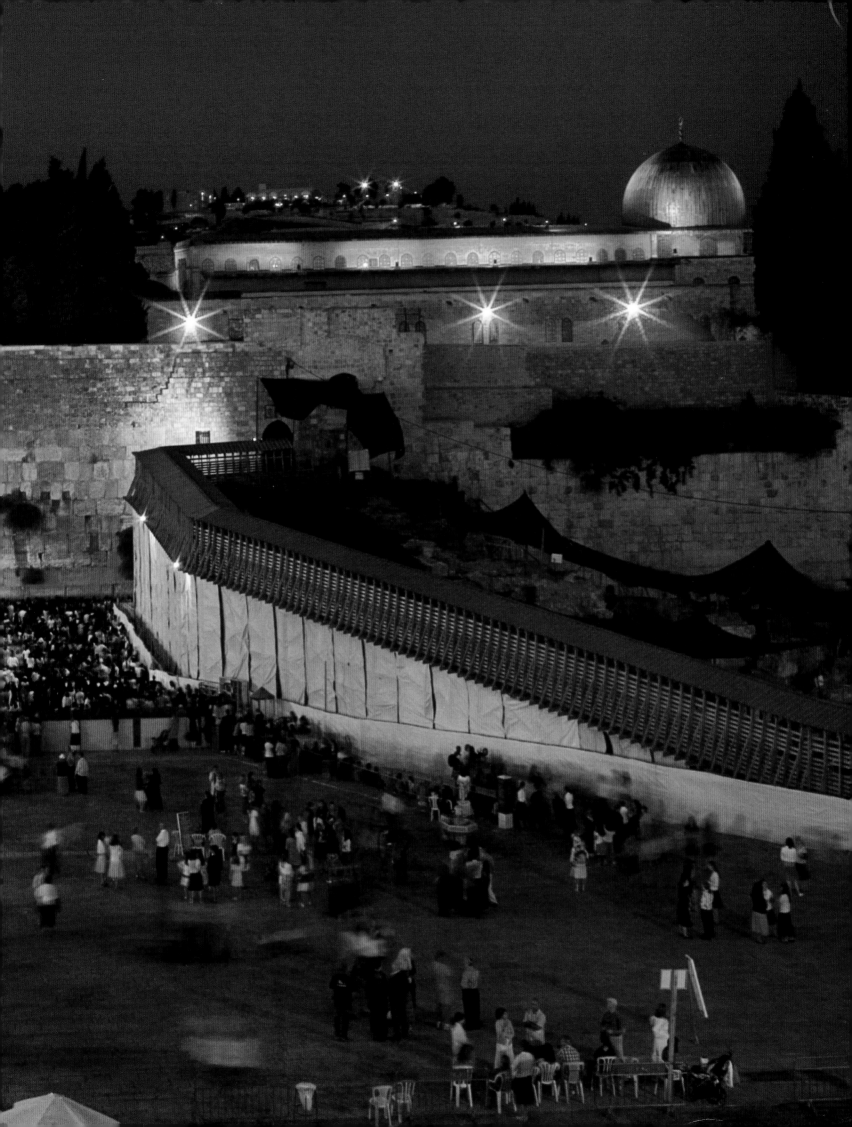

ONE HOLY CITY – THREE RELIGIONS

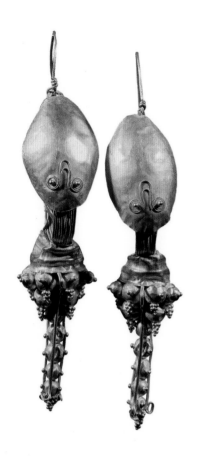

By one of those frequent paradoxes that so enrich history, the name Jerusalem, the symbolic city for the three great monotheistic religions, appears for the first time with absolute certainty in the secret archives of the first man to establish a monotheistic cult. The discovery – in which Jews, Christians, and Muslims are first able to glimpse an indication of the fate in store for the Creator's chosen city – was made in 1891 in Egypt by archaeologists excavating the site of Tell el-Amarna. The capital had been transferred there by the last pharaoh of the 18th Dynasty, Amenhotep IV (1370-1350 BCE), who took the name Akhenaten and imposed on his subjects a form of monotheism in which they worshiped the sun god Aten. At that time the region of Canaan, the future Palestine, was under Egyptian control; it was therefore not surprising when three thousand years later there emerged from the earth four hundred clay tablets with cuneiform characters written by the pharaoh's vassals in the Middle East. Then, however, the transliteration of the tablets revealed that eight of these "letters" contained requests for help from Abdu-Heba, lord of a place called Ursaliimmu, and things then took a new turn – it was the oldest written document regarding the existence of Jerusalem, as well as evidence that the city was already of some importance in the 14th century BCE. Subsequently, somewhat older Egyptian clay fragments (18th-20th centuries BCE) were discovered, containing hieroglyphics that refer to curses against the sovereign of Urushalimum. The same place? It is difficult to say. In any event, it all supports the proposition that the history of Jerusalem did not begin in the year 1003 BCE, as those who remember the 1997 celebration of its 3000th-year anniversary might suppose. In reality, that anniversary refers to the year in which David took control of the city, creating a political and religious capital for the Israelites. A round and attractive number that pays tribute to David – the poet and musician king – who laid a foundation for the extraordinary history of Jerusalem to follow, a city whose beginnings are lost in the mists of time. Recent excavations have brought to light objects from the 5th millennium BCE, making Jerusalem one of the oldest cities in the world (although still three thousand years more recent than Jericho).

20 top and 21 The jewelry dating from 1500 BCE, discovered in the necropolis of Tell el-Ajjul in Ancient Gaza, attests to the wealth of a city that was located at the crossroads of the trade routes between Egypt and the Oriental cities (which may have already included Jerusalem). The great archaeologist Flinders Petrie discovered hundreds of intact tombs at Tell el-Ajjul in 1930; some of the opulent funerary objects from the tombs (bracelets, pendants, earrings) are now in the Israel Museum in Jerusalem.

20 bottom From Thutmosis III (1468 BCE) to General Allenby (1918), the Plain of Megiddo has been the setting for many historic battles. The famous Megiddo Ivories are the finest examples of art from the Canaanite civilization.

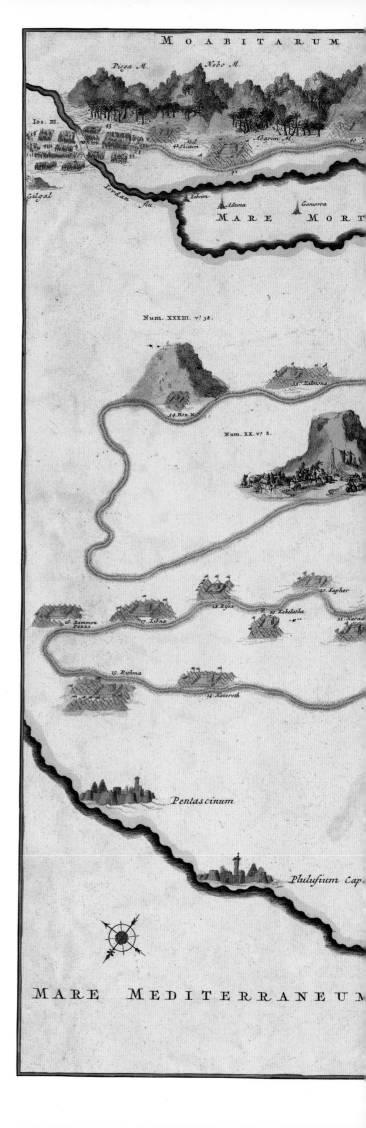

In the Canaanite language, Jerusalem may mean "founded by the god Salem." Salem was the divinity of the evening star, whose name appears on tablets discovered in Ebla, Syria dating from the 3rd millennium BCE. The Bible itself also identifies in Jerusalem a "Salem" governed by the priest-king Melchizedek, who, in one of the first chapters of Genesis, blessed Abraham in approximately 1800 BCE. Also, according to tradition, Jerusalem rose up around the summit of Mount Moriah, where Abraham built an altar to sacrifice his son Isaac.

After the reign of Akhenaten, Ramesses II reduced the Israelites to slavery in about 1300 BCE. Moses then led the exodus from Egypt to the Promised Land. Upon reaching it, however, it was his successor Joshua who defeated the confederation of Canaanite tribes and put to death the Jebusite king of Jerusalem, Adonizedec.

22 The Assyrian markings on an ivory plaque found at Megiddo are a reminder that in the 7th century BCE the fortress fell into the hands of the Assyrians, who were unable, though, to capture Jerusalem at a later date.

22-23 With a bit of imagination, the Dutchman Pieter Mortier depicted the wanderings of the Jews during the flight from Egypt. In the upper corner there is a representation of Mount Nebo, where Moses died after having seen the Promised Land only from a distance.

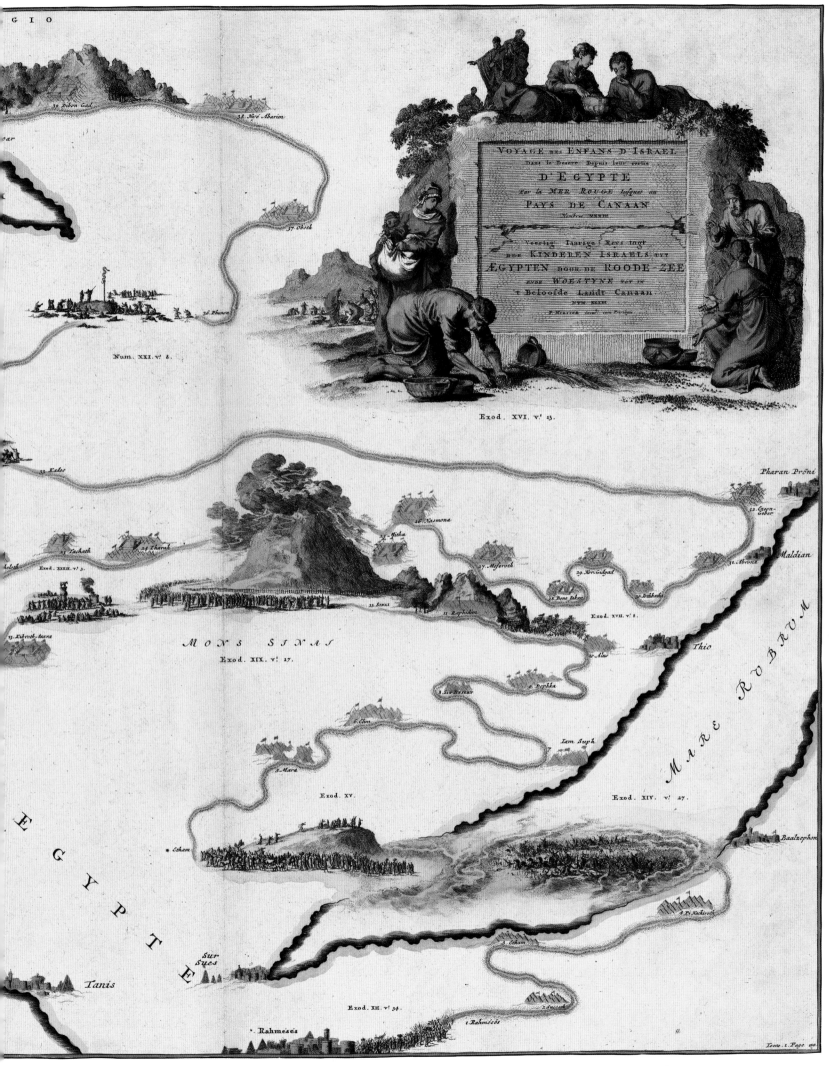

VOYAGE DES ENFANS D'ISRAEL
Dans le Desert Depuis leur sortie
D'EGYPTE
Par la MER ROUGE Iusques au
PAYS DE CANAAN
Nombres XXXIII

Veertig Iaarige Reys tögt
der KINDEREN ISRAELS uyt
ÆGYPTEN door de ROODE ZEE
ende WOESTYNE tot in
't Beloofde Landt Canaan
NUM. XXXIII

P. MORTIER Excud. cum Privilegio

Exod. XVI. v. 13.

Num. XXI. v. 8.

38. Iové Abarim
30. Dibon-Gad
37. Oboth
36. Phunon

33. Kades
26. Nasmona
25. Ietka
27. Moseroth
28. Bene Iakan
29. Hor-Gidgad
30. Ietbatha
31. Abrona
12. Ezeon-Geber
Pharan Pröni
Maldian

32. Tachath
24. Thareh
11. Raphidim
Exod. XVII. v. 8.
Exod. XXXII. v. 3.
12. Sinai
10. Alus
Thio

13. Kibroth-taava
MONS SINAI
Exod. XIX. v. 17.
9. Dophka
8. Sin Desert

6. Elim
MARE RUBRUM

Iam Suph

5. Mara

Exod. XV.
Exod. XIV. v. 27.

Etham
Baalzephon

EGYPTE

4. Pi-Nachiroth

3. Etham
Sur Sues

Tanis

Exod. XII. v. 34.

Rahmeses
1. Rahmeses

Tome 1. Page 110

23

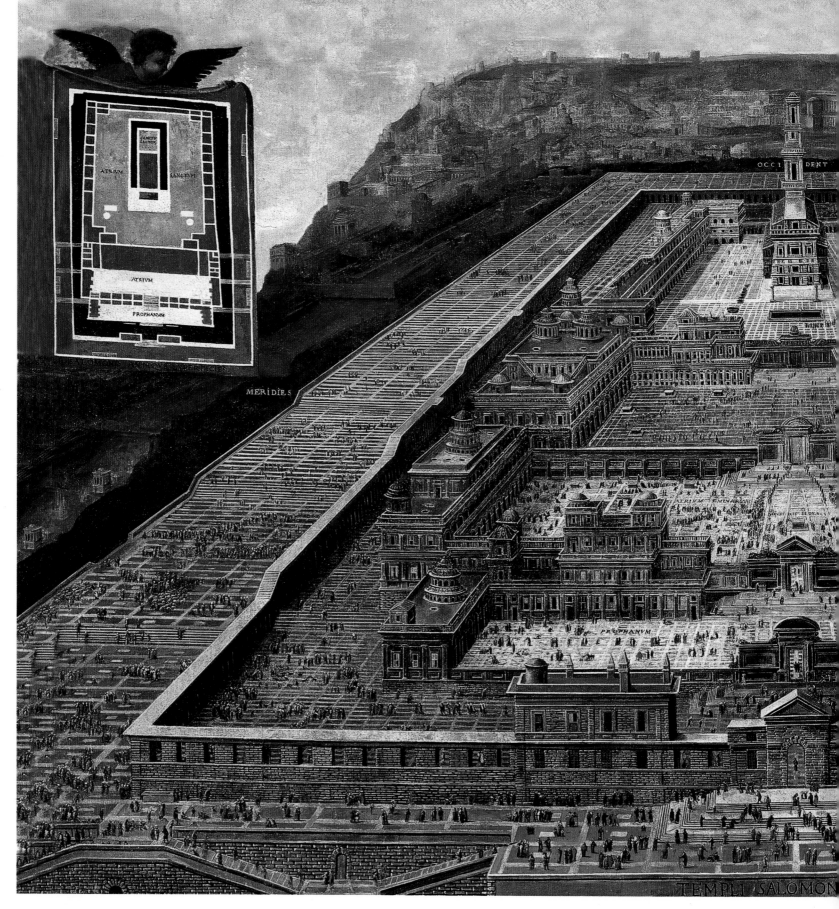

Subsequent Israelite leaders then sacked the city-state nestled on a cliff without occupying it, perhaps because they were unsure of what to do with it. Thus for two centuries Jerusalem remained inhabited by Jebusites. Finally, David, with bit of cunning, was able to definitively

drive them away. David, the virtuous blond who played the zither, moved the Ark of the Covenant onto the Ophel, at the south east of the current walls, in the citadel of Zion (the name is often synonymous with Jerusalem) where he built a fortified palace. The "City of David" (Ir

David), never having belonged to any of the twelve tribes of Israel, was non-partisan enough to become the political capital and religious center of a kingdom that, at that point in time, extended from the Red Sea to the Euphrates.

David, a great artist but also a

great womanizer, was succeeded by a son who was perhaps less of a genius than his father but who was quite wise. Solomon (970-933 BCE) has the distinction of transforming an assortment of quarrelsome and barbarous tribes into a united nation. It is Solomon who brought Jerusalem

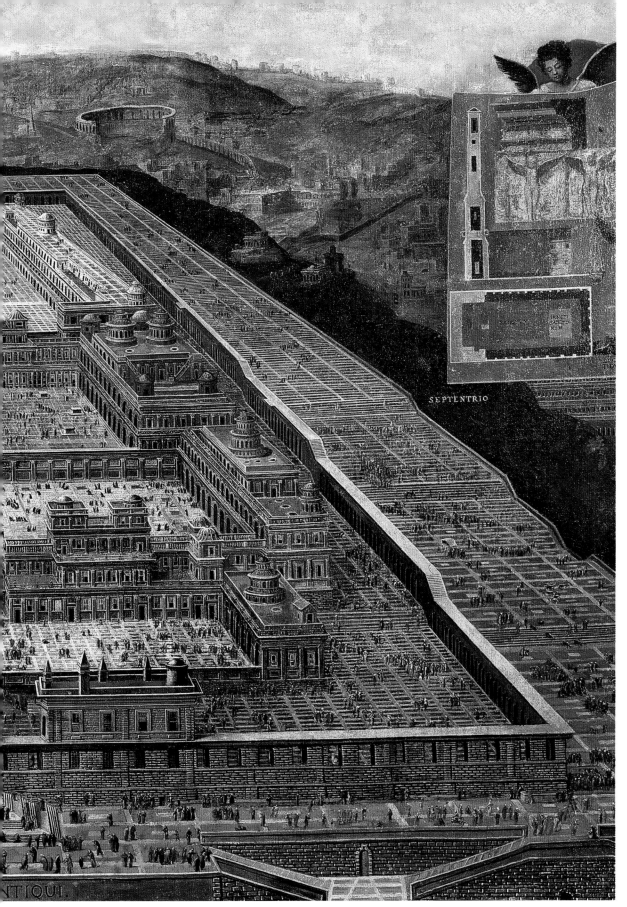

SEPTENTRIO

ANTIQVI.

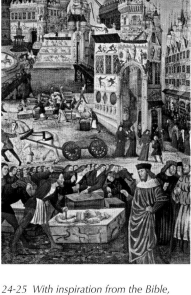

24-25 With inspiration from the Bible, the Spanish scholar Benito Arias Montano envisioned, in the 16th century, an exceedingly grandiose Temple of Solomon, whose style is reminiscent of the Italian Renaissance.

25 top This Flemish miniature from the 15th century depicts King Solomon overseeing the construction of the First Temple. The blocks of stone used for the temple came from quarries in Jerusalem, and the wood came from Lebanese forests.

25 bottom A miniature from the Maciejowski Bible, commissioned in 1250 by King Louis IX of France, shows King David dancing before the Ark of the Covenant, and then performing a sacrifice to celebrate the placing of the Ark on Mount Zion.

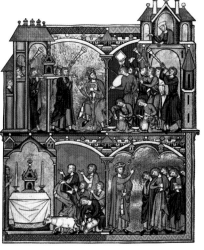

to a splendor never before seen by constructing colossal architectural works. After leveling the peak of Mount Moriah to create a large trapezoidal terrace, Solomon erected the sumptuous First Temple to house the Ark of the Covenant, which had until that point been kept in a tent, thereby symbolizing that the Israelites were no longer a nomadic people. Nearby, he constructed his royal palace which was linked to the City of David by an embankment. Finally, he enlarged the city walls to enclose the areas that are now the Armenian and Jewish Quarters.

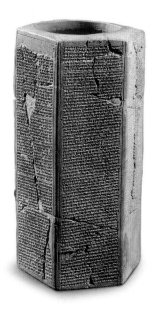

26 top The chronicles of the eight military campaigns of Sennacherib, which are inscribed on the hexagonal Taylor Prism discovered at Nineveh, affirm that the Jerusalem of King Hezekiah was the only city able to resist the attack of the Assyrian king in 701 BCE.

26 bottom The relief from the Palace of Sennacherib at Nineveh shows the inhabitants of Lachish being driven into exile by the Assyrians.

Jerusalem would never again experience such a golden period. Shortly after the death of the wise king, the Israelites divided: in the north, ten tribes formed the Kingdom of Israel, establishing its capital at Samaria; in the south, the tribes of Judah and of Benjamin created the Kingdom of Judah, which retained as its capital a Jerusalem whose political power was diminished, but whose religious prestige was conserved. The subsequent governors of Jerusalem, as God himself guaranteed through His prophet Nathan, were all descendants of David and numbered approximately twenty in total until the arrival of the Babylonians in 587 BCE. During these three and a half centuries, the two kingdoms were weakened by Egyptian, Philistine (from which the word Palestine is derived) and Bedouin raids, and started to decline. Jerusalem did experience brief periods of revival, particularly under King Josiah who built Elat on the Red

Sea, and under the religious King Hezekiah, who enlarged the city walls and tunneled a subterranean canal that guaranteed water for the city in case of siege. However, tragedy loomed.

In 721 the Assyrians, having arrived from Nineveh, destroyed Samaria and demolished the Kingdom of Israel, exiling the inhabitants to Mesopotamia. The Assyrians then turned south to the Kingdom of Judah and its capital Jerusalem, which, however, was able to resist the attack and remain the last Jewish stronghold. Josiah "the good king," taking advantage of the demise of the Assyrian empire in 612 BCE, for a brief period was able to restore the Jewish kingdom to the boundaries that David had established. These were the final glimmers of hope – soon the Jews would bow before a new power, the Babylonians. In 602 King Nebuchadnezzar brought King Jehoiachin to Babylon as a hostage, along with the best artisans of Israel.

When Jerusalem revolted, he laid siege to the city for nearly two years and in 586 razed it to the ground, destroying the Temple and exiling the population. The first great Jewish Diaspora had begun, and the Ark of the Covenant was lost forever. The desolate scene is described in the Book of Lamentations, where the city is compared to a woman who has suffered the shame of rape: "How lonely sits the city that was full of people! She has become like a widow who was once great among nations! She who was a princess among the provinces, has become a forced laborer. She weeps bitterly in the night and her tears are on her cheeks."

The 48 years of the Babylonian Captivity shaped forever the spirit of the chosen people, and reinforced Jewish nationalism. The Kingdom of Israel was erased from history, but the desire for vindication would survive the millennia.

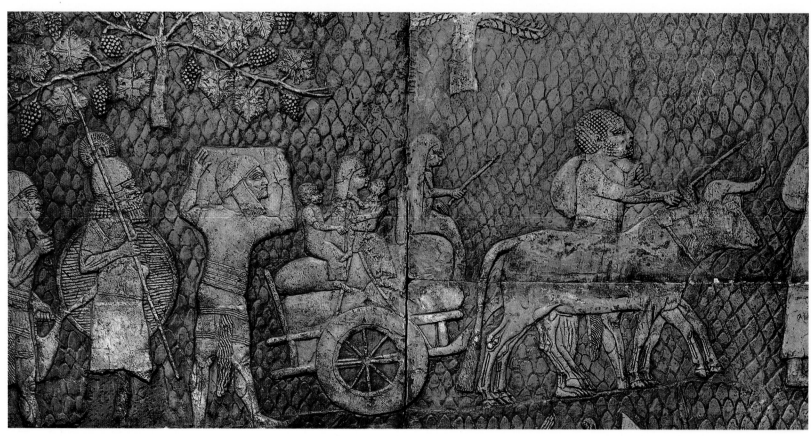

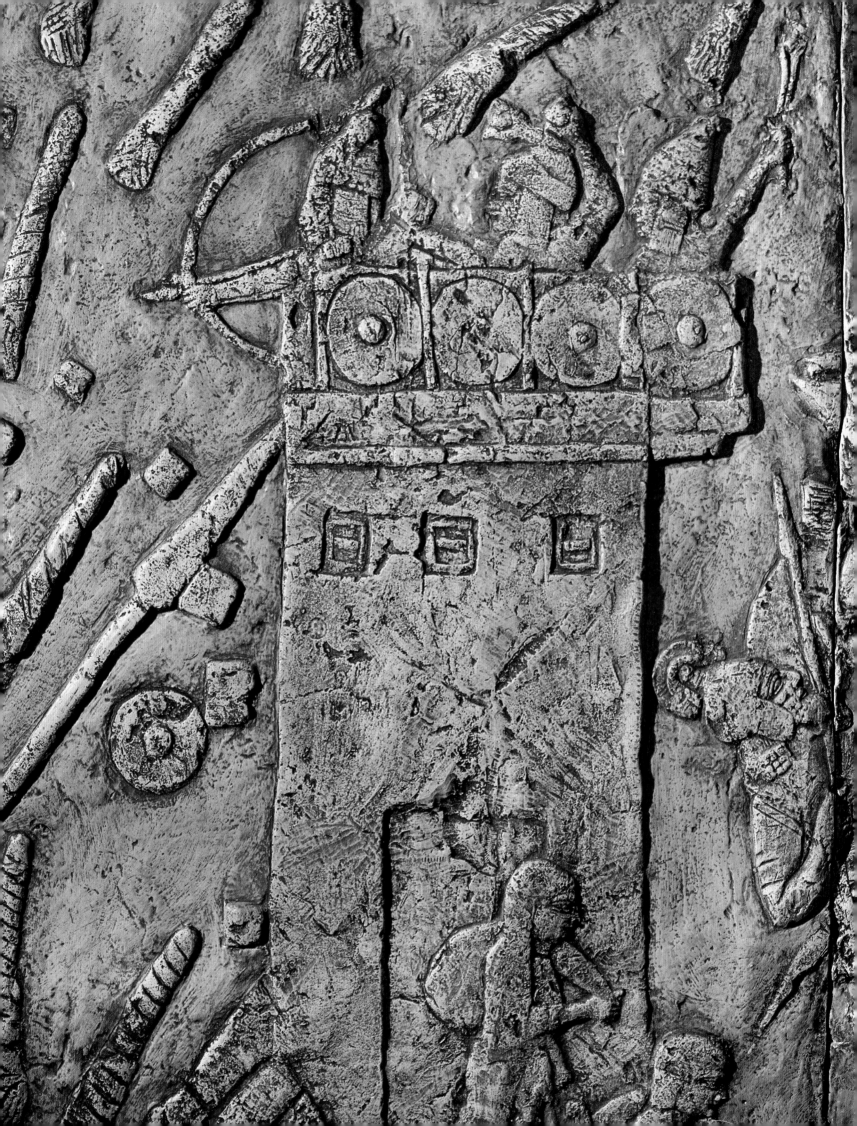

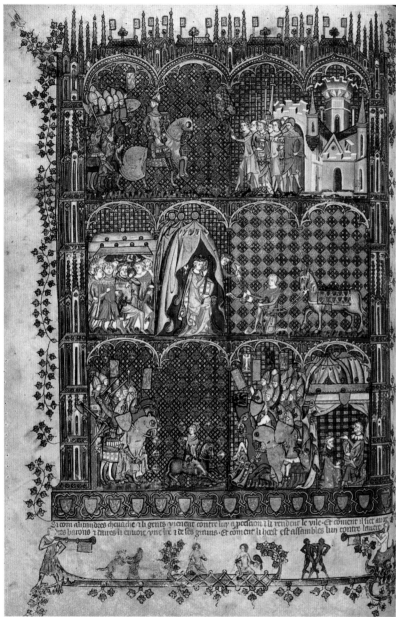

29 In a 14th-century edition of Jewish Antiquities by Flavius Josephus, the Seleucid King Antiochus IV Epiphanes profanes the Temple in 167 BCE by sacrificing a pig, thereby inciting the Revolt of the Maccabees.

Finally liberated in 538 BCE by a generous edict from the Persian ruler Cyrus the Great, 50,000 Jews along with the Prophet Zacharias returned to Jerusalem, making their first goal the reconstruction of the Temple. The work was completed in 515 BCE, but, as this reconstructed Second Temple did not actually house the Ark of the Covenant, God became spiritualized: the word Shékinah from then on indicated the mysterious presence that resided in the Temple. Thus, Judaism became Messianic and developed the idea of progression, of waiting for something better, of trust in the fact that God would reward those who believed in Him – these concepts were unprecedented at the time and would bear fruit, both philosophical and civil, continuing to the present day.

Under peaceful Persian protection, Israel rebuilt itself as a nation. After 445, the pious Jew Nehemiah, minister for King Artaxerxes I, renewed the faith and rebuilt the city walls. These walls, however, did not protect them from new invaders.

In 332 the city was occupied by Alexander the Great. After his death nine years later, control of Palestine passed to his generals: first to the benevolent Egyptian Ptolemies, then to the tyrannical Syrian Seleucids who, to the great sorrow of the prophet Daniel, dedicated themselves to the Hellenization of the country and the destruction of its religious identity. King Antiochus IV Epiphanes (175-164 BCE) went so far as to dismantle the city walls and rededicate the Temple to Zeus, inciting in 166 BCE the glorious rebellion by the Maccabees (meaning "hammer"), the five sons of the Jewish priest Matisyahu of the Hasmonean family. Jerusalem was thereby liberated and the Temple was reconsecrated (the victory and the "miracle of the oil" are remembered every year with the Jewish festival of lights or Hanukkah). The independence lasted eighty years, in which time money was coined and stamped with the phrase "Jerusalem the Holy."

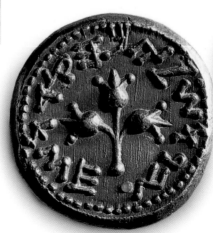

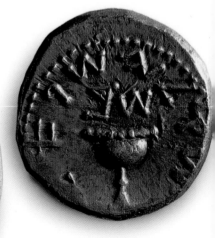

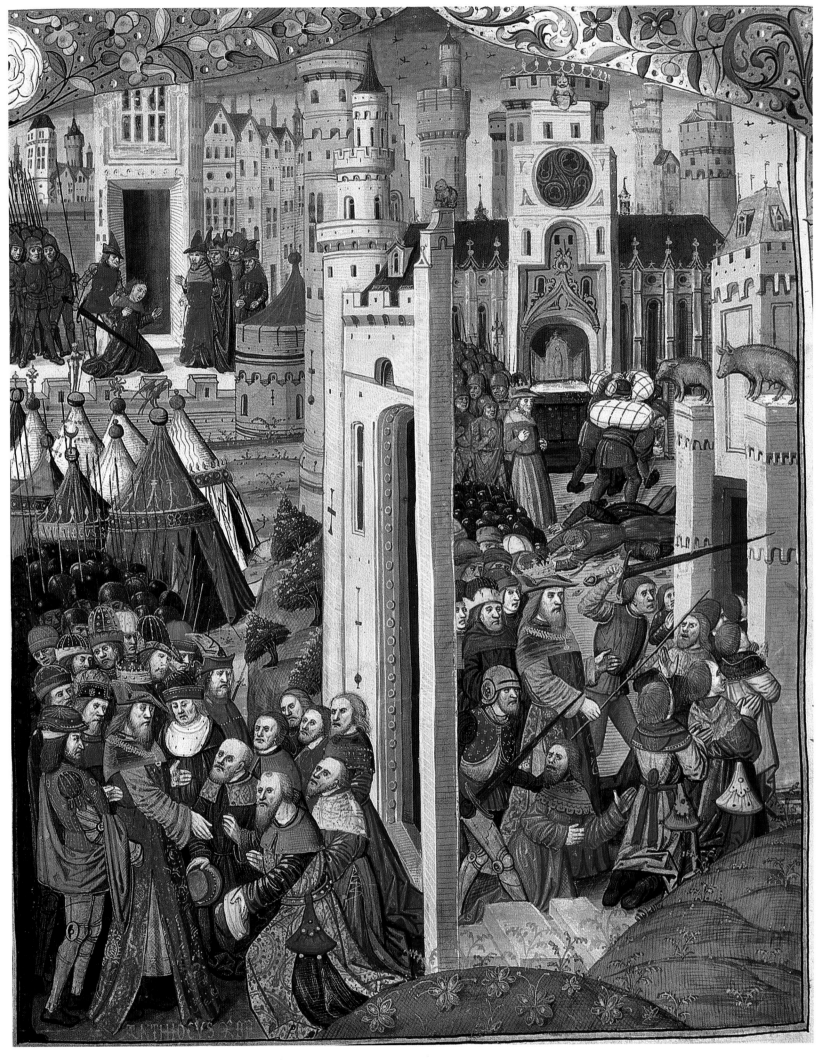

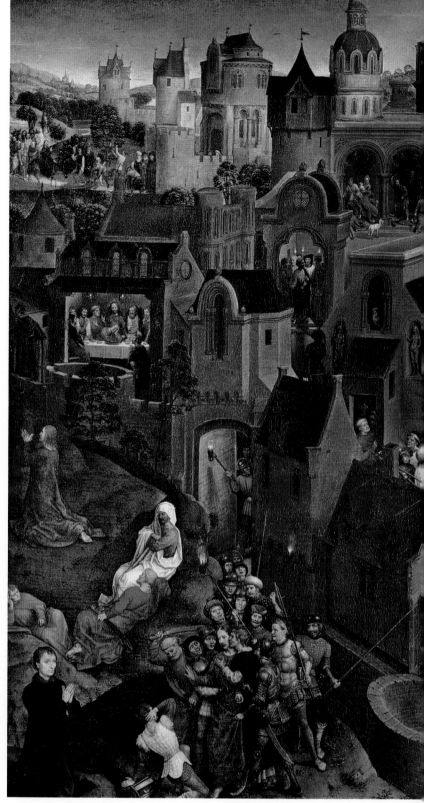

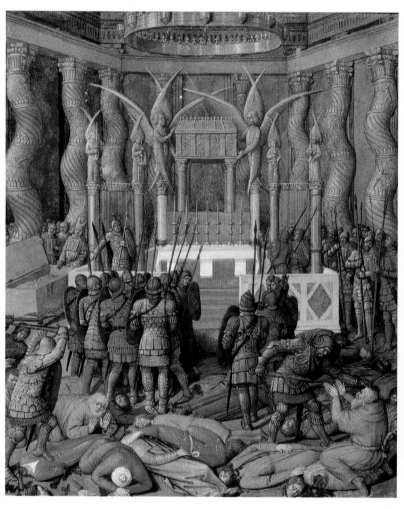

In the end, however, internal fighting among the Hasmoneans gave the Romans the opportunity they had been waiting for – in 63 BCE general Pompey entered Jerusalem and once again profaned the Temple, astonished to find not even a statue in the Holy of Holies. Palestine became a vassal state of Rome.

In 37 BCE the Roman Senate named the astute and loyal Idumean Herod as King of Judea. Herod directed a series of important improvements for which he became known as "the Great": he initiated the lavish restoration of the Temple, he increased the size of the Temple Mount and erected enormous walls, and he constructed the Antonia Fortress. Crueler than most sovereigns, Herod had his two sons strangled, and according to Christian tradition, two years later ordered the killing of all male infants in Bethlehem under two years of age (the Massacre of the Innocents), believing that among them would be the future "King of the Jews" described in the biblical prophecy.

Herod died in 4 BCE. His son Archelaus ferociously fought against Emperor Augustus; as a result, he was exiled in 6 CE and Palestine came under the direct rule of Roman procurators. Partly for convenience, and partly to humiliate Jerusalem, the capital of the new province of Judea was moved to the sea, at Caesarea. One of the Roman procurators will be remembered more than others – Pontius Pilate. From Pilate's viewpoint the "King of the Jews" without an army, that defenseless man whom he had crucified at Passover in

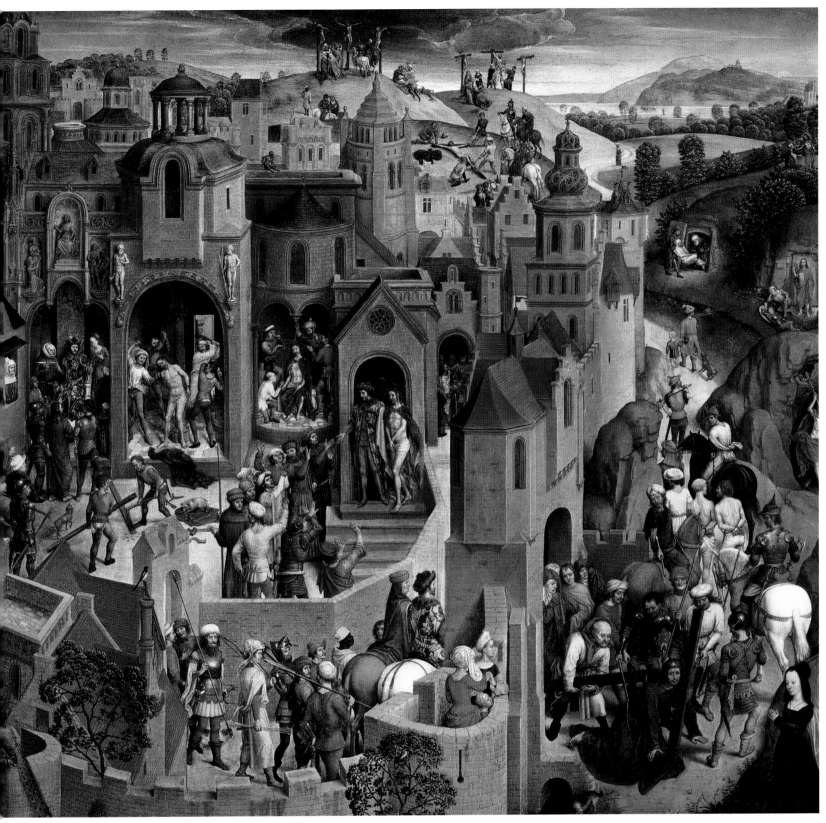

approximately 30 CE, did not represent his most important problem when compared with the unruly Jews who were always ready to challenge Roman authority or to fight amongst themselves over incomprehensible religious issues. Pilate could not have imagined that one day a Roman Emperor would accept as his own a religion founded on that same man who was born in a nearby village,

grew up in Galilee, and went to the city because, according to his disciples, he was convinced that ". . . no prophet can die outside Jerusalem."

Jesus Christ died on the cross just outside of the city walls, but from that point on his followers, who were preaching His resurrection and His ascension into heaven from the summit of the Mount of Olives, multiplied.

Persecuted by Herod Agrippa from 41 to 44, having yielded their first martyrs to the faith, and experiencing increasing conflicts with the Temple priests, the Christians abandoned Jerusalem. It was for them an important city but one which their faith could manage without – after all, the sepulcher was empty and Jesus had promised to be among them wherever they gathered together.

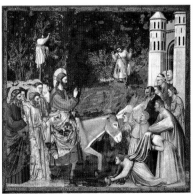

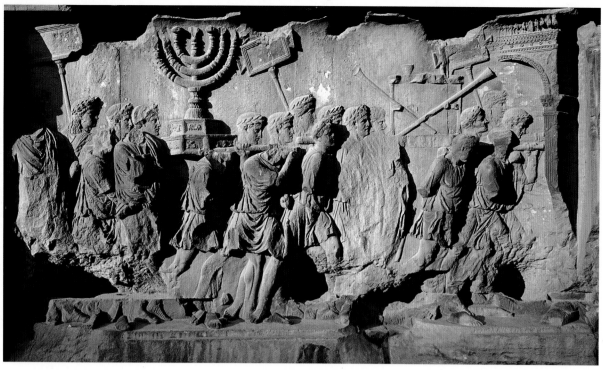

32 top *The relief on the south side of the Arch of Titus, in the Roman Forum, portrays the triumph of the general, returning with booty plundered from the Temple in Jerusalem: the menorah with seven branches and the two trumpets made of silver (hatsotsrot).*

33 *Having won the Second Jewish War in 135 CE, Hadrian tried to eradicate Judaism from Palestine. One of the most beautiful bronze busts of this emperor was discovered in Beth Shean, the ancient Scythopolis.*

Meanwhile tax pressures and sacrilegious acts increased the rancor that Jews felt toward the Romans, until finally in 66 the Great Revolt began, led by the extremist sect the Zealots. The Romans were held at bay for four years, a conflict that was narrated in detail by one of the greatest traitors in history – the Jew Josephus Flavius, author of a series of seven books called *The Jewish Wars*. Finally after a long siege in 70 general Titus (whose father Emperor Vespasian had given him command of the operation) entered Jerusalem, razed it to the ground, tore down the city walls, burned the temple built by Herod (which had been completed only a few years earlier) and took the Menorah, or sacred candelabra, which he brought to Rome as booty. The war cost 600,000 lives, and not a single stone of the Temple remained standing, just as Jesus had prophesied, weeping for is Jerusalem: "For the days are coming upon you when your enemies will raise a palisade against you; they will encircle you and hem you in on all sides. They will smash you to the ground and your children within you, and they will not leave one stone upon another within you because you did not recognize the time of your visitation." (Luke 19:43). The Jews who were not enslaved or sent to Rome to die in the arena dispersed throughout the world – thus beginning the second Diaspora of a people that, for almost the next 2000 years, will take to heart again the words of Psalm 137, those of the Babylonian captivity: "If I forget you, Jerusalem, let my right hand wither. May my tongue stick to my palate if I do not remember you, if I do not exalt Jerusalem beyond all my delights." Nevertheless the few remaining Jews refused to resign themselves, and remained indomitable – in 132 a second revolt began, led by Bar Kochba ("the son of the star") who was seen by some as the Messiah and whose letters, now conserved in the Shrine of the Book, were discovered in 1960 near the Dead Sea. It took three years to repress the rebellion. Afterwards, Emperor Hadrian decided to take care of this small, stubborn group of people and their capital once and for all, to the extent of even changing the regions' names. Judea from then on become the province of Syria Palaestina, and upon the ruins of Jerusalem was erected a Roman city dedicated to the emperor – Aelia Capitolina. The Jews were not allowed to enter the city, on pain of death, but the rabbis found at Tiberias a suitable setting for the creation of the Mishnah, the first written records of the laws of Moses, and the perpetuation of the Jewish religion. In addition, Hadrian gave orders to erase every trace of Judaism and Christianity from the city. Forums and pagan temples were erected upon the most sacred sites of both religions; yet, in reality, this practice merely served as a reminder of the prior sites and showed future archaeologists where to dig.

32 bottom *After his son Titus conquered Jerusalem, Vespasian had "Iudaea capta" written on the reverse of the sestertius coined for the Judaic province. On the front of the coin appeared the face of the emperor.*

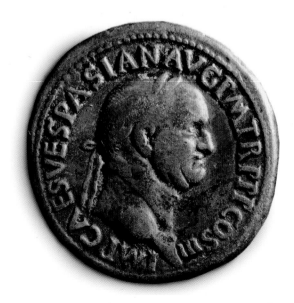

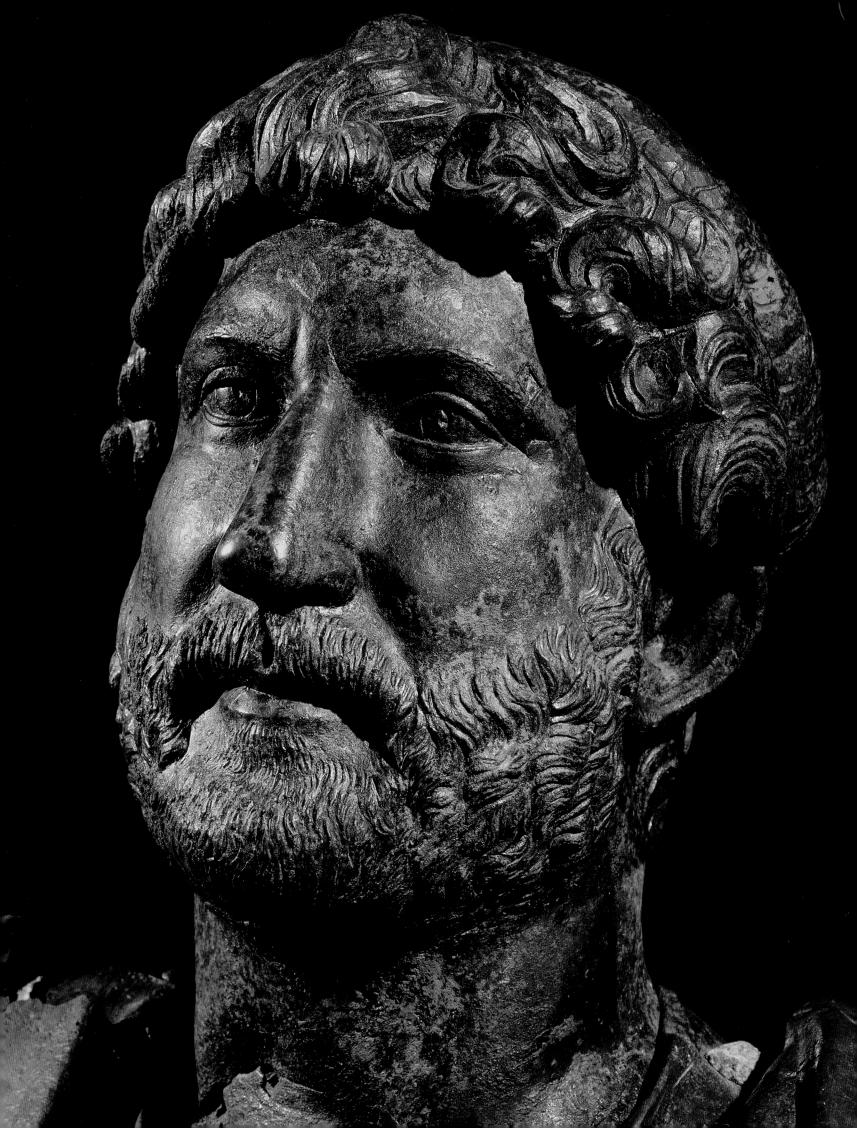

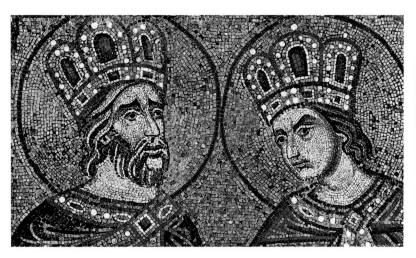

Two centuries later, Emperor Constantine, who granted religious freedom to the Christians in 313, and built the most beautiful basilica in Christendom on Calvary and on the Holy Sepulcher, and even more so his mother the octogenarian Empress Helena, would thank Hadrian for indicating where the old sacred sites were located. Helena, arriving in Jerusalem from Rome, excavated throughout the area and uncovered the three Holy Caves in which, respectively, Jesus had been born, had instructed his disciples, and where he was buried. Helena also brought to light a cross reputed to be that of the Savior. Jerusalem, at that point a Christian city (except for the brief attempt by Emperor Julian the Apostate to restore Judaism) became a pilgrimage destination as it once had been for the Jews. The faithful, such as the Pilgrim of Bordeaux and the Spanish nun Egeria, left diaries detailing the voyage that would be very useful for future scholars, while the grottoes in the Desert of Judah, which surrounds the city, also became populated by hundreds of monks and hermits. The city was then named the seat of the Patriarchate and Justinian gave it a refined Byzantine appearance.

34 Christian Jerusalem owes a great deal to Constantine and his mother Helena. Although a Byzantine mosaic (now in Venice) places haloes above both of them, Emperor Constantine is considered a saint only in the Orthodox Church.

34-35 The Madaba Mosaic in Jordan depicts Jerusalem, during the Byzantine era, with 21 towers and six gates. On the right is shown the great Nea Basilica, built in 540 by Justinian, of which few traces remain today.

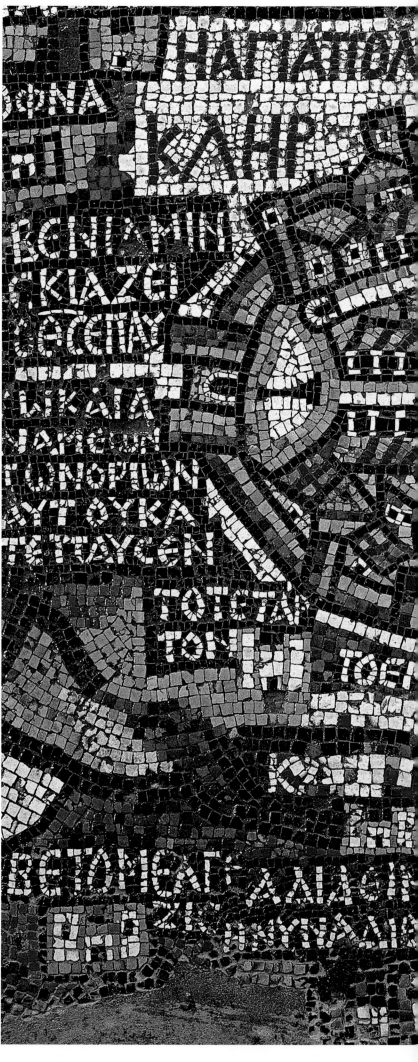

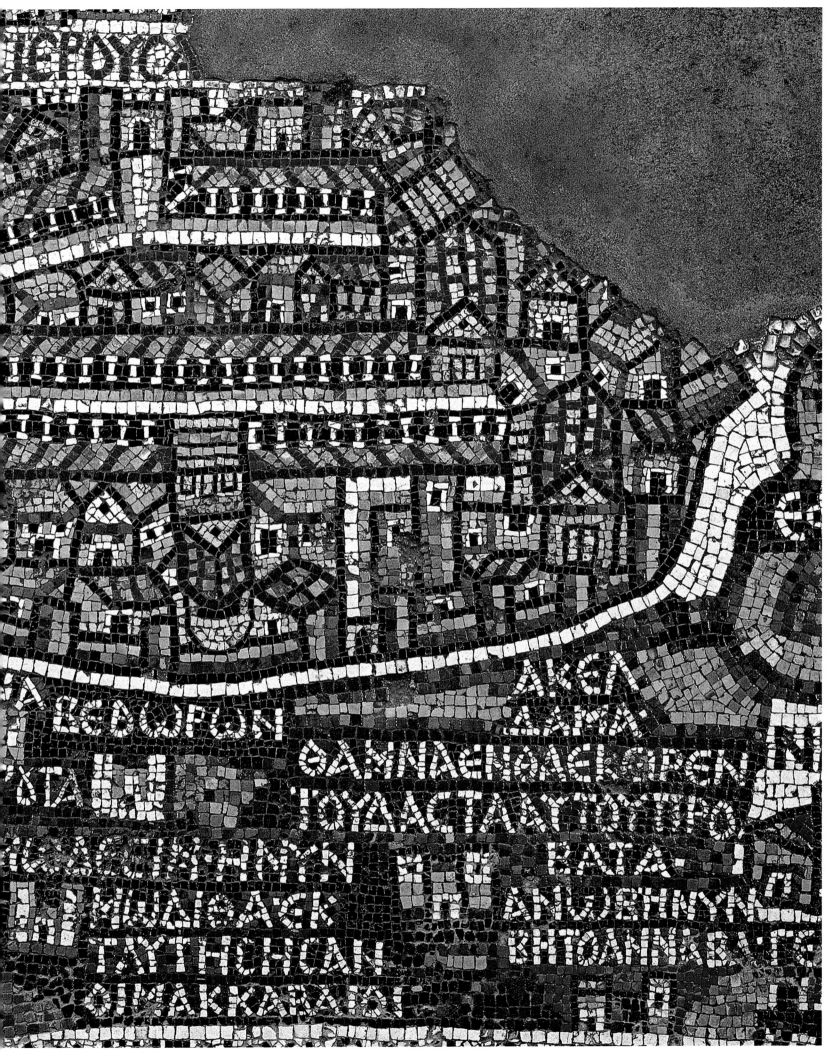

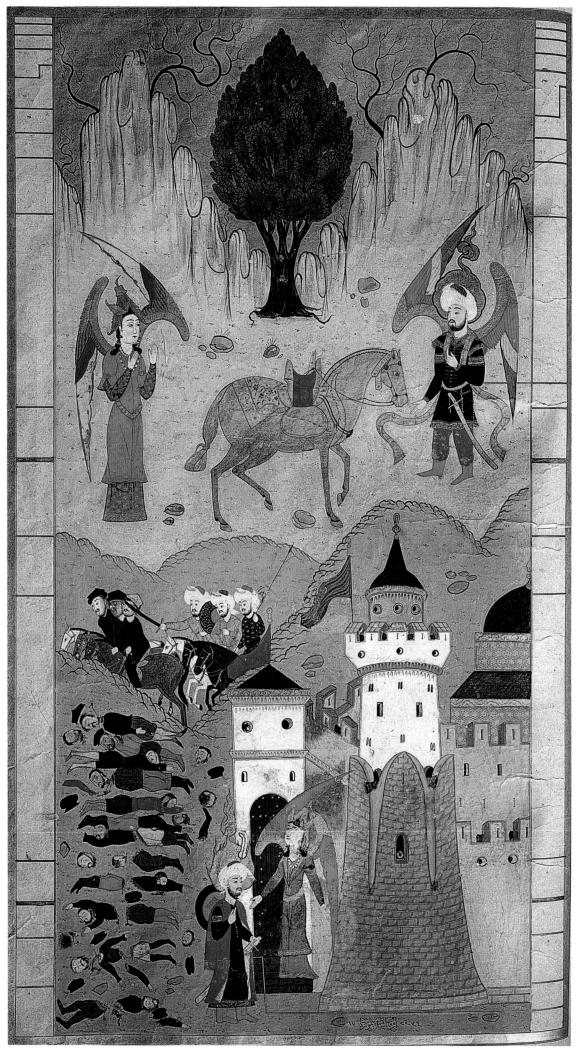

In 615, however, the Persians of Khosrau II, followers of Zoroaster, invaded the city with a blind fury, attempting to wipe away every trace of Christianity. In this they were helped by the Jews, who felt oppressed by the Byzantines. The Byzantine Emperor Heraclius recaptured Jerusalem in 629, but in 638 it fell into Arab hands, without offering any resistance. Just six years after the death of Muhammad, Caliph Omar, his second successor, made Jerusalem the third holy city of Islam, after Mecca and Medina. Later caliphs would embellish the Temple Mount with spectacular mosques.

The Jews, in the meantime, were authorized to re-enter the city and began their custom of praying in front of the Western Wall, while the Christians were allowed to build hospices for pilgrims. It was during these centuries that the various religious communities began grouping together in their own areas, sowing the seeds of the current four quarters of the Old City. The ruling dynasties of the Umayyad (661-750) and the Abbasid caliphates (750-973) were followed by the Shia Fatimids (973-1055). One of the Fatimid sovereigns who lived in Cairo, Hakim (the "Crazy Sultan" and self-proclaimed incarnation of Allah), broke the policy of tolerance: in 1009 he had all of the churches in Jerusalem destroyed, including the Church of the Holy Sepulcher. This destruction of the tomb of Christ aroused an indignation in Europe great enough to give birth to the idea of freeing the Holy Land.

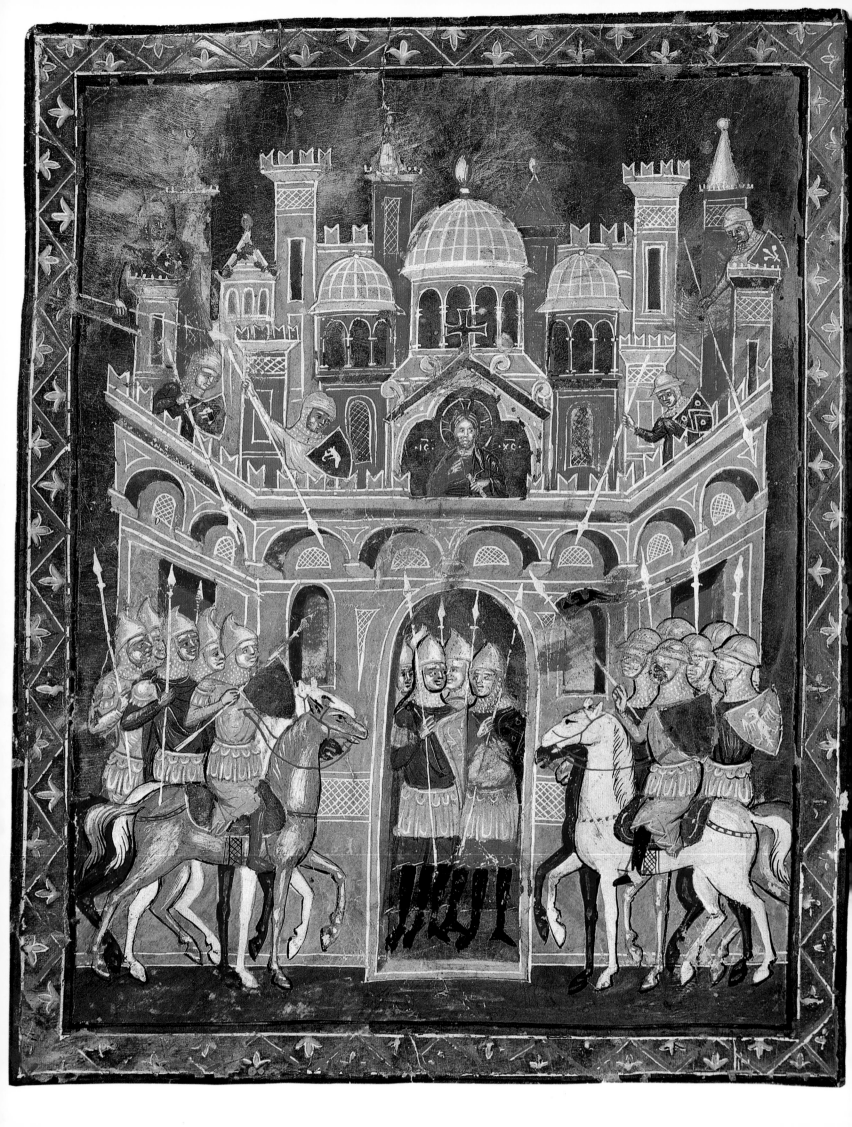

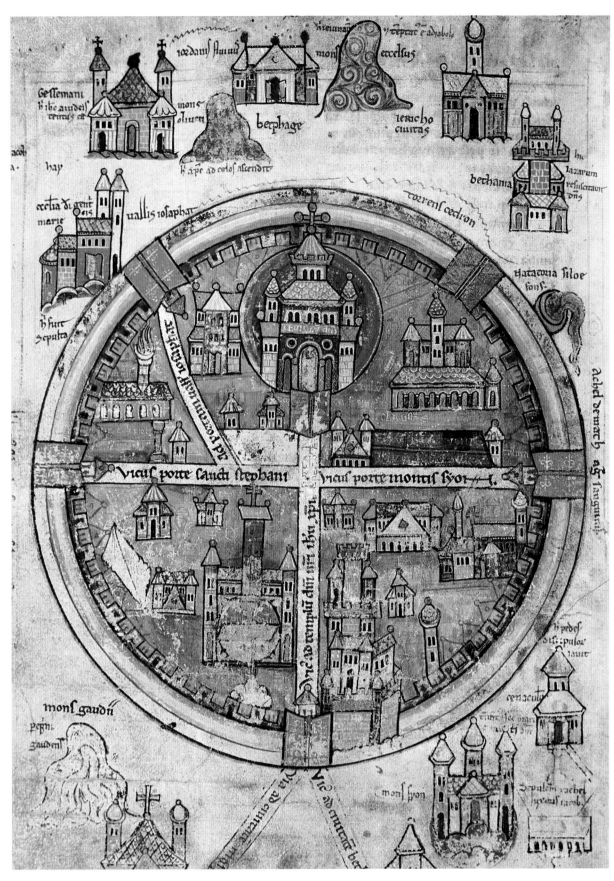

The First Crusade, called by Pope Urban II, departed in 1096, and on July 15, 1099 the crusaders entered Jerusalem through Herod's Gate, committing a horrific massacre (it is said that 70,000 Jews and Muslims died). Godfrey of Bouillon, the Duke of Lower Lorraine, then laid his sword upon the Holy Sepulcher and proclaimed himself Defender of the Holy Sepulcher rather than King, "not wanting to wear a crown of gold where Christ was once crowned with one of thorns." Upon Godfrey's death, however, his brother Baldwin did accept the crown of the King of Jerusalem, on Christmas night in Bethlehem in the year 1100. Thus began the Frankish reign of Jerusalem, that officially lasted until the fall of Acre (Akko) in 1291. However, the Holy City was actually lost before this in 1187, when it was captured by Saladin (Salah al-Din, or "Righteousness of the Faith"), the Kurdish Sultan of Egypt and Syria. Nine crusades were called (eight in total by the year 1270) but Jerusalem was never again to be Christian, with the exception of a period of ten years in which the Sultan of Egypt al-Kamil (known also for having met with Francis of Assisi) returned it to Frederick II in the agreement of 1229.

In 1249 Jerusalem came under the control of the Mamluks, the ex-slave Circassians who later became sultans in Cairo. Like the Crusaders before them, they were noted for their architectural fervor, filling Jerusalem with elegant palaces. Also, the Mamluks showed tolerance toward

Jews and Christians, although both groups were required to wear a symbol on their clothes, yellow for the Jews, and blue for the Christians. It was the Mamluks who in the 14th century allowed the Franciscans to establish themselves in Jerusalem, thereby becoming from then on the major presence for Catholics in the Holy Land.

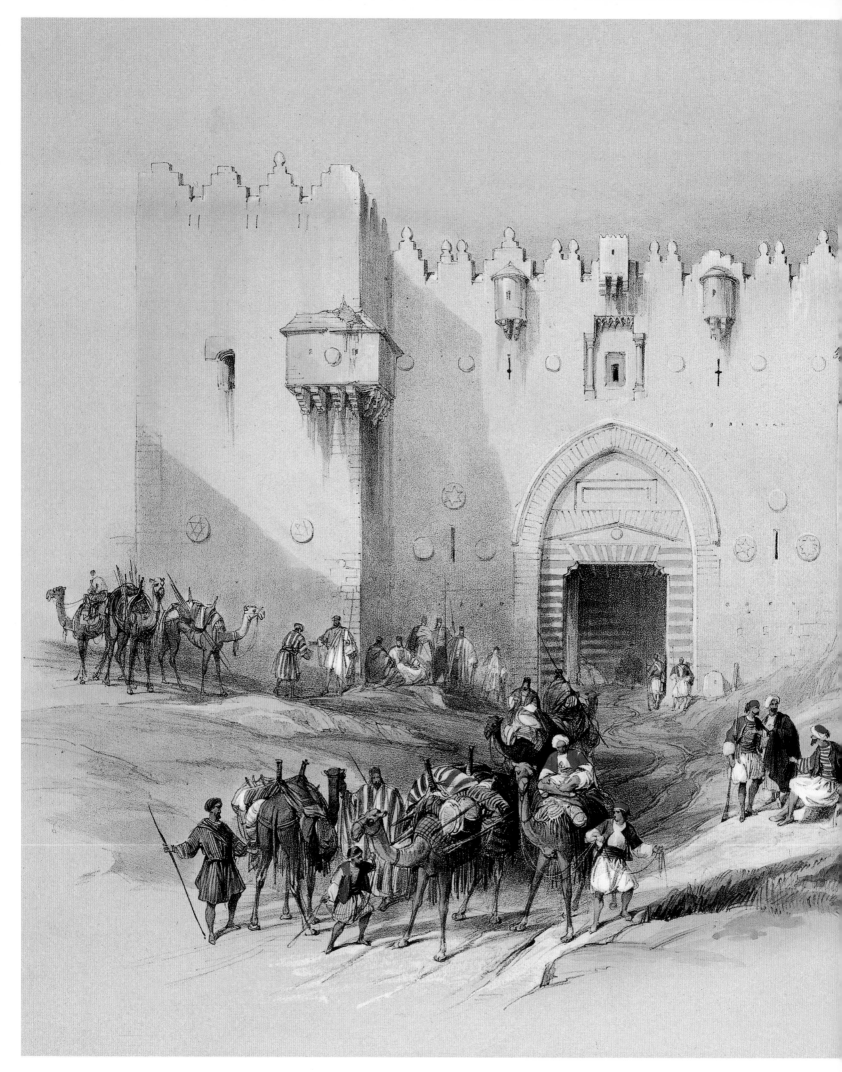

40-41 and 41 In 1839 the Scottish artist David Roberts painted dozens of splendid watercolors in the Holy Land. His *Damascus Gate* (left) shows there was nothing outside the city walls during that era. In the paintings to the right, the monolith of the so-called *Tomb of Absalom* and the *Dome of the Rock* appear noticeably enlarged.

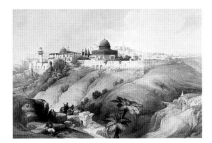

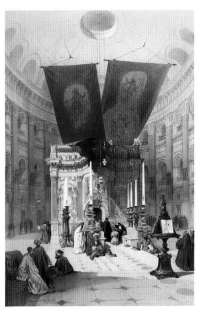

Subsequently, in 1516 the Turkish sultan Selim I began four centuries of Ottoman control. His son, Suleiman II the Magnificent, restored Jerusalem's beauty and power, constructing the current city walls and many of the gates, including the Damascus Gate. After the long reign of Suleiman II, the presence of the Sublime Porte began a gradual decline that was particularly evident in the peripheral areas of the empire such as Jerusalem, which was left abandoned to raids by Bedouin bandits and to the fiscal greed of the pashas.

Meanwhile a group of Sephardic Jews arrived from Spain; then in 1700 the first large group of Ashkenazis arrived, some 500 Jews from Poland. In the 19th century a brief occupation by the Egyptian Ibrahim Pasha loosened restrictions on non-Muslims, thus increasing the flow of Christian pilgrims and Jewish immigrants into the city. The administration of the holy places became more difficult as tensions rose both among the different religions as well as among the various Christian denominations, who fought over every square foot of the Church of the Holy Sepulcher. In 1852 Sultan Abdul-Megid I imposed a modification of the 17th-century status quo, which had delineated possession of the holy places. Two years later, the Crimean War broke out due to a dispute between Russia and France over the control of these same holy places.

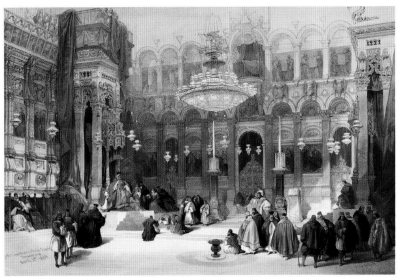

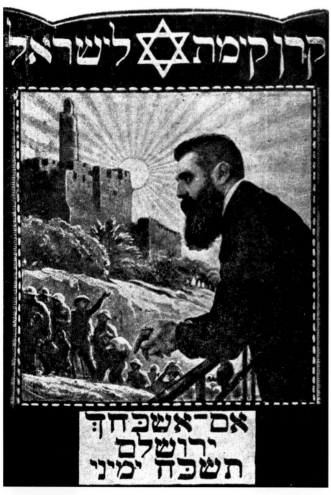

קרן קימת ✡ לישראל

אם־אשכחך
ירושלם
תשכח ימיני

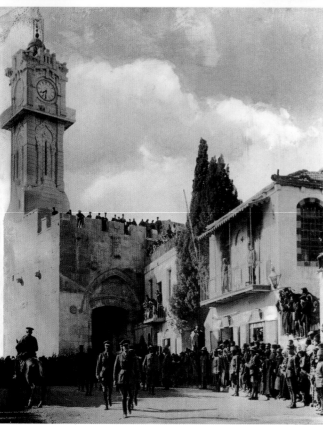

By this time the Old City had become crowded. In 1860 Sir Moses Montefieore, an English magnate of Italian origins, financed the creation of a new Jewish quarter, the first located outside the city walls. In 1897, in Basel, the first meeting of the World Zionist Organization, called by the Hungarian journalist Theodor Herzl, proclaimed the need to turn Palestine into a Jewish state. This right was recognized by Great Britain in the Balfour Declaration of November 1917, stating that it was favorable to the creation of a "national Jewish home" in Palestine. Also in 1917, after the fall of the Ottoman Empire in World War I, the British General Edmund Allenby entered Jerusalem on foot through the Jaffa Gate. Great Britain thereby began governing Palestine (among the first measures was the requirement to use only local sandstone in Jerusalem's buildings). In July of 1922 the League of Nations officially entrusted western Palestine to the British with the Mandate of Palestine, while to the east was created the Emirate of Transjordan. This ignited the flames of Arab and Jewish nationalism – especially terrible in the 1929 massacres.

42 top Theodor Herzl, the founder of modern Zionism, did not like Jerusalem, which in 1898 he found it to be full of "fanaticism from all sides." He would have preferred Haifa as the capital of Israel.

42 bottom Having already defeated the Turks at Gaza, the British General Edmund Allenby then conquered Jerusalem on December 9, 1917. Two days later, he entered Jerusalem through the Jaffa Gate on foot, out of respect for the Holy City.

42-43 During a speech to the inhabitants of Jerusalem, given from the platform in front of the entrance to the Citadel, Allenby declared freedom of religion in the Holy City. For the first time since the era of the Crusades, however, Jerusalem was controlled by Christians.

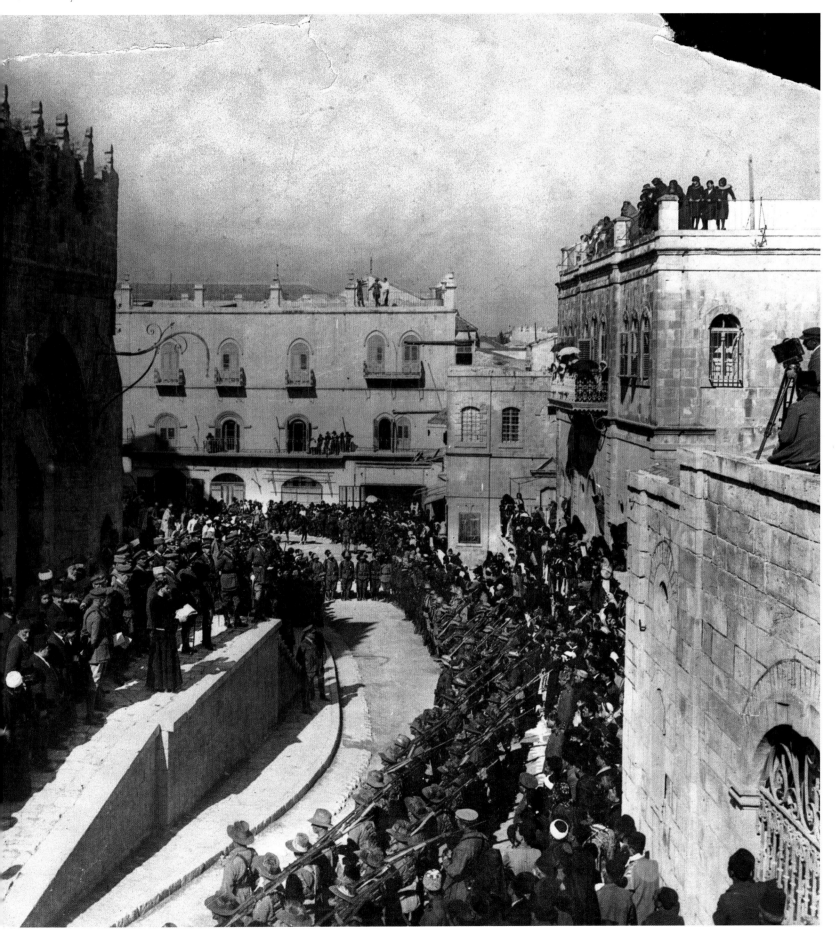

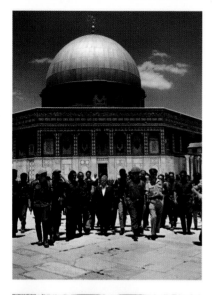

44 top On June 7, 1967 Israeli forces occupied the Temple Mount. For the first time in almost two thousand years, Jews were free to walk where Solomon's Temple and later Herod's Temple once stood.

44 bottom The Military Commander Uzi Narkiss, the Minister of Defense Moshe Dayan, and the Head of State Yitzhak Rabin, entered the Old City through the Lions Gate.

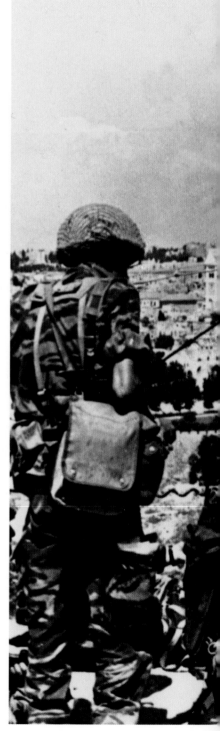

On the eve of World War II the British government tried to place a limit on Jewish immigration, while the paramilitary Zionist group Irgun carried out terrorist acts. After the end of the war, on July 22, 1946, a commando unit that included the future Israeli Premier Menachem Begin bombed the King David Hotel, which housed the British command, killing about 80 people. The British government stated its intention to end its responsibilities relating to the Mandate of Palestine, and on November 29, 1947 the recently formed UN decided that Palestine would be divided into two states, one Arab and the other Jewish, and that Jerusalem would be considered a separate entity.

David Ben-Gurion proclaimed the birth of the state of Israel in Tel Aviv on May 14, 1948. The next day the British left Palestine, and Egypt, Jordan, Syria, Iraq and Saudi Arabia invaded; the first Arab-Israeli War lasted a year and ended with a partition of both the region and of Jerusalem. The ancient city was divided by the Green Line (the armistice line of 1949), which could only be crossed at the Mandelbaum Gate. Israel occupied 80 percent of the region, causing millions of Palestinians to flee, while the Arab League occupied all of the Old City, and destroyed the synagogues. For 19 years no Jew was allowed to pray in front of the Western Wall.

In the following years, the Law of Return allowed immigration to Israel for all Jews, not just those who had survived the Holocaust, and Hebrew – a language that had been dead for centuries – was reborn.

In 1964 the Palestinian Liberation Army (PLO) was founded. That same year Pope Paul VI completed an historic voyage to the Holy Land: at the Church of the Holy Sepulcher he embraced the Patriarch of Constantinople, Athenagoras I, putting to an end nine centuries of animosity between the Orthodox and the Catholics, and reaching an agreement on the administration of the Christian holy sites (another historic voyage would be completed 36 years later by Pope John Paul II for the 2000 Jubilee, where he paid tribute to the Wailing Wall and the Holocaust Museum).

After the Six Days' War ended in June of 1967 with the defeat of the Arabs and the Israeli conquest of the entire city of Jerusalem, the Jews could once again freely pray in front of the Wailing Wall: it was here that, by demolishing a Muslim quarter, General Moshe Dayan obtained in a single night a sufficient clearing to hold 100,000 people. For the following 28 years the city was governed by the extremely popular mayor Teddy Kollek, and experienced a period of revitalization and development, especially in the western quarters.

After the Yom Kippur War (1973), started by the Arabs on the holiest day of the Hebrew calendar, ended in a stalemate, Israel and Egypt initiated talks. The historic visit to Jerusalem by Egyptian leader Anwar Sadat in 1977 was a prelude for the peace talks at Camp David in 1978.

44-45 On the Mount of Olives, Moshe Dayan's soldiers prepared for the final assault on the Old City, which had been under Jordanian control for 19 years. After the victory, they all prayed in front of the Western Wall.

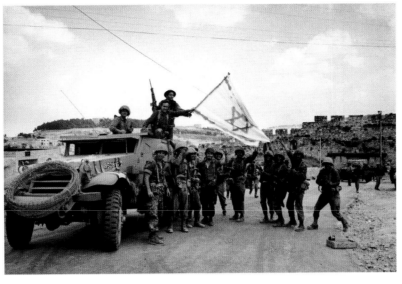

45 top left In Jerusalem the fighting raged from house to house. Finally, troop commander Motta Gur communicated to Narkiss three historic words: "Har habayit beyadenu," – "the Temple Mount is in our hands."

45 top right Near the Damascus Gate, Tsahal's troops celebrated the conquest of the eastern part of Jerusalem. In the following days, tens of thousands of Israelis rushed to see the Old City.

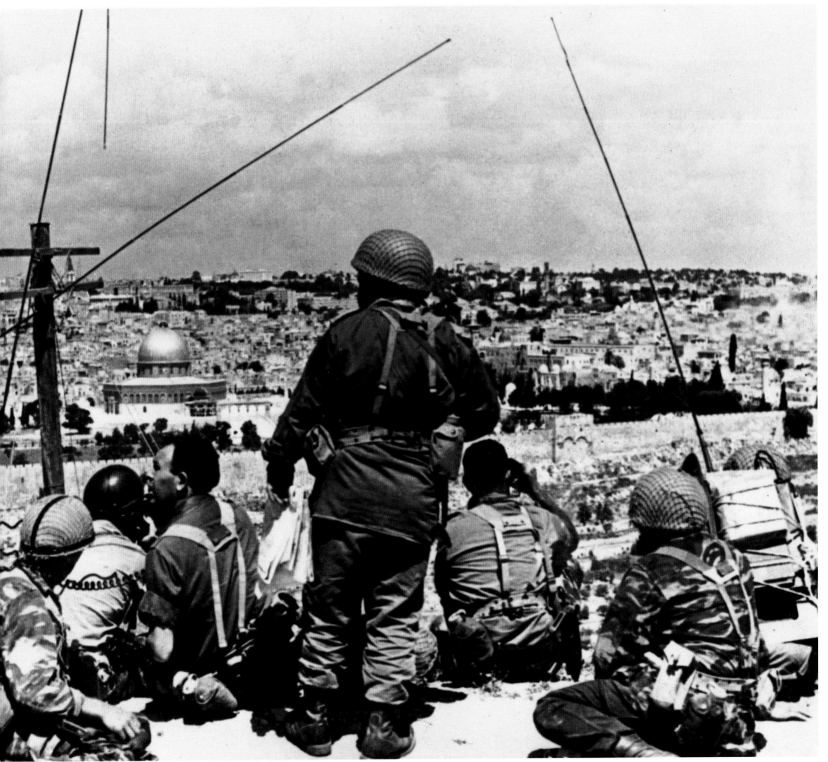

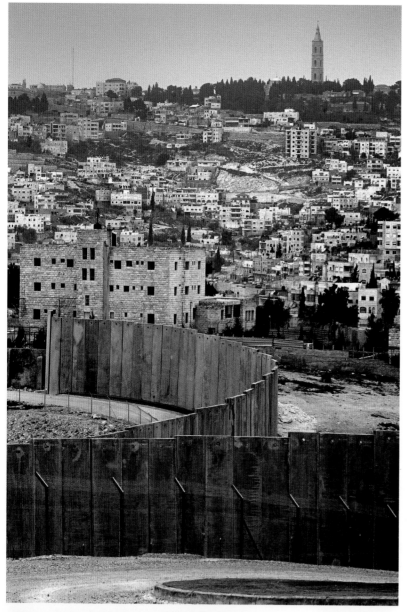

In 1980 the Israeli Knesset forced the issue of Jerusalem by proclaiming Jerusalem to be the "complete and united capital of Israel." This Basic Law was condemned by the UN and by the Palestinians, but it was not retracted. In 1987 the PLO began the Intifada, "the revolt of the stones," in the Israeli-occupied territories. In the 1990s the Oslo Accords (1993) between the Israeli Prime Minister Yitzhak Rabin and the Palestinian leader Yasser Arafat, initiated a period of peace between Israel and Jordan. The birth of the Palestinian National Authority appeared to be a prelude to a solution for the status of Jerusalem, which the Palestinians also claimed as their capital. During this period, the city was revived and post-modern architecture and hi-tech companies multiplied. Then, however, Rabin was killed by a Jewish extremist, and the new Prime Minister Ariel Sharon made a controversial visit in 2000 to the Temple Mount, provoking the al-Aqsa Intifada, or the second Intifada. Israel then began the construction of the West Bank Barrier, a 450-mile (728-km) barrier that is designed to protect the national territory from suicide attacks and infiltration by Arab terrorists. In Jerusalem, which was becoming ever more modern and populated (in 2007 the city had 732,000 inhabitants, of which 65% were Jewish, 32% were Muslim and 2% were Christian), the existence of an 26-ft (8-m) tall wall that winds around the Jewish colony and between Qalqily and East Jerusalem became an additional element of tension. Jerusalem remains, in summary, a tormented city, as it has almost always been for the past 3000 years. However, as Psalm 90 states, in the eyes of God "a thousand years . . . are like a day that has just gone by."

46 top In addition to the Western Wall, there is now another wall that divides Jews and Muslims, creating strong political and social tensions – the "security barrier" that also impinges on the territory of Jerusalem.

46 bottom With Bill Clinton observing, the historic handshake between Israeli Prime Minister Yitzhak Rabin and PLO leader Yassir Arafat formalized, on Septemeber 13, 1993 in Washington D.C., a peace that, unfortunately, was fleeting.

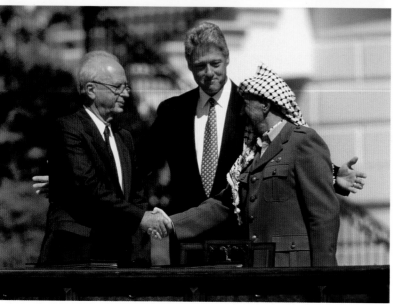

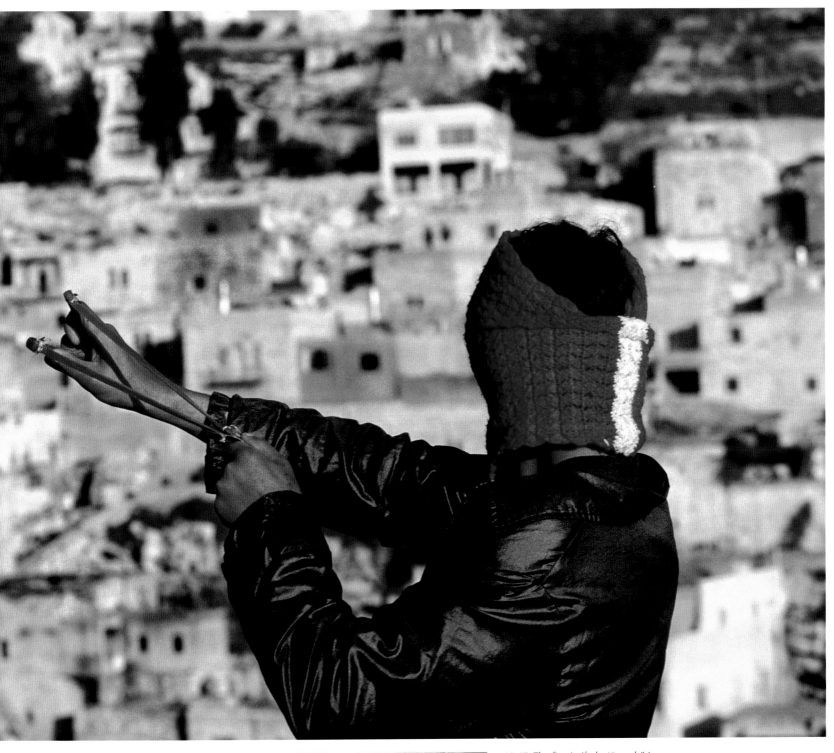

46-47 The first intifada ("revolt" in Arabic) erupted in 1987 in the Palestinian refugee camps, subsequently spread as far as East Jerusalem, and was not extinguished until the Arab-Israeli Oslo Treaty was signed in 1993.

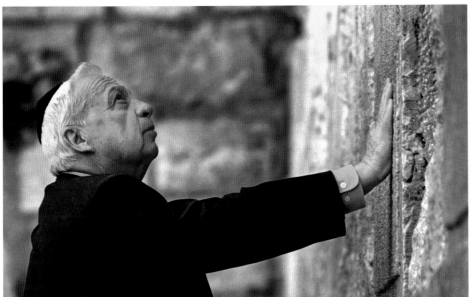

47 bottom Ariel Sharon prays in front of the Western Wall. On September 28, 2000 he ascended to the mosque on the Temple Mount with one thousand men, igniting the second Palestinian intifada, or the al-Aqsa Intifada.

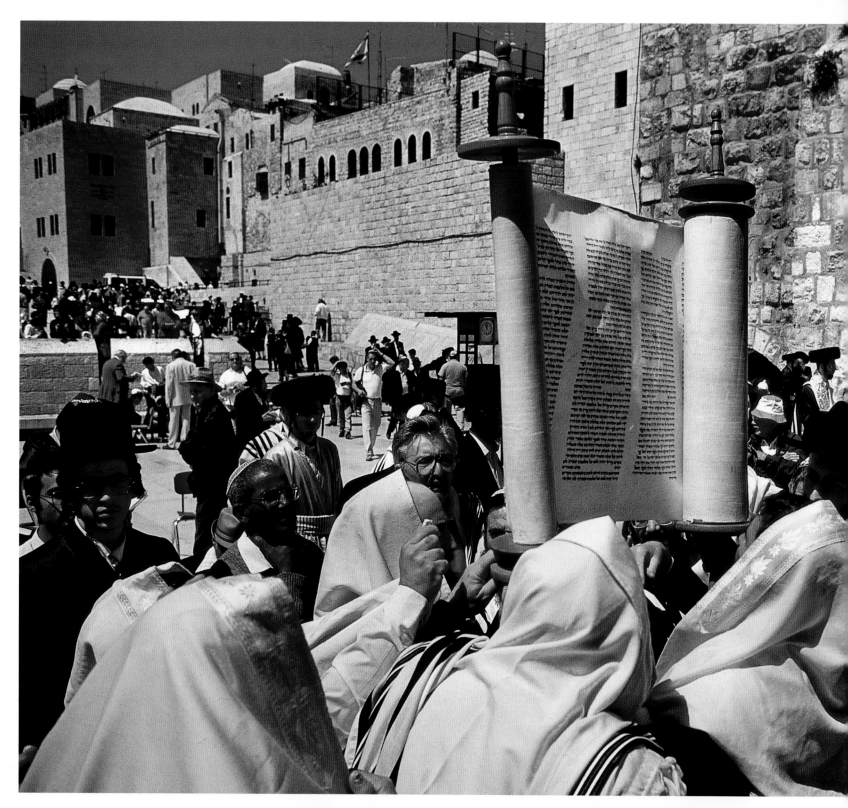

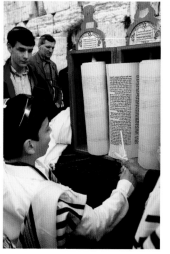

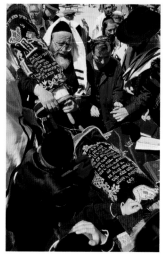

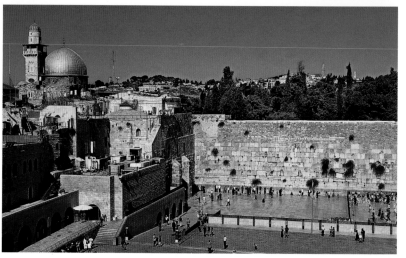

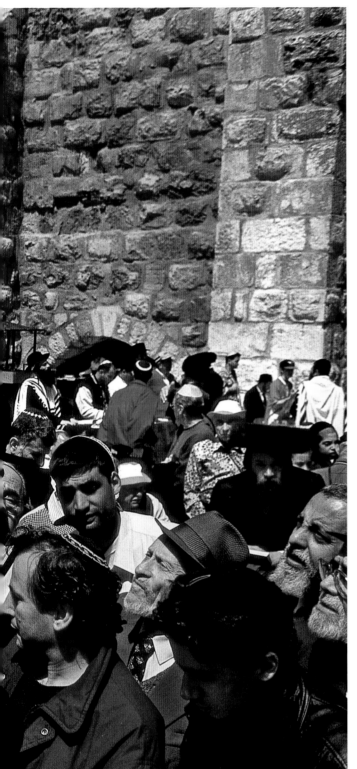

THE JEWISH QUARTER

AN IMPOSING WALL OF BARE ROCK, WHICH AT SUNSET RETURNS THE HEAT ACCUMULATED DURING THE DAY AND TURNS THE COLOR PINK.

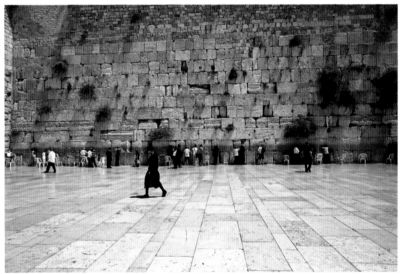

48-49 At any time of day, there is always activity at the Western Wall. With a prayer shawl known as a tallit or a simple skullcap covering their heads, the faithful hold Scrolls of the Law, which were prohibited during the British Mandate period.

48 bottom left With their Bar Mitzvah or Bat Mitzvah, Jewish children become adults and must respect the positive commandments. At the end of the festive ceremony, they receive the benediction of an elder and of the crowd.

48 bottom center Every Monday and Thursday morning, Bar Mitzvahs ("Son of the Commandment") are held in front of the Western Wall. Elder rabbis bring Torah scrolls from which 13-year-old Jews read aloud for the first time in public.

48 bottom right and 49 The Western Wall or Kotel is the only surviving part of the immense wall built by Herod the Great, in 20 BCE, to enable the enlargement of the Temple Mount.

There is no other religion in the world that has as it most sacred site a place of such simplicity; this is even more evident when compared to the Dome of the Rock, which looms over the wall from the Temple Mount. This is the Wailing Wall. Or, more correctly, what is erroneously known throughout the world as the Wailing Wall and what to the Jews is simply *ha-Kotel*, the Wall; more specifically, *ha-Kotel ha-ma'aravì*, the Western Wall.

To understand the spirit of Judaism, the capacity to survive millennia of horrible trials, it is necessary to stand before this powerful symbol of destruction and rebirth, this place said to be closer to God than anywhere else in the world. The visitor can come any day and at any hour, under the dazzling light of day or the pale light of the moon. But above all the Wall should be visited on a Saturday, when the great square fills with pilgrims, becoming an animated outdoor synagogue: Ultra-Orthodox Jews with black coats and brimmed hats, rabbis who explain the scriptures, the faithful who pray while rocking backward and forward, groups of American Jews in short sleeves, tourists who receive upon entering either a skullcap (kippa or yarmulke) made of cardboard for the men, or a cloth to cover their legs for the women (a small section of the Wall, to the right, is reserved for women). If instead it is a Monday or a Thursday, the Wall becomes a place of celebration, where happy families press around a thirteen-year-old who is becoming a "Son of the Commandments" in a Bar Mitzvah ceremony, reading aloud a passage from the Torah for the first time before being blessed by an elder and carried on their shoulders, to the applause of everyone present.

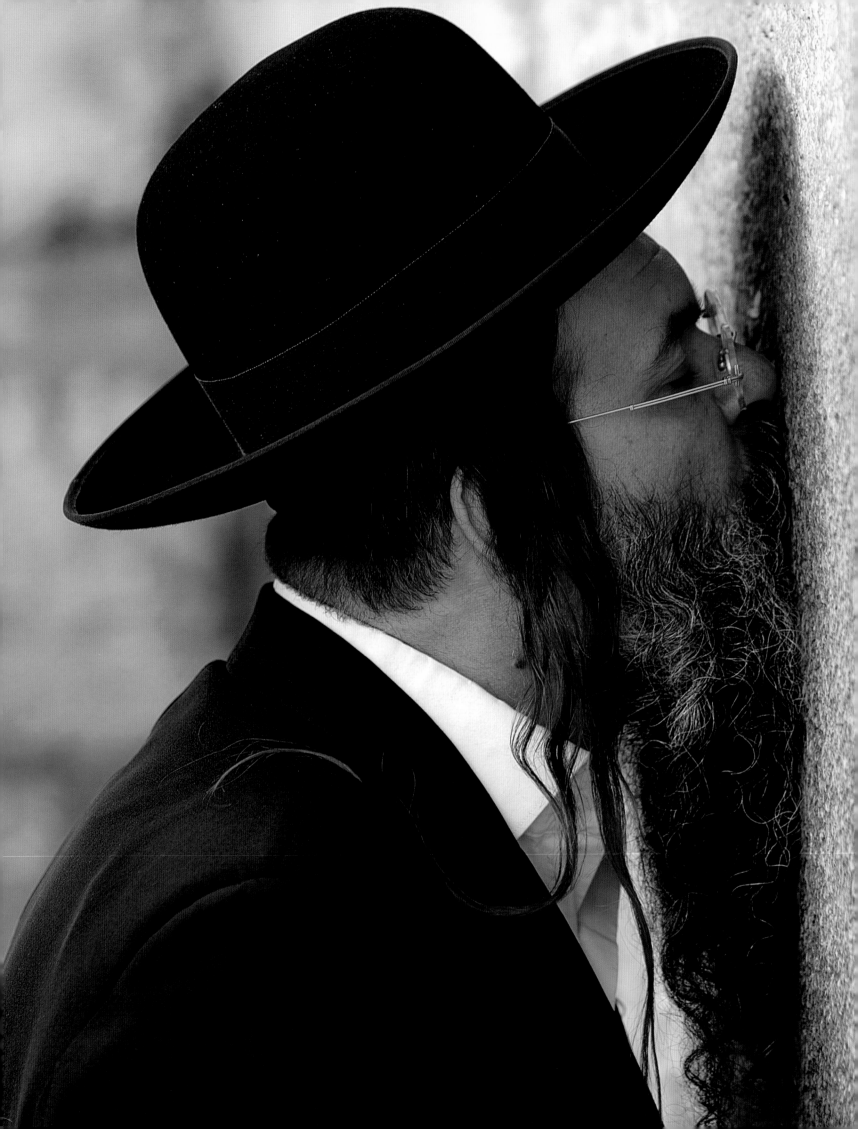

50 Kissed, touched, and caressed, the Wall is sacred to the Jews because it is closest to where the Holy of Holies once stood. The faithful insert small pieces of paper with prayers to God between its enormous stone blocks.

51 left Bands of leather called tefillin encircle the left arm, serving as a reminder of the verse in Deuteronomy in which God asks that His laws be "as a sign upon your arm and as a totafot between your eyes."

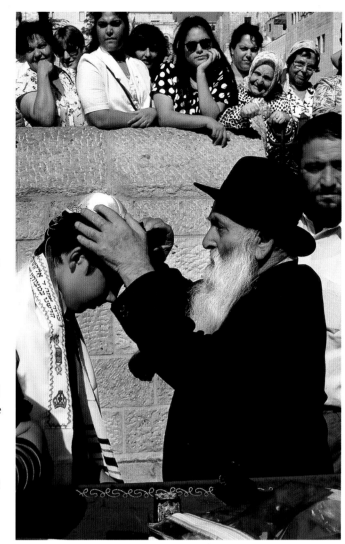

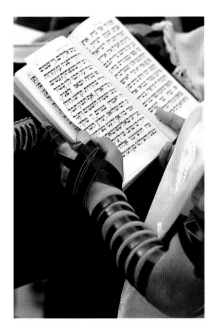

There are those who read the Scriptures, who bring a chair close to the Wall, who pray with their faces pressed against the stone, who push into the cracks of the Wall small pieces of paper with personal requests to God (every so often the Wall is cleaned, and the worn papers are collected and buried in a sacred place). Now even those who live abroad can send their prayers to what has been called "God's mailbox"; prayers can even be sent by fax or e-mail, and the messages will be brought to the Wall. The visitor can lean against the sacred bastion to photograph those who are praying,

and no one will complain. But woe to the person who holds a camera on the day of the Sabbath. In a moment he will be surrounded by zealous Ultra-Orthodox Jews who threaten: "We will take you to the police."

The sanctity of the Wall is linked to the Shékinah, the mysterious and ineffable Presence of God that would never abandon the last remains of the sanctuary in which the Presence had resided for centuries: the Shékinah first resided in the Ark of the Covenant; then, after the Ark was lost forever, thereafter dwelt in the Holy of Holies of the Second Temple, reconstructed by the Jews when they returned to their homeland from Babylon; finally, when the Second Temple was destroyed by Titus in 70 CE, this Presence would have impregnated itself in the last remains of the foundation, the imposing Wall that Herod the Great had built 90 years before to support the enlargement of the Temple Mount. This was a colossal undertaking, with the wall being being constructed of squared stones layered as dry blocks without mortar, often measuring more than 3 ft (1 m) thick and weighing as much as 100 tons each: a feat worthy of the Great Wall of China.

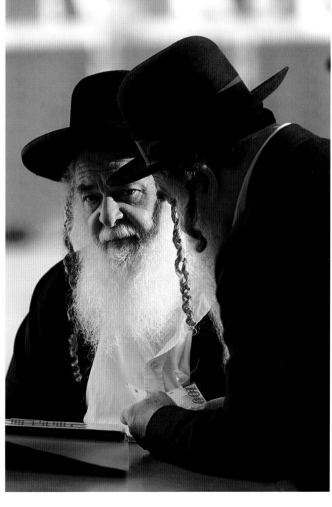

51 right From 1948 to 1967, under Jordanian occupation, the Jews were forbidden to go to the Western Wall to pray. Now, a rabbi willing to explain the Scriptures to the faithful can always be found at the Wall.

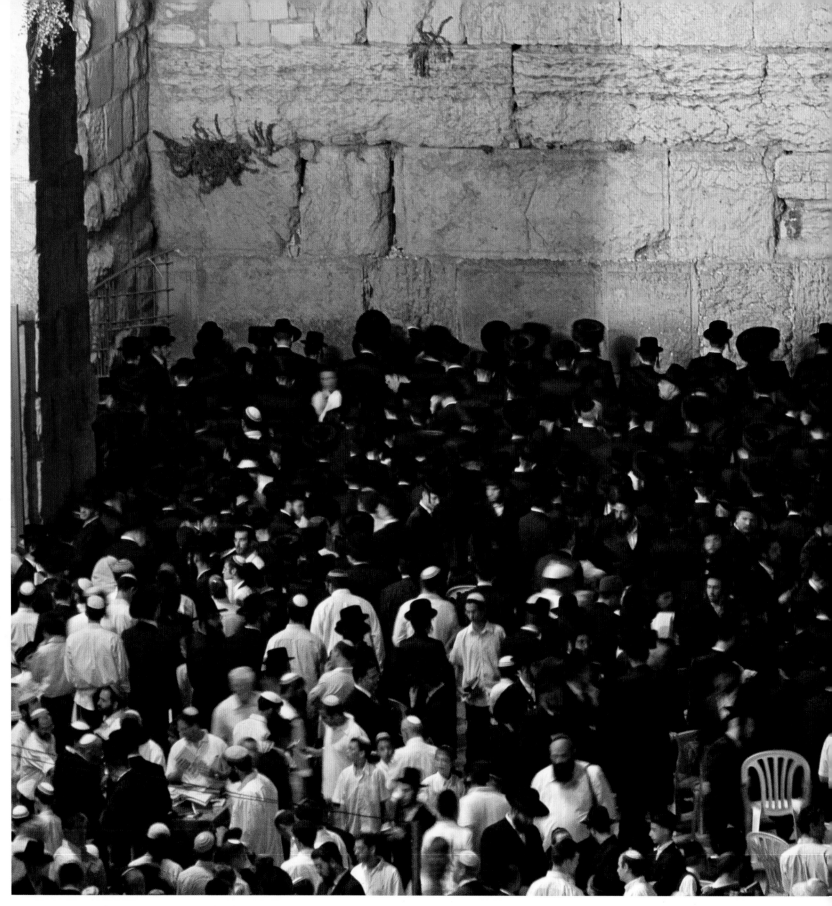

The Western Wall, which measures 1600 ft (488 m) in length, is only visible for approximately one third of this distance. Similarly, only eleven levels are visible, three of which were uncovered after the Israeli reconquest in 1967. A veto by the rabbis has impeded the excavation of the additional 17 levels still below the surface.

To the right of the Wall, near the southwest corner of the Temple Mount, protrudes a piece of the broken arch known as Robinson's Arch, which had a 40ft (12-m) span. This arch is named after the American archaeologist Edward Robinson, who discovered it in 1838. The arch was once part of an enormous stairway that climbed to a

door in the Temple wall. Shortly afterwards, a Hebrew inscription was discovered below the arch, possibly dating to the time of Emperor Julian the Apostate (362 CE), quoting a passage from the Prophet Isaiah. Today the inscription is protected by a sheet of glass. The four lateral niches in the arch housed exchange offices that changed

money for pilgrims on their way to the Temple, where offerings were accepted only in local currency.

To the left of the Wall is another arch, called Wilson's Arch, discovered in 1867 by the English archaeologist Charles Wilson, and is today embedded in a synagogue. This arch was part of a viaduct that passed above the now

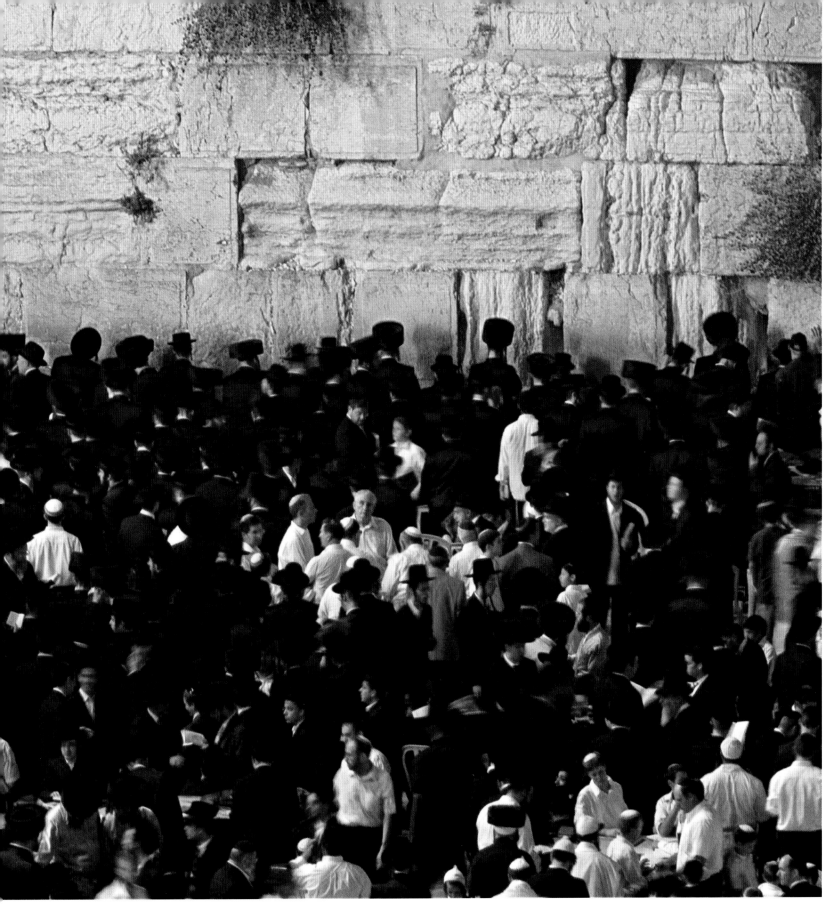

filled Tyropoeon (the Valley of the Cheesemakers), and as early as the Maccabeean period climbed up from the city to the Temple Mount. In the rooms under the arch, whose access is reserved to men, it is possible to see sections of the Second Temple Wall. Also located below Wilson's Arch is the entrance to the controversial Western

Wall Tunnel, the 984 ft (300 m) extension of which caused clashes and deaths among Israeli and Palestinian soldiers in 1996.

Passing through the Tunnel, the visitor sees secret passages, digital reproductions of the Temple, water cisterns and other remnants of the ancient Hasmonean aqueduct; the

visitor also encounters groups of Jews praying in small synagogues, and just a few yards above these Jews' heads, on the Temple Mount, resound other prayers – those of the Muslims. Also Muslim is the quarter into which the tunnel opens, the courtyard of a madrasa, which happens to be the very place where the Christian Via Dolorosa

begins. In Jerusalem, despite all attempts by the religions to avoid meeting, they always end with their paths intertwined.

52-53 On the day of the Sabbath, the square that lies before the Wall becomes an open-air synagogue. In the front, the Orthodox rabbis wear the characteristic head coverings reserved for holy days.

Seeing the refined appearance of the Jewish Quarter, modern and even a little cold, it is difficult to believe the Jews had lived here 2800 years before in the time of King Hezekiah. Unfortunately, in this quarter more so than in other areas of the Old City, the signs of history have been erased by the destruction carried out during and after the Jordanian occupation. The radical reconstruction, started in 1967 by the Israelis, has reclaimed an area that before 1948 was inhabited mostly by very poor Jews who were living under terrible conditions, and which today has become both peaceful and expensive. Other than the students of the impressive *yeshivot*, only a few hundred wealthy Jews live there (it is forbidden for non-Jews to buy or rent property in the quarter). It is pleasant, however, to stroll along the quiet streets, observing on the doorframes the artistic mezuzah containing parchments with the first two parts of the Shemà, the fundamental prayer of the Jewish religion. Not even the most secular of Jews would forgo this tradition, which was recommended by Maimonides in *mitzvà* No. 81 of his list of Talumudic precepts "Place a mezuzah upon every doorframe.

After slipping into the subterranean market dating back to the era of the Crusaders, visitors exit into the reconstructed and restored section of the Cardo, the central artery of Aelia Capitolina, or Roman Jerusalem. Nahman Avigad, the archaeologist who discovered the Cardo in 1975, was quite certain of where to look: he merely had to follow the directions on the "treasure map" – a Byzantine mosaic found in 1880 under a church floor in Madaba, Jordan, just across the Dead Sea. Dating from 560 CE, this mosaic, one of the most fascinating maps from antiquity, was created from two million colored tesserae and shows the Holy Land represented by unusual symbols: a fish swimming down the Jordan River to the Dead Sea, but then returning after being sickened by the salt water. On the mosaic map from Madaba, "the holy city of Jerus..." (some of the tesserae containing the Greek letters are missing) is shown as a compact and multi-colored oval surrounded by a turreted wall. The basilica of the Holy Sepulcher is clearly visible, while near the southern wall is the massive shape of the Nea, the imposing basilica built by Justinian in 543 CE, of which only a few stones remain today. However, the most noticeable feature on the map is the straight line of the Cardo, which divides the city into two parts and is lined with columns on both sides. The mosaic demonstrates that four centuries after the time of Emperor Hadrian, the Cardo continued to run north to south between what are currently the Damascus Gate and Zion Gate, and that its appearance was similar to that of the small section reconstructed by archaeologists. The arcades of the portico housed shops during that era as well, but they were certainly not like the luxurious boutiques with lighted window displays that make this a very exclusive area today. During that era there was no enormous menorah to be seen; it was put in place by those who supported the construction of the Third Temple.

54 *During the era of the Crusaders, the Cardo was transformed into a covered market; today this section of the ancient street has the look of an upscale shopping area, below street level.*

54-55 *Built by Hadrian as the principal artery of Aelia Capitolina, the Cardo was later widened by the Byzantines; the columns of the small restored section date from the Byzantine era.*

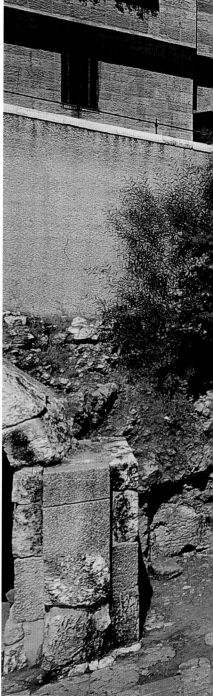

55 top left Devastated during the 1948 War, the Jewish Quarter of the Old City was completely reconstructed beginning in 1967, displaying a balance of traditional style and modern features.

55 top right Along Rehov HaYehudim or Jewish Quarter Road, which runs parallel to the nearby covered street, the Cardo, there are numerous artisan shops specializing in Judaica, jewelry and articles related to the Jewish religion.

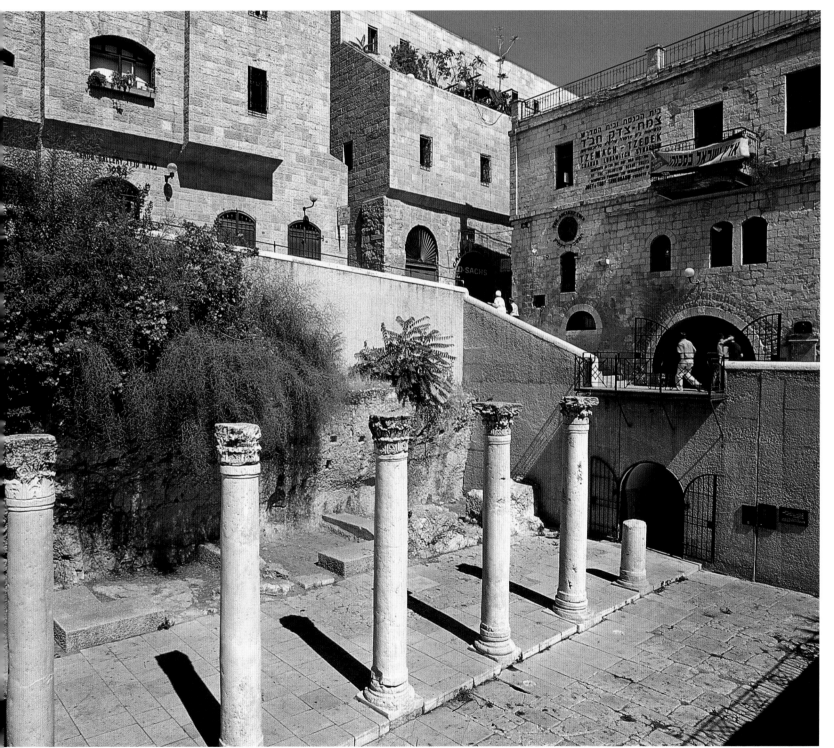

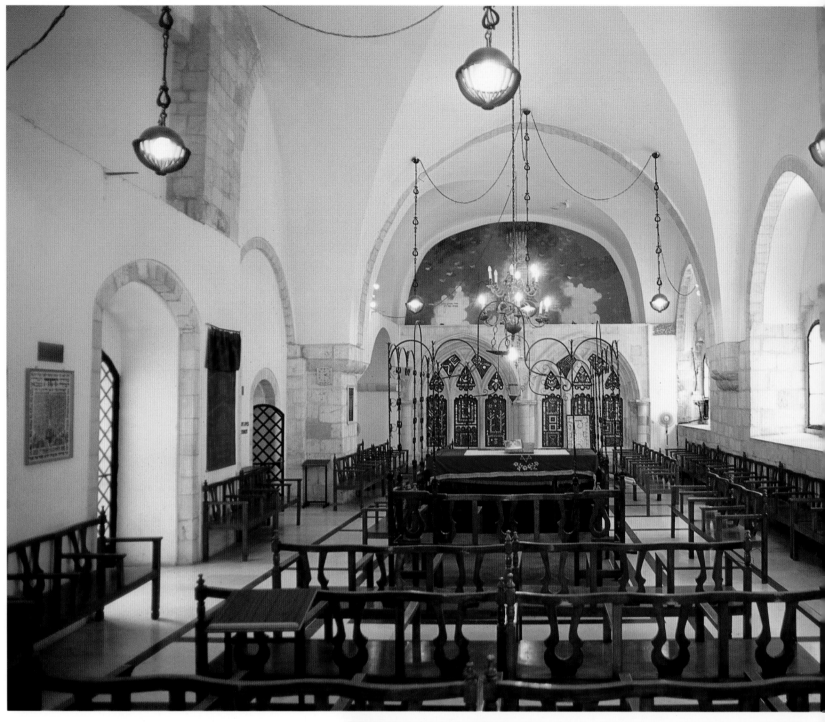

56-57 *Yochanan Ben Zakai Synagogue is the name given to an entire complex containing four Sephardic synagogues, constructed in 1610 in the heart of the Jewish Quarter by Jews who arrived from Spain.*

56 bottom *The Late Medieval Ramban Synagogue was the first synagogue to be founded in Jerusalem after the Jews were expelled by the Romans. In 1599 the Ottomans reduced it to a warehouse, and it was only in 1967 that the synagogue was reconsecrated.*

57 top *The crown on the wooden ark of the small Middle Synagogue, or Kahal Zion, was purchased from an Arab artisan from the Negev who forged it from a cannonball.*

57 bottom *Inside the 17th-century Istanbul Synagogue there is a beautiful* bima *with four columns (the platform for reading the Torah) which originated from a synagogue in Pesaro, Italy, that was damaged during World War II.*

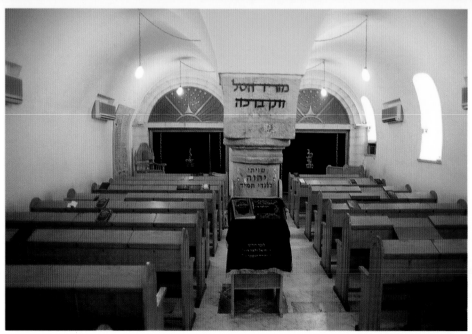

The historic synagogues in the Jewish quarter all shared the same sad fate in 1948, when Arab mobs burned 22 of the 27 and Jordanian soldiers demolished the other five. The two most important of these synagogues are located on Hurvà Square, the central square of the Jewish quarter, and have long been a point of reference for the Ashkenazim and the Sephardic Jews. Hurvà Synagogue (The Ruin) was erected in 1705 by the first large group of Ashkenazim to arrive in the Promised Land, a community of five hundred Poles who went deeply into debt for its construction. Unable to pay their debts to the Muslims, in 1725 the Poles fled and the synagogue was burned (thus the name "The Ruin"). More than a century later, the Ashkenazim community of the Perushim was granted permission by the sultan to construct a new and larger synagogue on the site. This synagogue, inaugurated in 1864 thanks to the help of the Rothschild family, had a beautiful dome that was the tallest in the Jewish Quarter. However, remaining faithful to its name, the synagogue was again brought to a state of complete ruin: on May 27, 1948 the Arab League reduced it to rubble; this was a tragic day for Jews the world over. Since 1967, it has frequently been suggested that the synagogue be rebuilt for a third time. In 1977, one of the four large arches was raised, which stood silhouetted against the sky for 30 years, suggestive and yearning. Finally, since 2007, thanks to considerable financing from overseas, the great dome of the Hurvà once again dominates the Jewish Quarter.

Like the Hurvà synagogue, the nearby Ramban synagogue, the oldest place of prayer in the Jewish quarter, rises on the remains of the Crusader church of St Martin, and is dominated by the minaret of the adjacent 14th-century mosque of Sidi Umar. These things are normal in Jerusalem, that melting pot of faiths and architecture.

The name Ramban refers in an abbreviated form to the initials (RMBM) of a famous Spanish rabbi, Rabbi Moshe ben Nachman, who in 1267 founded a Sephardic synagogue on Mount Zion, which was later moved in 1400 to its current location. Seized by the Muslims in 1585, partially destroyed by Jordanians in 1948, the Ramban synagogue was reconsecrated just after the Six Days' War in 1967, exactly seven centuries after its foundation – another sign of the Jewish people's unbreakable will to survive. On one side, a large inscription pays homage to Rabbi Moshe Segal, the rabbi who, during the British Mandate, challenged the prohibition of the authorities every year by sounding the shofar beneath the Western Wall for the end of Yom Kippur.

Among the other historic synagogues of the quarter are four of great importance, located just south of Hurvà Square, that were constructed by the Sephardic Jews between 1588 (when they arrived from Spain) and 1700. During this period, the Ottomans had declared that only minarets could be built taller than the roofs of houses. The Sephardic synagogues were therefore constructed below street level. The last Jewish strongholds to fall into the hands of the Jordanians in 1948, today these synagogues display beautiful carved arches and platforms (bima) for reading from the Torah, which came from 17th- and 18th-century Italian synagogues. The smallest of the four synagogues is the Middle Synagogue. There are also the Istanbul Synagogue, which served congregations from Istanbul, and the Elias Synagogue (Eliyahu Hanavi), which was erected on the spot where the prophet prayed on the day of Yom Kippur. Finally there is the synagogue dedicated to the wise Rabbi Yochanan Ben Zakkai, whose name is given to the entire complex. During the siege of the city by Emperor Vespasian, this venerated rabbi pretended to be dead,

in order to be brought outside of the walls in a coffin. Once outside the city, Ben Zakkai asked for an audience with the future emperor, who was at that time a general, greeting him "Vive domine imperator," thereby reminding him that only a king could capture Jerusalem. Admiring his courage, and perhaps also flattered by the prophecy, Vespasian allowed Ben Zakkai to open a rabbinical school at Jàmnia (Javneh) along the Mediterranean coast. Thanks to Ben Zakkai's wisdom, Judaism was able to survive the destruction of Jerusalem and the Temple.

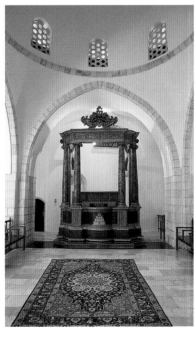

During the time of Jesus, what is now the Jewish Quarter of the Old City was the most refined residential area of Jerusalem. Such was its elegance that Herod Antipas selected this quarter to erect his splendid palace, the same palace to which Jesus was taken by order of Pilate. To understand what the quarter was like before the city was devastated by Titus in 70 CE, and at the same time to enter into the daily life of a wealthy Jew of the 1st century CE, it is useful to visit both the six residences of the Herodian Quarter, part of the Wohl Archaeological Museum, and, just to the north, the seven chambers of the Burnt House. Both of these museums were created by the work of Israeli archaeologists after the victory of the Six Days' War. All of the residents of these ancient buildings were priests from the nearby Temple, who apparently had a relaxed lifestyle: to reach work on the Temple Mount took only ten minutes, and their standard of living was quite high. The six villas of the Herodian Quarter, beneath the Hakote rabbinical school, were luxurious homes on several levels, with mosaic floors, porticoed courtyards, and several baths. The most important building, the palace, had two floors and measured 6230 sq ft (1900 sq. m). The Peristyle Building, has, of course, a peristyle or internal porticoed courtyard. Among the objects discovered in the nearby Burnt House (the fire happened during the final Roman assault of the upper city) was a minting die for making coins. The name of the owner, a priest called Kathros, is even known, as it was inscribed in Aramaic on a weight found in the house. The excavation of the Burnt House has recovered many other objects of daily usage, along with one item that is rather macabre: the arm of a woman who died in the fire. One of the rooms of the Burnt House has been left with its walls blackened, as testimony to the tragedy.

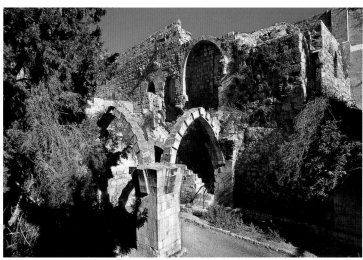

58-59 Below the Yeshiva Hakotel are the arches of the Sephardic Yeshiva Porat Yosef, which was inaugurated in 1923 and destroyed by the Jordanians in 1948. After 1967, it was reconstructed by Moshe Safdie in a modernist manner, with a semi-transparent dome.

59 top The arcades of the Medieval church of St Mary of the Germans, which dates from the Crusader era, are the only remaining vestige of Christianity in the Jewish Quarter. A hospital and a hostel for pilgrims once stood here as well.

THE MUSLIM QUARTER AND
THE MAMLUK BUILDINGS

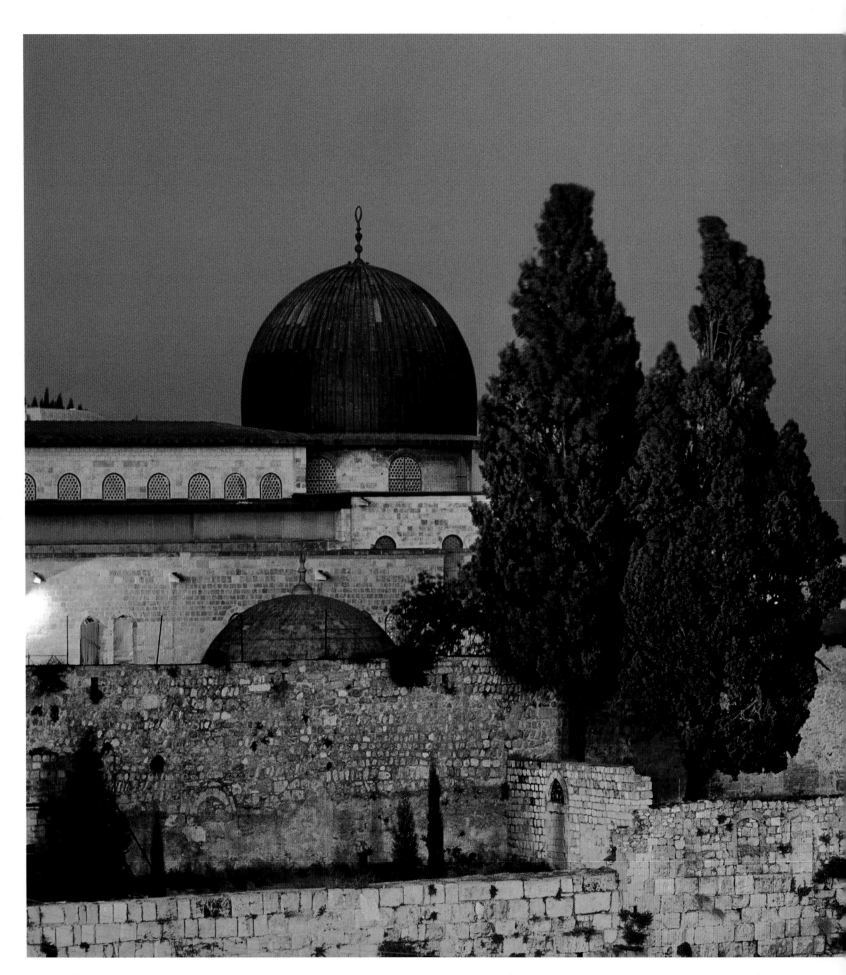

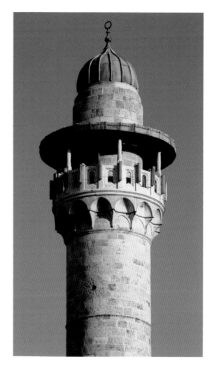

Here the days are distinctly divided between commerce and prayer, just as they were during the time of Saladin or of the Mamluk sovereigns. Even the alleys, houses, fountains, madrasas, caravanserai, hospices for Islamic pilgrims and funerary monuments have changed little over the centuries (being administered by the Islamic entity of the Waqf).

The most elegant palaces in the quarter are the 14th- to 15th-century Mamluk palaces, which are richly ornamented yet maintain an elegant lightness. In addition to the bands of pink, white, and black stone of the arches (a technique called *ablaq*), there are also present mosaics, stained glass, calligraphic decorations and geometric arabesques, marble windows, and the *muqarnas* that hang like stalactites inside the dome. Unfortunately, the best façades often face interior courtyards, and are therefore inaccessible. The most beautiful buildings, however, are those along Chain Street (in Arabic Tariq ab el-Silsilah, "the Street of the Gate of Chains") that leads to the gates of the Temple Mount.

60-61 Located near the dome of the Mosque of al-Aqsa, the Fakhriya Minaret dominates the southwest corner of the haram.

61 top Dating from the 14th century, the cylindrical Mamluk minaret Bab al-Asbat, the "Gate of the Tribes," is the most elegant of the four minarets that stand on the perimeter of the Temple Mount.

61 bottom left An ogee arch in red, white, and black stone, with typical Mamluk "stalagtites," is situated at the entrance to the Madrasa al-Ashrafiyya, the masterpiece built by Sultan Qait Bey in 1482.

61 bottom right In the streets of the Muslim Quarter, in particular in Chain Street or Tariq Bab el-Silsila, numerous examples of elegant Mamluk architecture are evident, including façades, portals, and sabil (drinking fountains).

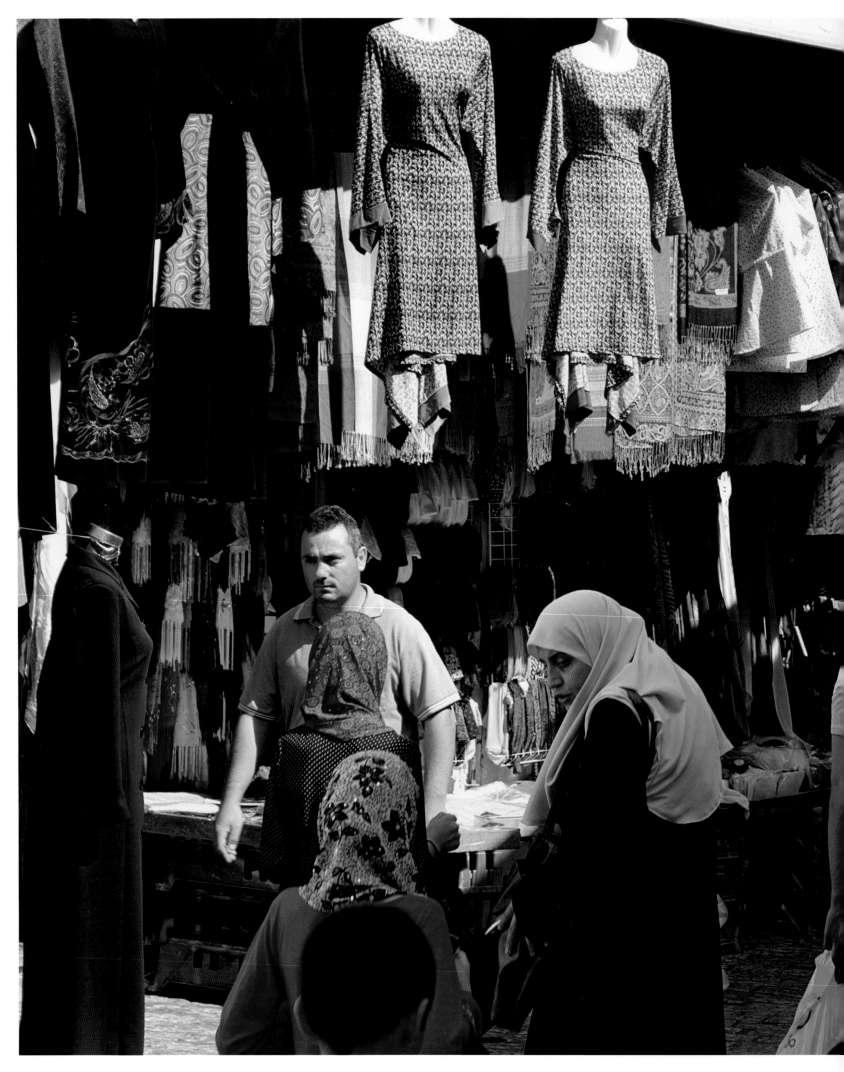

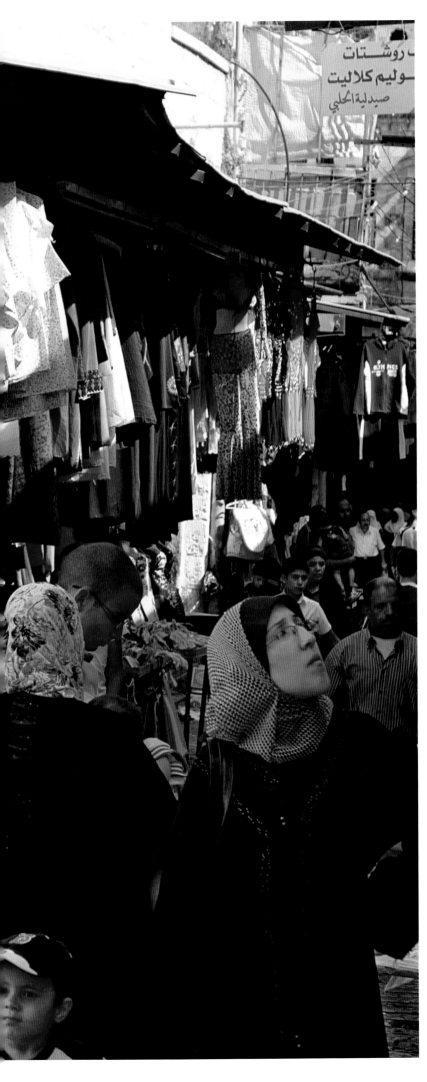

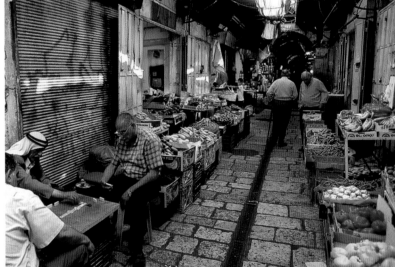

62-63 and 63 top Together with the mosque, the market is another place that marks the rhythm of daily life for the Arab inhabitants, who go there not only to make purchases, but also to pass the time.

63 bottom Precious gems and jewelry were once sold primarily in the central suq al-Khawajat, or gold market. Today, these items are generally found in the vicinity of monuments that are visited frequently by tourists.

64 right The suqs of the Old City are a celebration of colors and fragrances. The variety of available spices seems infinite, especially now that those used in Indian cuisine are also sold at the market.

65 The most extensive market areas of the Old City are found along the straight routes of the ancient Cardo Maximus (Khan er-Zeit) and the Cardo Minimus (El Wad).

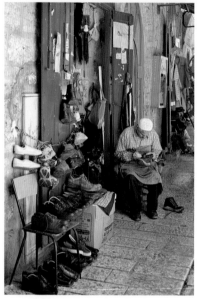

64 top left With its shops and bustling crowds, the Muslim Quarter is the most typically Middle Eastern, as well as the most densely populated, of the four quarters that comprise the Old City.

64 bottom left In addition to the souvenir stores for tourists, the Muslim Quarter still has numerous shops where artisans practice traditional trades.

Overpopulated, chaotic, bustling with shopkeepers and small children, the Muslim Quarter of the Old City is a kaleidoscope of colors, smells and tastes. Visitors arrive in its suq either to purchase spices, fabrics, rugs, jewelry, objects made of olive wood, kefia with red and white or black and white checks, or just to watch the spectacle. Arabs, on the other hand, come to find whatever it is they need, from food to clothing – the best evidence that these are authentic markets in the ancient tradition.

Upon arriving from David Street, the visitor immediately finds the central suq: three parallel, covered streets on the site where the Roman Cardo once passed; the suq el-Lakhamin, or butcher's market, is a scene that is only suitable for those with strong stomachs; while the next markets, the suq el-Attarin and suq el-Khawajat, which were once dedicated to spices and gold, now sell mostly clothing. Farther along is the famous suq el-Qattanin, the market covered with cotton. It was first constructed by the Crusaders, and the Mamluks later connected it to the Temple Mount with the beautiful Cotton Merchants Gate. It also contains two evocative Turkish baths or hammam.

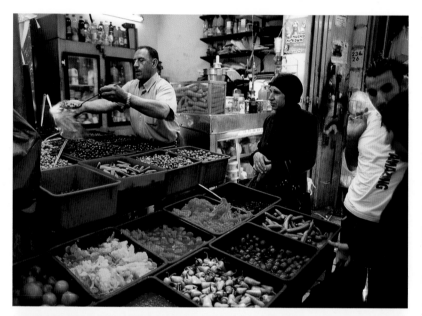

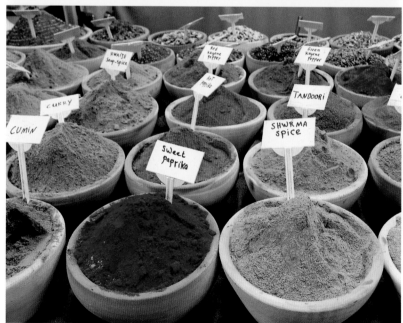

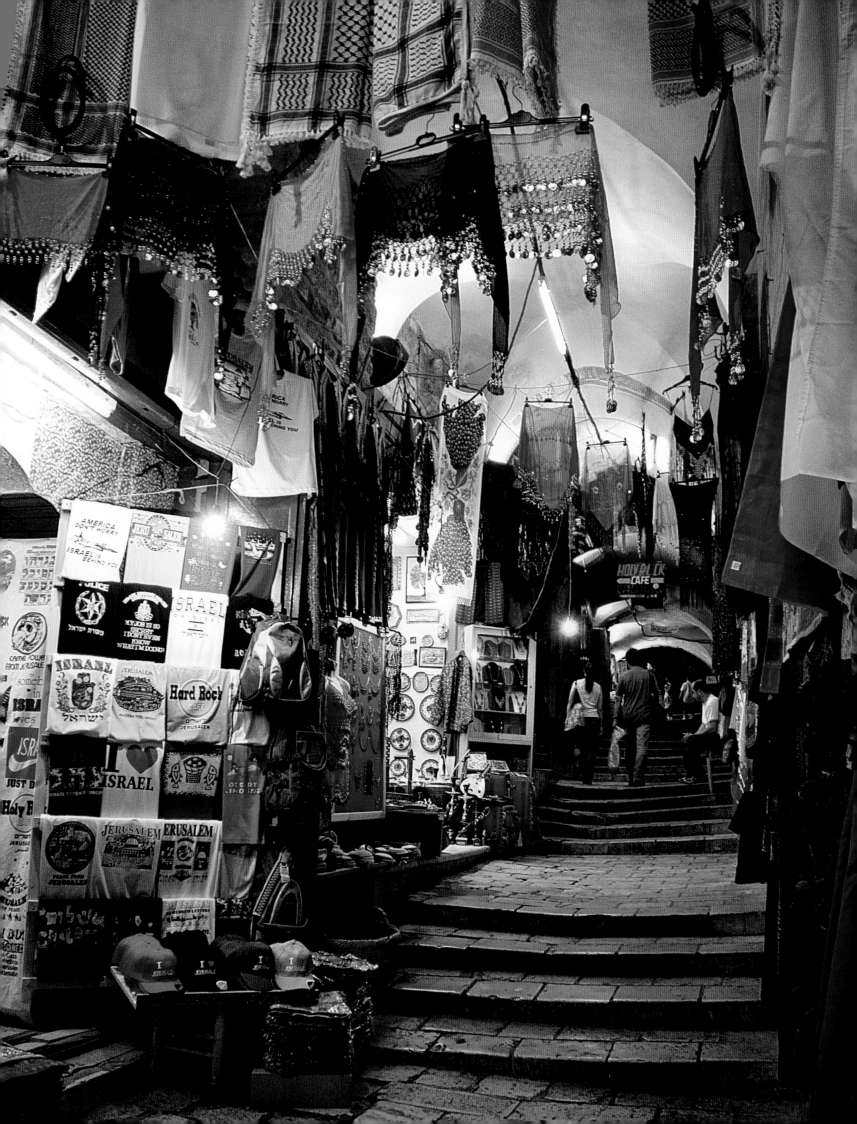

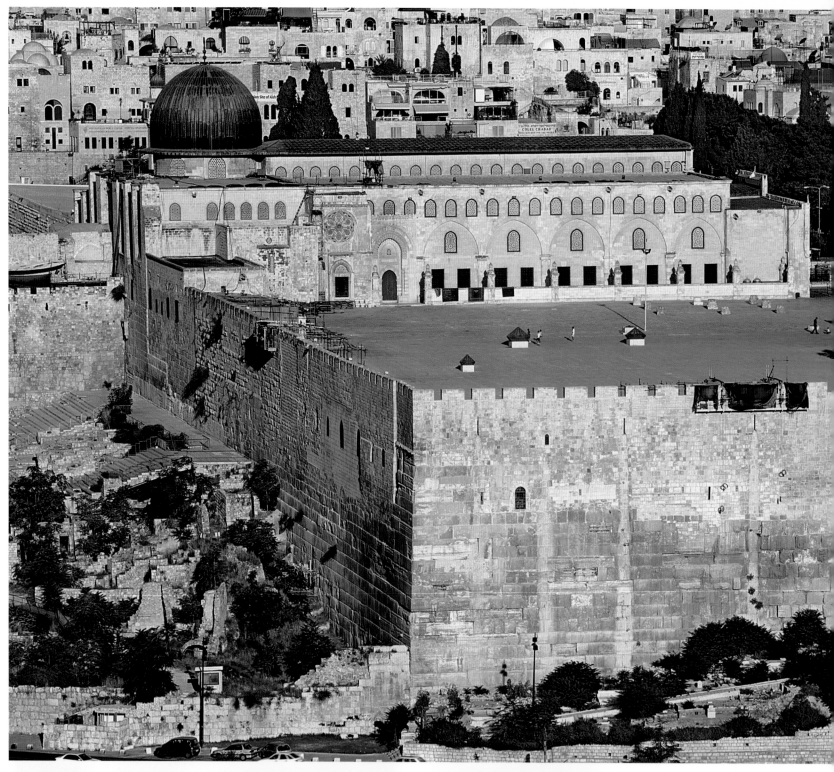

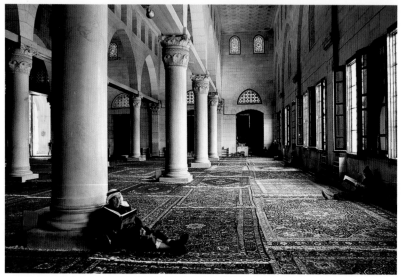

Where the sacred Temple of the Hebrews once stood, there is now a large, irregular 30-acre (12-hectare) trapezoidal area 1610 ft (491 m) on the west, 1017 ft (310 m) on the north, 1515 ft (462 m) on the east, and 922 ft (281 m) on the south) with mosques, minarets, fountains, and museums. After Mecca and Medina, this is the third most scared place for Muslims. Haram esh-Sharif, the "noble enclosure" known to Westerners as the Temple Mount, occupies a sixth of the area of Old Jerusalem. For Islam it is sacred not

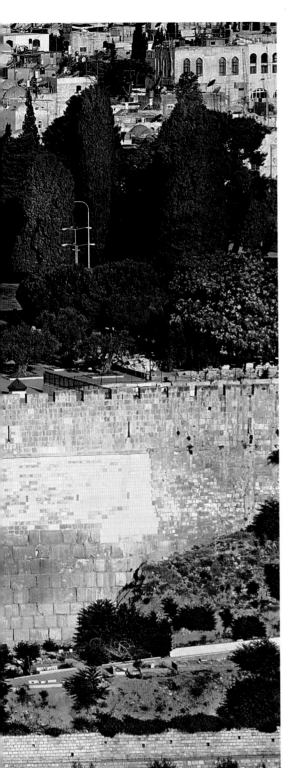

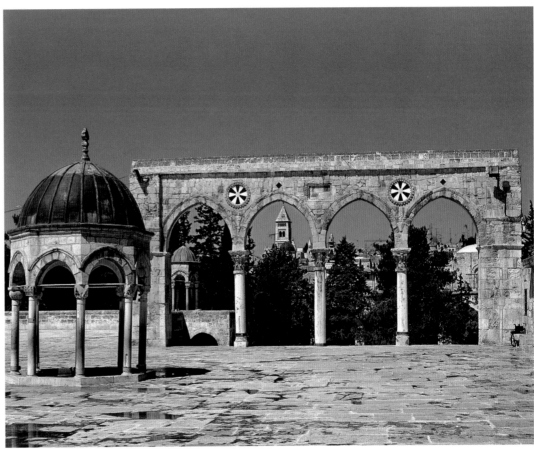

66-67 *The southeast corner of the Temple Mount, situated to the east of the al-Aqsa mosque and standing high above the Valley of Cedron, is believed to be the famous "Pinnacle of the Temple," where Christ was tempted by the devil.*

66 bottom *The interior of the al-Aqsa ("the farthest") Mosque contains nine white Carrera marble columns that were donated by Benito Mussolini for the mosque's 1938 restoration, after it had suffered damage from an earthquake.*

67 *Eight stairways lead to the Dome of the Rock (Qubbet as-Sakhra). At the top of each stairway stand arcades (qanatir); it is believed that Allah, at the end of the world, will weigh souls on balances (mawazin) suspended from the arches of these arcades.*

only for its mosques, but also for its entire surface, as is affirmed in sura 17 of the Qur'an ("Glory to (Allah) who did take His servant for a Journey by night from the Sacred Mosque to the farthest Mosque, whose precincts We did bless. . . ."). This verse, according to a later interpretation, refers to a nocturnal flight that Muhammad made from Mecca to Jerusalem, "the farthest" (al-Aqsa). Caliph Omar, having conquered Jerusalem in 637 CE, discovered that the Temple Mount had been transformed into a garbage area; indignant, he ordered the

Christian Patriarch Sofronius to crawl through the refuse. Caliph Omar then had a wooden mosque erected on the site, and fifty years later the Dome of the Rock was built, which is often erroneously called the "Mosque of Omar."

On the opposite side of the haram, located behind the great fountain of el-Kas (which was constructed in 1320 for the ritual ablutions performed before praying) lies the Great Mosque of al-Aqsa, with its grey dome of silver. The mosque was erected at the beginning

of the 8th century, subsequently destroyed by an earthquake, and then finally reconstructed in its current form by the Fatimite Caliph az-Zahir in 1033. With the Crusaders, the Knights Templar made this their headquarters for several decades, calling it the Palace of Solomon. After recapturing the mosque, Saladin, adorned it with remarkable mosaics, inscriptions from the Qur'an and the *mihrab*, which indicates the *qibla*, the direction of Mecca for prayers.

Over the centuries, the Mosque of al-Aqsa underwent various

modifications until important restorations and renovations were finally carried out from 1938 to 1943 – nine white Carrara marble columns, a donation from Benito Mussolini, and a sumptuous gilded coffered ceiling, given by Farouk of Egypt, were installed in the mosque. The Columns of the Judgment, located in the east transept beyond the expanse of red carpets, represent the boundary that will be crossed on the final day to enter Paradise. To the right are two small prayer niches dedicated to Moses and Jesus (Issa, in Arabic).

68 top With its dome of finely worked stone, the fountain (sabil) built by the Mamluk Sultan Qait Bey is the most beautiful of the seven fountains on the Haram esh-Sharif.

68 center The small aedicule that stands at the top of the Dome of the Ascension was added by the Crusaders, who refurbished this Islamic building in the 13th century, and transformed it into a baptistery.

The preferred location for prayer, but frequently also for political protests, al-Aqsa has seven naves that can hold up to 5000 faithful. Even recently, the mosque has been the scene of dramatic events. In 1951 King Abdullah of Jordan, founder of the Hashemite kingdom and grandfather of King Hussein, was killed there. In 1969 a fanatical Australian Christian set fire to the mosque, thereby destroying, among other things, a splendid pulpit (*minbar*) made of cedar that Saladin had brought from Syria. In addition, a visit by Prime Minister Ariel Sharon in 2000, in which he asserted the right of Jews to visit the Temple Mount, incited the Palestinians and started the Second Intifada, or the al-Aqsa Intifada.

Until the middle of the 19th century non-Muslims were forbidden access to the Temple Mount. Today, entry is allowed (though only by passing through the Maimonides Gate to the right of the Wailing Wall), but since 2000 access to the al-Aqsa Mosque and the Dome of the Rock has been forbidden. Also off-limits are the ramparts facing the Valley of Cedron. Located in this off-limits area is the famous Golden Gate (in Arabic Bab al-Rahmeh or the Gate of Mercy), which was walled-up, probably by the Arabs, during the Middle Ages. The Jews believe that the Messiah will enter Jerusalem through this gate, and therefore came to pray before it during the Middle Ages, much as they do now before the Wailing Wall. As the Muslims also associate the Golden Gate with the Last Judgment, it has always been a privilege to be buried in the Islamic cemetery below.

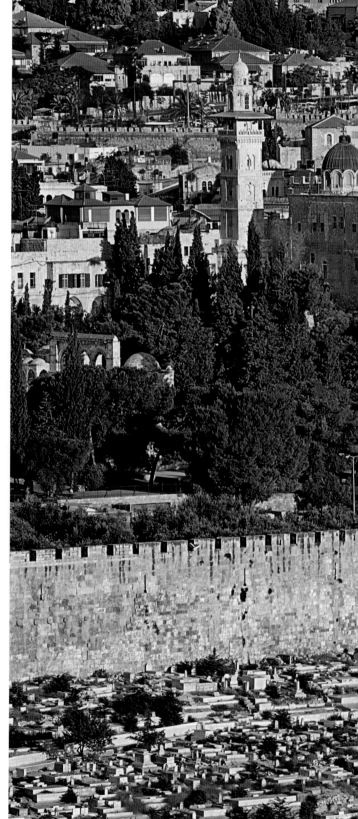

68 bottom The half-moon crescent or hilal, *symbol of Islam, refers to the lunar calendar, which regulates the life of every good Muslim and determines the dates of the principal religious holidays.*

68-69 The two arches of the Golden Gate, located on the eastern side of the Haram, were closed by the Muslims in the 13th century. The Jews maintain that upon the Messiah's return, He will enter Jerusalem through this gate.

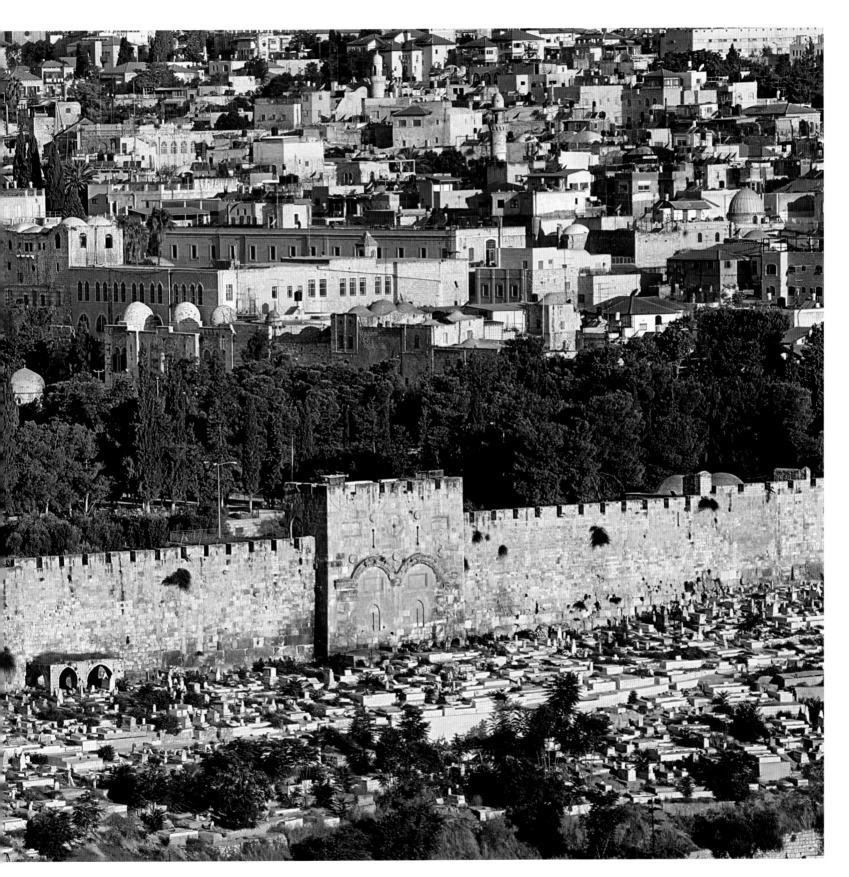

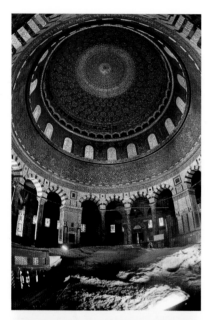

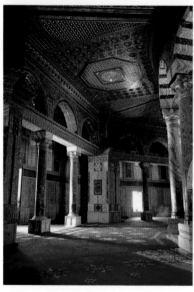

70 The heart of the Qubbet as-Sakhra is the Sacred Rock, the summit of the biblical Mount Moriah. Above the Sacred Rock rises the amazing double dome, from whose center is suspended a golden chain that falls down onto what is considered the "navel of the world."

From there, God took the dust to create Adam. Abraham went there to sacrifice his son Isaac, and also there made the alliance with God. David, after having met an angel there, purchased from a Jebusite the threshing floor that had there been built. Solomon, having built the Temple to hide the rock from the view of men, made there the foundation for the Altar of the Holocaust for the God that could not be named, unless in the chamber where His Presence resided (the Holy of Holies). Muhammad, arriving in flight from Mecca on the winged mare al-Buràq, made a platform there on which to rest the shining stairway on which he climbed to Seventh Heaven. The Crusaders there founded the Order of the Templars, Medieval Jews and Christians made it the geographical center of the world, Muslims continue to believe that in the grotto under it the spirits of the dead meet twice a week to pray. . . .

With this ancient and impressive background, it is apparent why the Sacred Rock, located upon the summit of the biblical Mount Moriah, has provoked and continues to arouse such passion. Upon it existed what the Jews held most precious: the Temple. Also the Muslims, while already possessing another sacred stone, the Kaabah in Mecca (59 ft/18 m by 43 ft/13 m), constructed above the Sacred Rock, the most ancient as well as the most beautiful, the most elegant and the most spectacular of Islamic monuments.

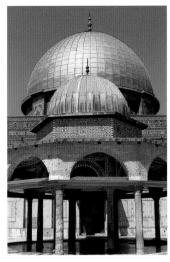

71 top left The small Dome of the Chain (Qubbet al-Silsila), with its magnificent interior decorations, takes its name from the chain that a person was required to hold while swearing an oath; if the oath was false, the person would be struck by lightening.

71 top right The frieze above has decorative geometric motifs and verses from the Qur'an which exalt Allah. Other writings found on the interior of the Dome of the Rock invite Christians to recognize that Jesus was only a prophet.

70-71 The Dome of the Rock is frequently called the "Mosque of Omar." In fact, the edifice is not a mosque but rather a sanctuary that was built by Caliph Abd el-Malik between 685 and 691 CE, a half-century after the time of Caliph Omar.

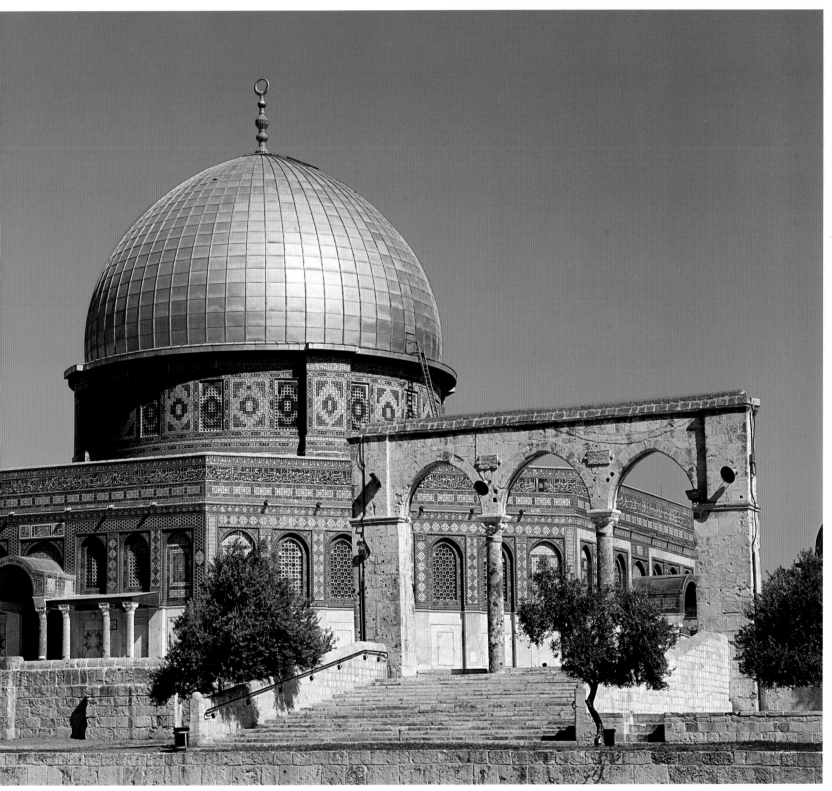

72 Each exterior side of the octagonal Dome of the Rock has a series of windows with majolica tiles and double grates, which in the 16th century replaced the original ones of marble and wrought iron.

72-73 In the 9th century, the Abbasid Caliph al-Mamun had his own name placed on the frieze of the Dome of the Rock that contains Arabic writing, replacing the name of the man who actually constructed the edifice between 685 and 691 CE, Caliph Abd al-Malik. This deceit was not discovered until the 19th century.

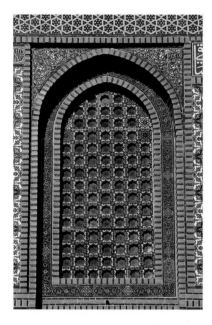

The harmonious Dome of the Rock (Qubbat as-Sakhrah). The dome, measuring 115 ft (35 m) tall and more than 65 ft (20 m) in diameter, is absolutely mesmerizing from any viewpoint, and is even more so since King Hussein of Jordan donated 176 lbs (80 kg) of gold to replace the aluminum and bronze alloy covering of 1960 that was made in Italy. Dazzling also are the Iznik ceramic tiles in blue, white, and green which Suleiman the Magnificent used in the 16th century to adorn the exterior of this octagonal edifice upon which rests the circle of the dome.

On the interior, the rough bare rock, which rises about 6 ft (2 m) above floor level, contrasts with the refined symmetry of the surroundings: the polychrome marble, the elaborate Qur'anic inscriptions that exalt Allah and contest the Christian Trinity, and the Byzantine mosaics in which visitors may glimpse Christian symbols (ears of grain, bunches of grapes). After all, Caliph Abd al-Malik, ninth successor of Muhammad, had to turn to Byzantine architects and workers to erect the mosque between 687 and 692 CE. It is therefore not surprising that the round interior, with its double ambulatory, is reminiscent of the Constantinian Anàstasis of the Holy Sepulcher. On one side, a reliquary contains what are reputed to be two hairs from the Prophet's beard.

The Rock of Creation, the Rock of Moriah is also associated with the Final Judgment. According to Christian tradition, God will place His throne there while the trumpets of the Last Judgment sound. Also the Muslims believe that on that day souls will be weighed on balances (*mawazin*) suspended from the arches (*qanatir*) located at the top of the stairways that encircle the Dome.

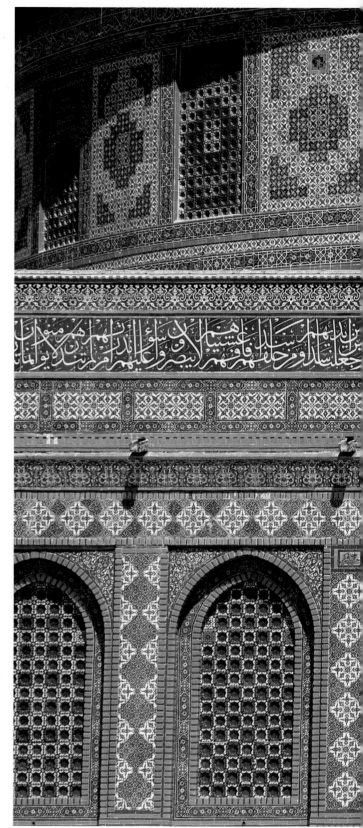

73 top The columns and capitals of the qanatir, the arches situated at the top of the stairways leading to the platform of the Dome of the Rock, were made during the Mamluk era using columns and capitals from the Crusader period.

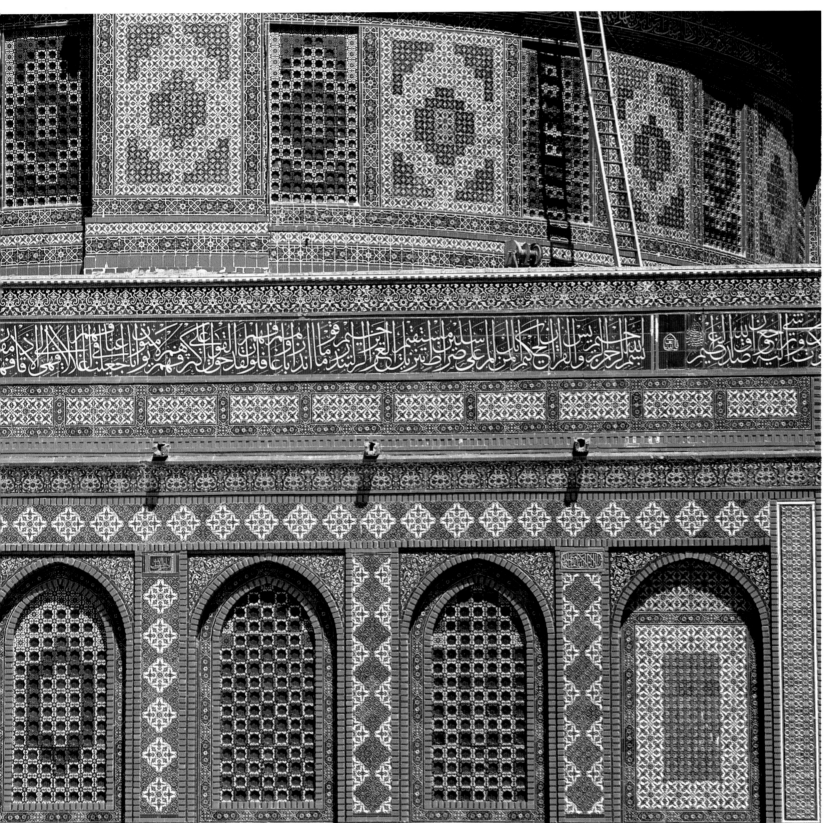

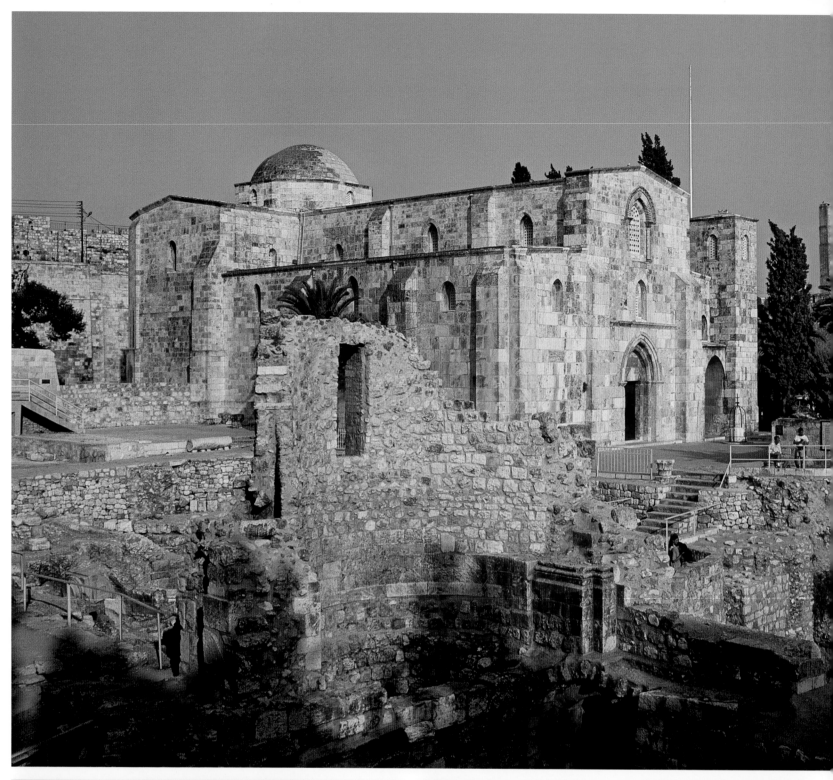

THE CHRISTIAN QUARTER

JESUS PASSED THROUGH THIS QUARTER, THROUGH A GATE THAT ONCE EXISTED TO THE EAST OF THE TEMPLE MOUNT, WHEN, ARRIVING FROM BETHANY, HE DESCENDED FROM THE MOUNT OF OLIVES AND ENTERED JERUSALEM.

Fortunately, no one proposed in 1967 that the gate through which General Moshe Dayan entered the Muslim quarter and the Old City, which his troops had just conquered, be given his name. His would have been another in a long list of names given to the gate, the only opening on the east side of the city walls, which faces the Mount of Olives: St Stephen's Gate, named after the first Christian martyr who, according to tradition, was stoned after being dragged outside the gate at the northeastern corner of the Temple (which does not coincide with the current gate); Lion's Gate, named after the bas-relief containing lions, the coat of arms of the Mamluk Sultan Baibars (13th century); St Mary's Gate, or Bab Sitti Maryam as the Muslims called it in remembrance of the fact that nearby, according to the apocryphal proto-evangelist James (3rd century CE) was located the house of the Virgin Mary. Rather than a house, it is a grotto, embedded by the Crusaders in the subterranean crypt of a beautiful church dedicated to St Anne, Mary's mother. Built in 1140 as a sort of fortress, this Crusader church was the only church to survive the Saracen invasion of 1187: Saladin spared the

church out of respect for Mary, who is also venerated by Muslims, but transformed it into an Islamic school. The building again became Christian in 1856 when the Turkish sultan, to repay help received during the Crimean War, gave it to France (who entrusted it to the White Fathers). Beautifully restored, St Anne's Church is now an impressive testimony to the Jerusalem of the Crusaders, the only intact Gothic building in Palestine. The three sober naves with apses have extraordinary acoustics that invite the tourist to test them – unfortunately few know Gregorian chants, and so too many have nothing better to sing than John Lennon's *Imagine*, if not something worse. In front of the Church of St Anne are the remnants of the famous Pool of Bethesda or the Sheep's Pool (from the Greek *probatiké*, "from sheep," by the Sheep Gate that in the time of Jesus opened to the north of the Temple). The two pools, as large as modern Olympic-size pools, 66 ft (20 m) deep and separated by a portico, were built two centuries before Christ as tanks to furnish the Temple with water, which was indispensable for washing away the blood from the numerous sacrifices. Soon, the rumor

that the pool of Bethesda, or Bezheta, had miraculous powers (a fame that quickly induced the Romans to construct a temple to the god Aesculapius) attracted to its sides". . . a great number of disabled people . . . the blind, the lame, and the paralyzed" as John the Evangelist states in his narration of the first great miracle of Christ in Jerusalem: a parable that invites reflection on the paucity of human gratitude.

Jesus, having recently arrived in the city, found a man, who had been paralyzed for 38 years, weeping because no one would help to immerse him in the miraculous water. Rather than merely helping him into the water, Jesus did more: He told the man to pick up his mat and walk. When the Jewish priests demanded to know from the man who had dared to cure him on the Sabbath, the day of repose, the man did not know how respond. Later, however, meeting Jesus at the Temple, the man immediately denounced the Nazarene to the authorities, who from that point on began to persecute him. Such is life, and in Jerusalem, in this ancient mixture of good and evil, it is no different.

74-75 In front of St Anne's Church, the remnants of the Sheep's Pool or the Pool of Bethesda (from the Aramaic beth hesda, "house of grace"), are a reminder of the place where Jesus performed His first miracle in Jerusalem.

74 bottom left In 1856 the Ottoman Sultan Abdul Majid made a gift of St Anne's Church to Napoleon III. The interior, which has three naves with apses, was recently restored and is famous for its perfect acoustics.

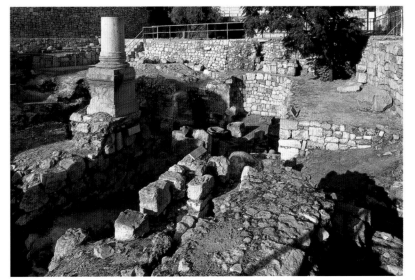

74 bottom right St Anne's Church was built by the Crusaders on the site of an earlier Byzantine church. An Arabic inscription on the tympanum of the main portal serves as a reminder that Saladin had the church transformed into a madrasa.

75 With two large basins and five porticoes, the Pool of Bethesda covered an area larger than a soccer field. Its basins were used for curative baths and had a depth of up to 65 ft (20 m).

76 "Via Dolorosa," whose name is written in Hebrew, Arabic and Latin on the street signs, is the street in the Muslim Quarter along which the first six stations of the traditional Christian Via Crucis (Way of the Cross) are located. The third station (bottom) is found at the intersection of Via Dolorosa and El Wad, on a site that was once a Turkish bath near the Armenian Catholic Patriarchate; in a 19th century chapel belonging to the Armenian Catholics, Christ's first fall on the road to Calvary is commemorated.

Every year thousands of Christians pass through the Muslim quarter following the Via Dolorosa, or "the Way of Suffering," unaware that Jesus may have climbed to Calvary along a different path. Nevertheless, over the centuries the course has actually been changed several times: the current route was established by the Crusaders, while the number of stations was set at fourteen by the Franciscans as recently as 15th century, to imitate the Via Crucis widespread in Europe.

Any association of a particular place to an event from the Passion of Christ is therefore rather arbitrary, but the pilgrims, less concerned with archaeological scruples and topographical precision, are more interested in remembering the sacrifice of Christ, and that is fine too. However, visitors accustomed to images in paintings and films may be surprised to realize that, rather than a long climb up a mountain, they must face a brief walk through narrow and crowded alleys. According to tradition, the Praetorium, where Jesus was condemned to death,

was located in the imposing Antonia Fortress, erected in 37-35 BCE by Herod at the northwest corner of the Temple, and named in honor of the Roman Triumvir Mark Antony. In reality, when Pontius Pilate went to Jerusalem from his home in Caesarea, he resided in Herod's Palace, near the current Jaffa Gate, and therefore his Praetorium (seat of authority) was also located there. In that case, the Via Dolorosa should actually depart from the Citadel. However, it is also true that during Passover the Roman governor transferred his residence and the Praetorium to the Antonia Fortress in order to better control the unruly Jews.

The Antonia Fortress was razed to the ground by Titus in 70 CE and the area where it once stood is now occupied by two Christian convents and an Islamic school. From this location at 3:00 pm each Friday, just when the Muslims are filling the mosques, departs the traditional Via Crucis. The procession begins at the Chapel of the Condemnation, in the courtyard of the Muslim madrasa,

which is located at the entrance to the controversial Western Wall Tunnel. From there visitors follow a wooden cross, passing through the narrow and crowded streets of the Muslim quarter, where numerous religions and diverse Christian denominations have left their trace. Gradually, the procession passes from the courtyard of a Franciscan convent, under the remnants of a Roman triumphal arch between two Arab houses, then past a French convent, a Polish chapel, an Armenian oratory, a Greek-Catholic chapel, a Greek convent, an Egyptian Coptic monastery, and finally enters into the Church of the Holy Sepulcher where the last five stations are located. Each of these stations commemorates an event, evangelical or apocryphal: the three falls of Christ, the encounters with Mary, with the Cyrenian who carries His cross, with Veronica who wipes His face, and with the pious women. The Via Dolorosa measures in total less than 2000 ft (600 m) long, and is undertaken in an environment that is not conducive to meditation, reflection, and prayer. People make their way with difficulty through the narrow alleys crowded with running children, people shouting into cell phones, Palestinians playing cards, shop owners trying to attract the pilgrims, tourists bargaining over a souvenir, shekels changing hands, photos being taken, kefia to try on, the scents of mint, coffee, saffron, oil frying. . . . Nevertheless, there may be nothing more useful than walking through a noisy and indifferent crowd to understand how Christ must have felt as he was walking to his death, because precisely the same type of people had ignored and betrayed him.

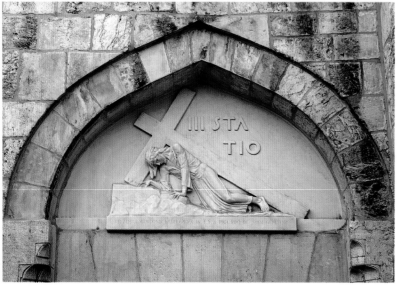

76-77 The Chapel of the Flagellation, which was reduced to being used as a stable during the Middle Ages, was restored in the 1920s by the Franciscan Antonio Barluzzi. The Second Station of the Cross is located in the courtyard.

77 bottom left In addition to the "official" Via Crucis that takes place every Friday at 3 pm (the time of Christ's death), there are daily processions of smaller groups of pilgrims who commemorate the Passion of Christ along the Via Dolorosa.

77 bottom right The Franciscans have been established in Jerusalem since 1229 in a location near the Fifth Station of the Cross. As guardians of the Holy Land, the Franciscans lead the crowded Via Crucis procession every Friday afternoon.

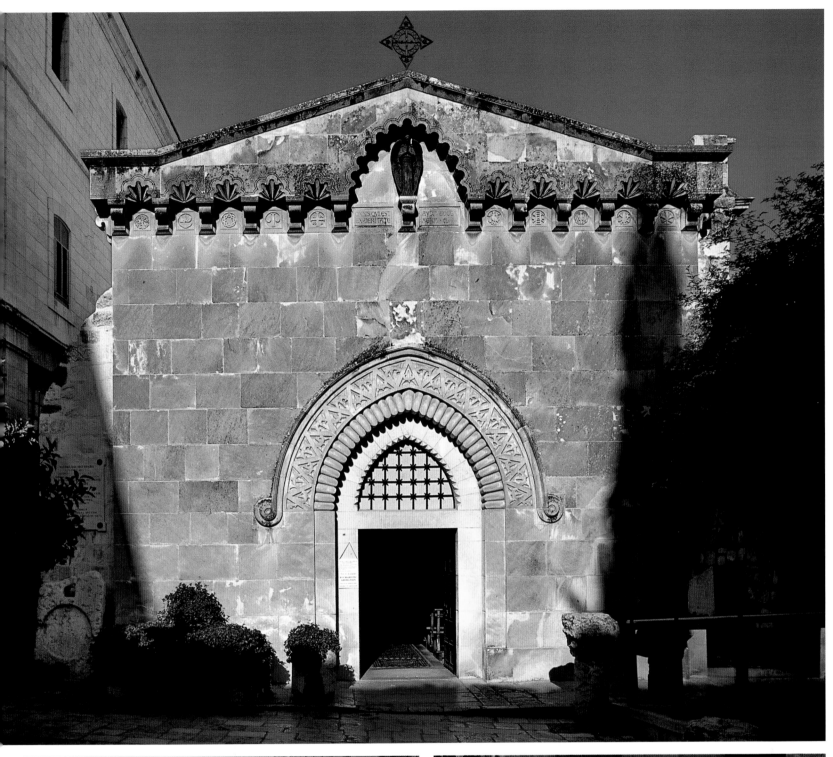

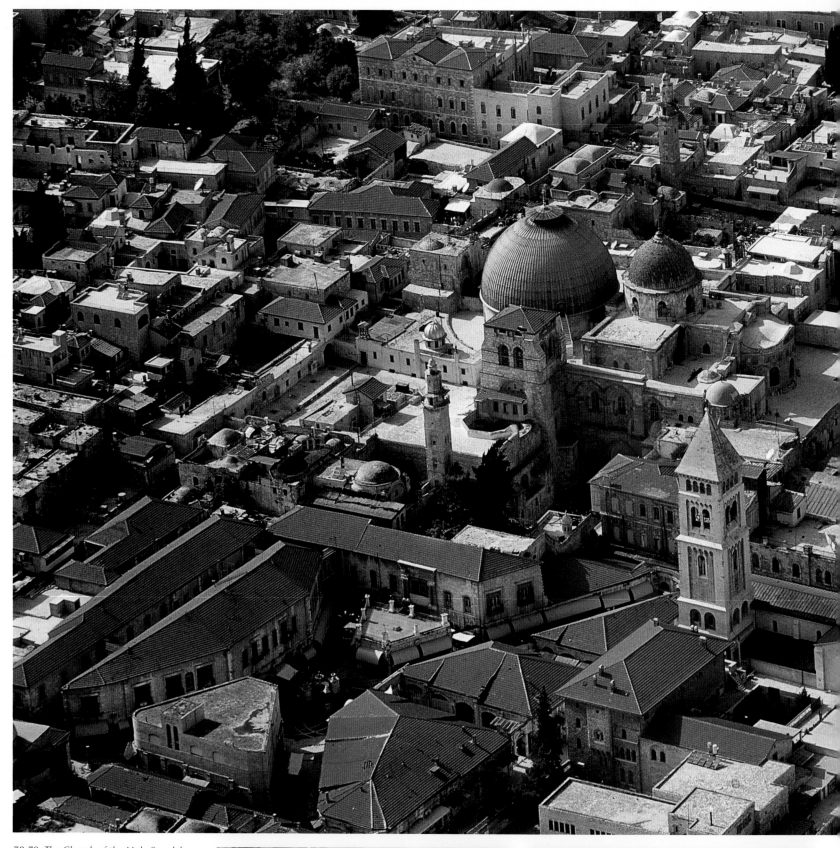

78-79 The Church of the Holy Sepulcher contains both Calvary and the Tomb of Jesus. The location of the large dome coincides with that of the former Anastasis Rotunda erected by Constantine over the Sepulcher.

78 bottom left In front of the Place of the Three Marys, an Armenian cleric honors the pious women who aided the dying Jesus. Throughout the day, various services are held within the church by the different Christian denominations.

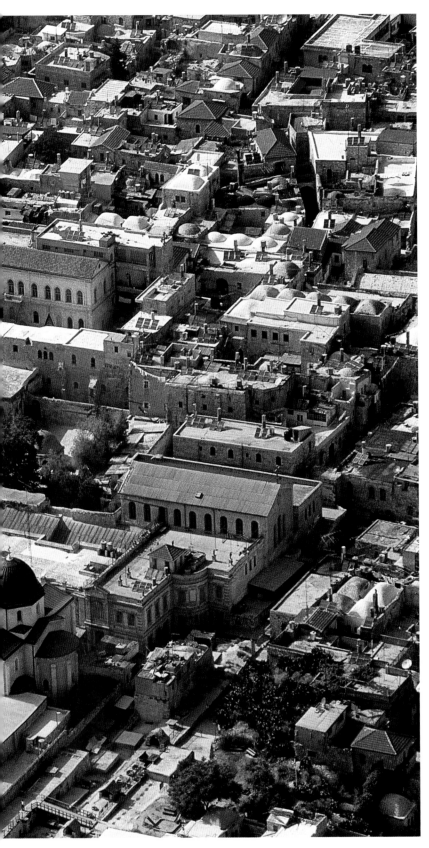

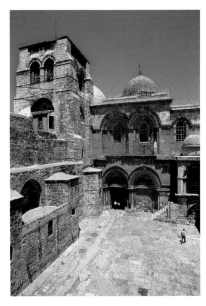

Just as the visitor may find the Via Dolorosa to be disorienting, there is the risk of being downright disappointed by the Church of the Holy Sepulcher (or, as the Greek-Orthodox call it, of the Anastasis, "the Resurrection") for not living up to preconceived ideas, which many have before coming to Jerusalem, regarding the places where Christ was crucified, buried and later rose again: Calvary and the Holy Sepulcher. Visitors discover with amazement that these sites are only a few dozen yards apart, and moreover, that they are located under the same roof. In addition, all of this is contained inside a gloomy building having both on the interior and the exterior, a chaotic architectural appearance – an assortment of styles with ponderous decorations.

Over a period of two thousand years, this place where Christ was tormented has also been increasingly tortured, as had the Man for whom the church has been venerated since the first Christians. In order to erase the memory of this most beloved Christian place, Emperor Hadrian constructed a Temple of Venus upon it. Two centuries later, while Empress Helena was excavating Jerusalem and uncovering the Holy Cross, Constantine demolished the pagan temple, had the terrain leveled, the rock cut, and squared off Calvary and thereby isolated the tomb of Jesus; upon Calvary he constructed a basilica with five naves, and upon the Sepulcher he built a domed aedicule. This site was subsequently devastated by the Persians, razed to the ground by the Arab Caliph Hakim the Mad, enclosed by the Crusaders under a single grandiose basilica, and finally distorted by the Greeks who in 1810, after a fire that destroyed the Aedicule, rebuilt the edifice creating, as the famous Scottish landscape painter David Roberts called it, a "horrendous kiosk."

Ultimately, however, the aesthetic scandal over the Church of the Holy Sepulcher is less important, in the eyes of believers, than the ferocious enmity among the Armenian, Coptic, Greek, Latin, and Syriac Christians who share the building and administer the basilica.

The status quo, an agreement imposed by the Ottomans on the various Christian denominations, in effect since 1757, has not prevented the shedding of blood on several occasions before the tomb of Christ, over unimportant matters such as a chair or a carpet shifting a few inches out of place. No other place in the world so aptly reveals the tension between the heights that man may achieve and the depths to which he may fall. The Church of the Holy Sepulcher is a mixture of heaven and earth, an apartment building torn apart, as is every apartment building, by contention and disagreement, by quarrels among the inhabitants, by lack of understanding between neighbors, by the conviction that the others, always the others, intentionally violate the rules and trample on someone else's rights.

It is therefore fortunate that, for the past seven centuries the keys to the Church of the Holy Sepulcher have been entrusted to two Muslim families, who pass down the keys to each new generation, and who are responsible for opening the church before dawn. Visitors enter the church through the left door of the two that face a narrow square set among houses (the right door has been closed since Saladin had it walled shut in 1187). Located just inside the entrance of the church is the Stone of Anointing, a slab of pink marble that serves as a reminder of how Christ, before being buried, was wrapped in cloths with aromatic oils (the slab in reality dates from 1810).

78 bottom right A few yards from the entrance, the reddish colored Stone of the Anointment (9 ft x 4 ft (2.7 x 1.3 m)) serves as a reminder that the body of Jesus was anointed. The stone slab has been replaced several times over the centuries – the present one dates from 1810.

79 top The two portals of the Church of the Holy Sepulcher date from the 12th century, but the one to the right has been closed since the time of Saladin. Only two floors remain of the massive Crusader era bell tower, which collapsed in the 16th century.

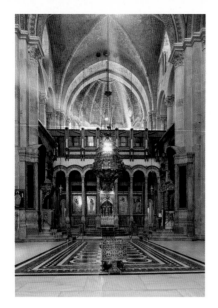

80 left Beneath the chapel of the Catholicon, or Greek-Orthodox choir, traces of the Martyrion, the great Basilica of the Resurrection built by Constantine in front of Golgotha, were recently discovered .

80 top right A Greek Orthodox altar approximately 32 ft (10 m) tall rises on Golgotha, or Calvary, the place where the cross of Christ once stood. The faithful stretch their arms into a round opening to touch the hole in the limestone that held His cross.

80 center right The Chapel of St Helen belongs to the Armenians, who call it the Chapel of St Gregory. In the apse to the right there is a seat where Empress Helena reputedly established herself during the excavations carried out in search of the Holy Cross. On the walls of the apse, Medieval pilgrims carved dozens of tiny crosses.

The Calvary area, situated 16 ft (5 m) above the surrounding church floor, is located immediately to the right of the entrance and is divided into two chapels: the Greek Orthodox possess the altar where a fissure in the rock purportedly once held Christ's cross; in the other chapel, the Franciscan friars must content themselves with an altar to the right.

The heart of the basilica and of Christianity is located to the left – the Aedicule of the Holy Sepulcher which, just as in the time of Constantine, is situated at the center of a rotunda, and whose current appearance is rather unattractive due to the Greek Orthodox reconstruction. Access to the Aedicule is regulated by a bearded monk who, at his discretion, frequently and enthusiastically impedes access to those who are not dressed properly, or those whom he simply does not like – at times after the person has waited in line for an hour. Inside the Aedicule, the small Chapel of the Angel leads, by way of a portico, to the True Sepulcher, measuring not more than 6 ft by 6 ft (1.8 m by 1.8 m), where

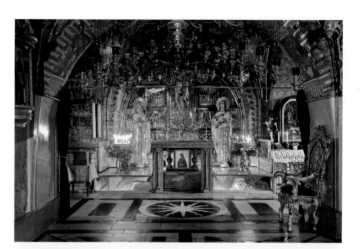

another Orthodox monk ensures that visitors remain for only a few seconds in front of the marble slab that covers the rock upon which Christ's body was reputedly placed.

While the central nave of the church is almost completely filled by a cumbersome catholicon or Greek Orthodox choir, the rest of the basilica is a labyrinthine mosaic of chapels, altars, niches, doors, columns, and corridors that are all divided unequally among the various denominations. The Coptic and Syriac Orthodox play the role of poor relative, possessing only minuscule chapels; nonetheless, they are still better off than the Ethiopians who, unable to pay the exorbitant Ottoman taxes in the 17th century, lost their property within the church and whose rights have since been confined to a roof of the monastery. Finally, at the back of the apse of the church, 29 steps descend to the Armenian Chapel of St Helena, from which another 22 steps lead to the Chapel of the Invention of the Holy Cross, located where Constantine's mother reputedly discovered the Sacred Cross in a Roman cistern.

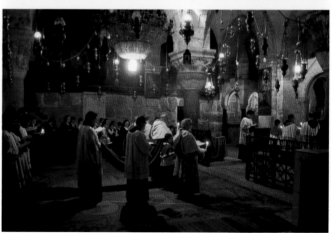

80 bottom right The Chapel of St Helen has Byzantine and Crusader origins. The beautiful floor mosaic, created in 1978, depicts the churches of Armenia. To the right, a stairway descends to the Latin Chapel of the Discovery of the Cross, where the mother of Constantine found the holy wood of the Cross in an abandoned cistern.

81 The current Aedicule in the Church of the Holy Sepulcher, which was constructed by the Greeks in 1810 and highly criticized, surrounds the Tomb of Christ, which Constantine had isolated by cutting away the surrounding rock. The innermost part is reached through a door that is only about 4 ft (1.33 m) high.

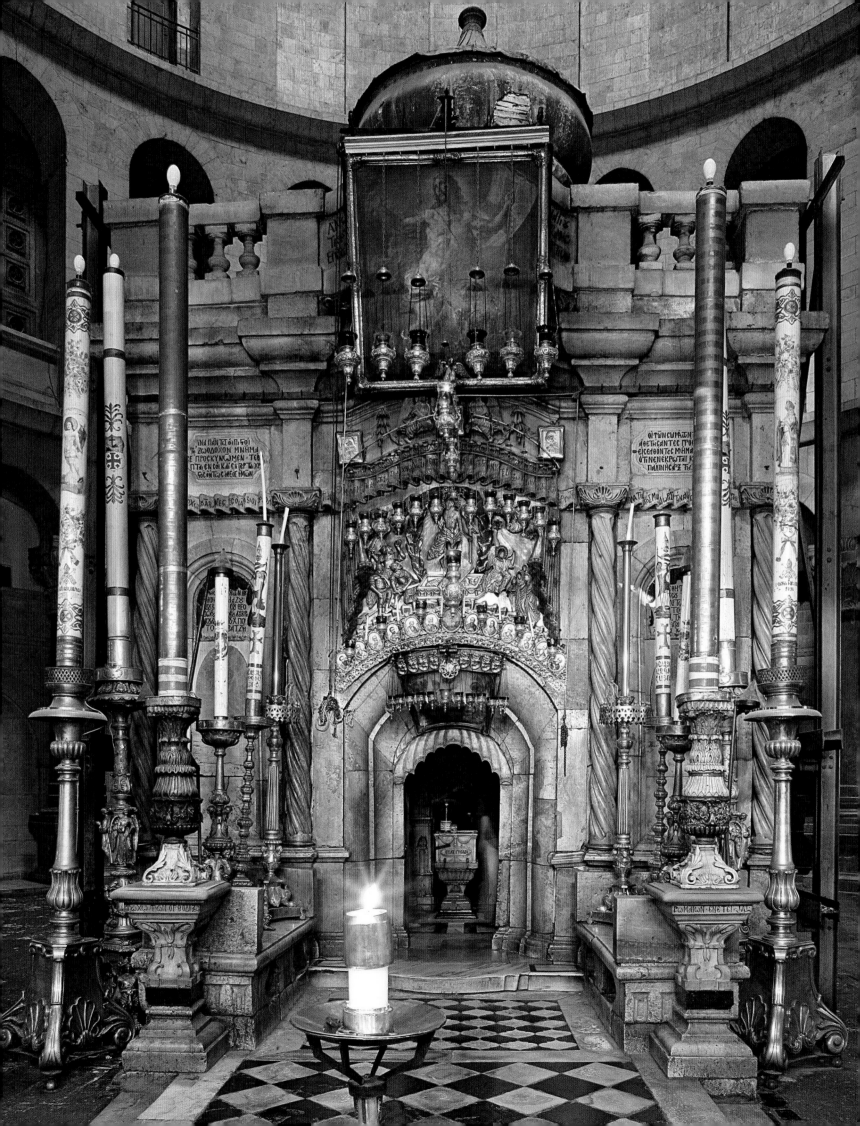

82 top A lamb, the symbol of Christ, is found at the entrance to the Lutheran Church of the Redeemer. A different portal that is located on the north side and displays the signs of the zodiac and the symbols of the months, originates from the Medieval church of St Mary of the Latins.

82-83 Located in the center of the Christian Quarter, this square in the Muristan with a large fountain built by the Greeks, stands in the area where Charlemagne opened a hospice for Christian pilgrims.

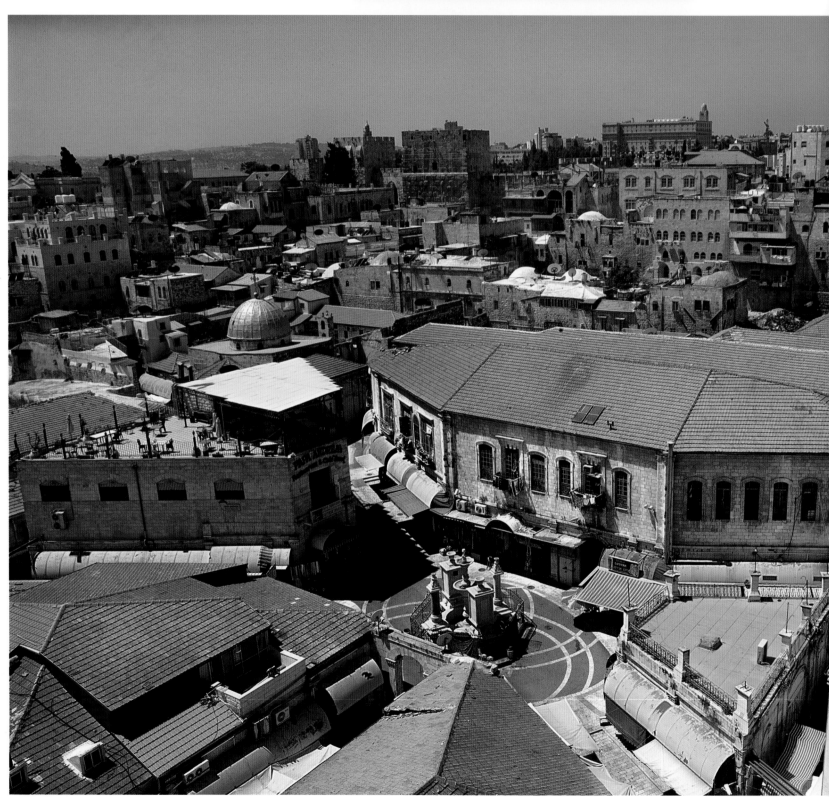

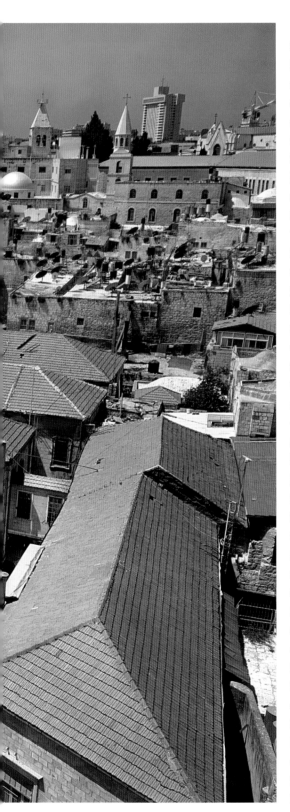

Between the Church of the Holy Sepulcher and David Street, the Muristan ("hospital" in Persian) quarter is the section of the Christian quarter where Medieval pilgrims were accommodated. Charlemagne was the first to construct a hospice for pilgrims in Jerusalem. The hospice, destroyed by Caliph Hakim in 1009 and subsequently reconstructed in 1030 by Amalfian merchants, became in the 12th century the first hospital of the Knights of St John (who later became the Knights of Rhodes and then the Knights of Malta), before Saladin had it seized. The hospice was situated in a spot which is today a small square with an elaborate fountain, located at the intersection of five streets filled with souvenir stores. The Amalfian merchants also erected two churches – one of the churches, dedicated to St John the Baptist, still exists and is believed to be the oldest church in Jerusalem, having been built upon the foundations of a 5th-century church; the other, dedicated to Mary Magdalene (Maria Minor), had a Romanesque portal decorated in bas-relief with the symbols of the zodiac and the months of the year. This portal is now visible in the Lutheran Church of the Redeemer, constructed at the end of the 19th century by the Prussians, and built in such a way that the former Catholic church is embedded in the more recent church. It is worth visiting the cloister of the Lutheran church, and even more so, climbing the 177 stairs leading to the top of the bell tower, which has an incomparable view of the Old City.

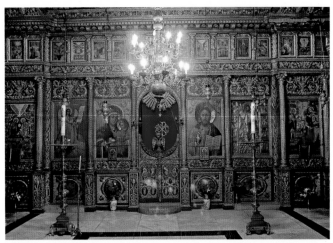

84 top The shining gilded iconostasis in the Greek Orthodox Church of Saint John the Baptist is the most elaborate in Jerusalem. It was here that the Order of the Hospitallers of Saint John was founded during the Crusader era.

84-85 The Church of St John the Baptist is the oldest existing church in Jerusalem. It was constructed by Amalfian merchants on the ruins of a 5th century church built by the Byzantine empress Eudocia, the repudiated wife of Theodosius II.

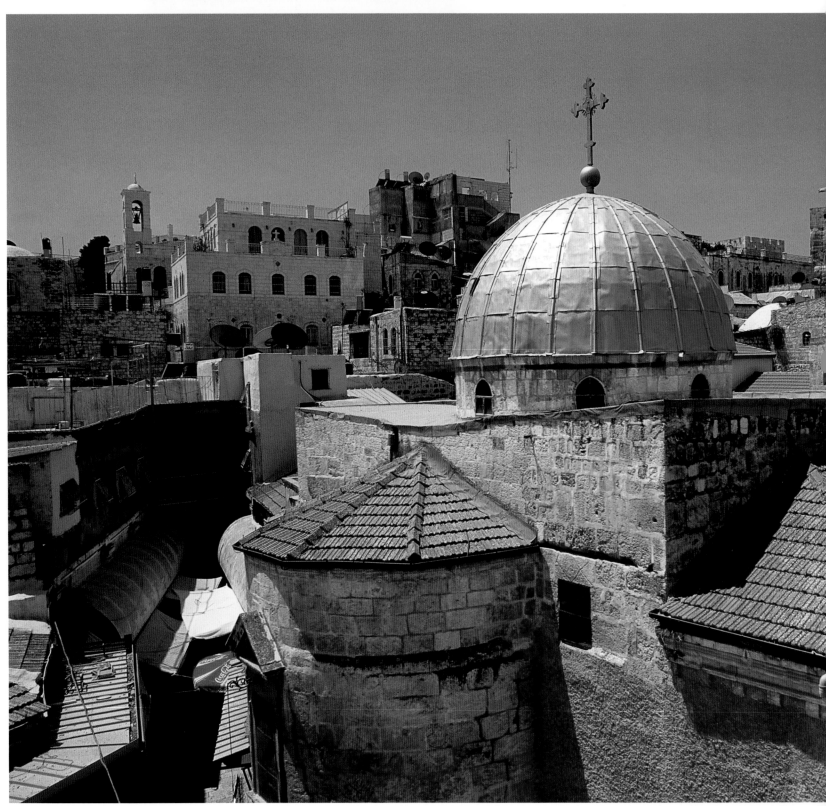

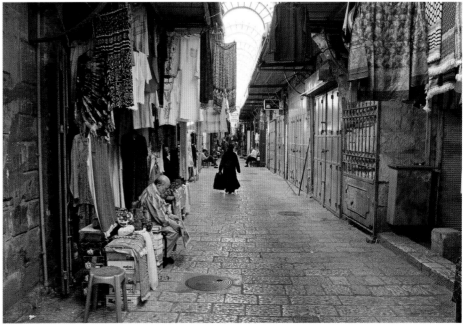

85 top The Christian Quarter, whose streets are slightly more calm and orderly than those of the Muslim Quarter, also has plenty of shops and cafés.

85 bottom Just to the south of the Church of the Holy Sepulcher, two of the oldest markets in the Christian Quarter are found, the suq al-Dabbagha and suq Attimos (also called the Greek bazaar), which are famous for selling jewelry and leather.

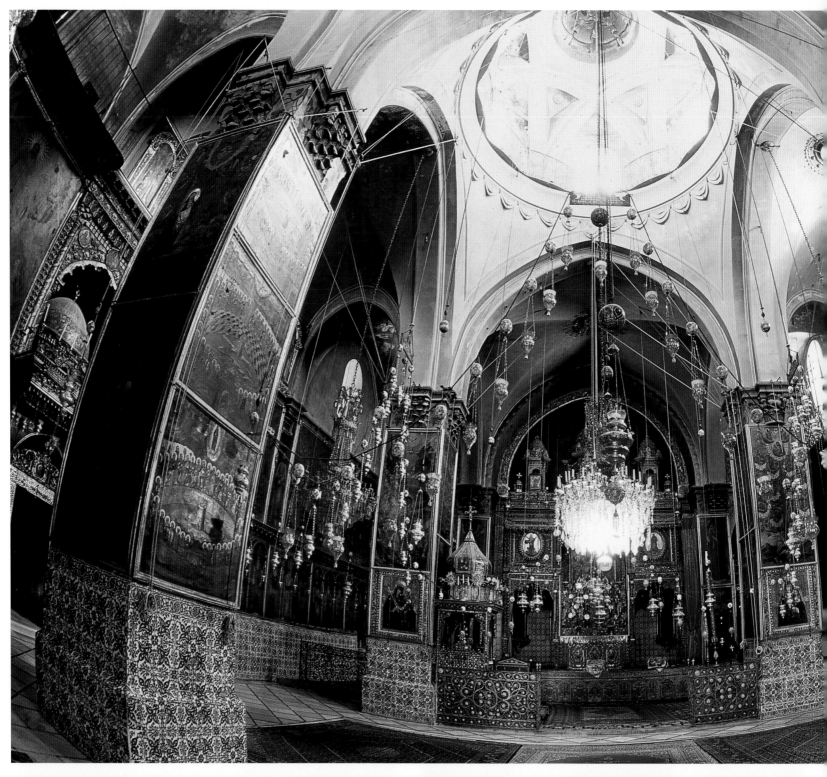

THE ARMENIAN QUARTER

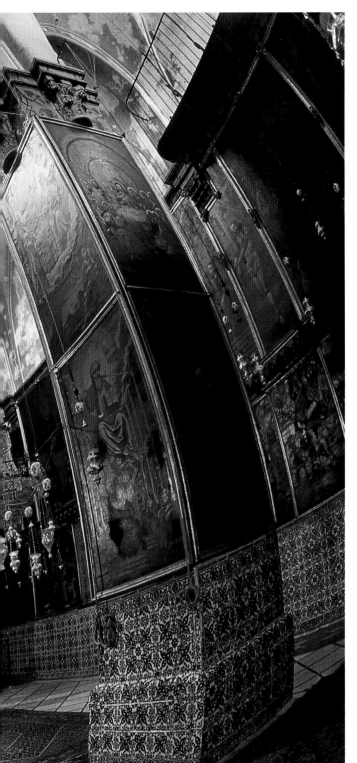

To the south of the bazaar that is David Street lies the smallest, most reserved, and least populated quarter of the city – the Armenian quarter. In this area live just over a thousand members of the first group to make Christianity their state religion (301 CE) and who, before the Arab conquest, possessed a total of seventy churches and monasteries in Jerusalem. Many of the current inhabitants of the quarter are the descendants of Armenians who fled Turkey in 1918 to escape a genocide that killed a million people and made another half million people refugees. Given this history, it is understandable that the Armenian Quarter, with its high walls, today somewhat resembles a bunker, a place where privacy and security are well guarded – it is unusual for the names of the residents to be shown on the doorbell, and at night the gates of the quarter are closed.

The jewel of the Armenian Quarter is St James Cathedral, said to be the most beautiful church in Jerusalem. It was constructed in the 12th century during the Crusader era upon the presumed tomb of the Apostle James, whose head is reputedly conserved in a chapel. In the portico of the Cathedral are found the *nakus*, or suspended wooden beams which were struck to call the faithful to Mass – a custom dating back to the Middle Ages when the Arab caliphs prohibited the use of bells. The three naves of the church are adorned with oriental carpets, oil lamps suspended from the ceiling, artistic blue and white tiles, altars, and thrones. The church treasury contains priceless medieval manuscripts. At the rear of the Cathedral, in the courtyard of the tombs of the Patriarchs, the twenty or so *khatchkar*, the traditional Armenian cross-stones that depict the tree of life, are of great interest.

Also of great value are the collections housed in the nearby Mardigian Museum: mosaics, illuminated manuscripts, liturgical objects, 17th-century tiles, and books made by notable Armenian printers. Some of the museum's rooms are dedicated to the genocide, and display photos that are truly chilling.

86-87 With its rich furnishings of lamps, icons, inlaid walls, golden chalices and prayer rugs, the Cathedral of Sts James is said to be the most beautiful church in Jerusalem.

86 bottom left The small and reserved Armenian Quarter stretches to the southeast of Omar ibn el-Khattab Square and to the east of the Citadel. An Armenian community was already living in this area in the 5th century CE.

86 bottom right The Armenians, like the Jews, have also had a diaspora and a history of persecution. For this reason, their quarter is structured as a labyrinth-like fortress whose gates are closed every night

87 bottom The Armenian cathedral is built on the burial site of two saints having the same name: the apostle James the Greater (martyred by decapitation, and whose head the church conserves as a relic) and James the Lesser, who was the first bishop of Jerusalem.

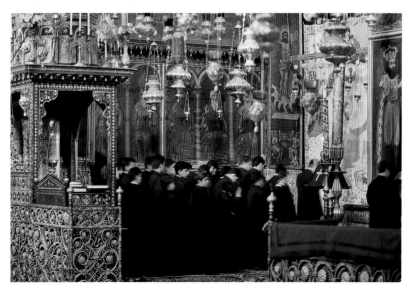

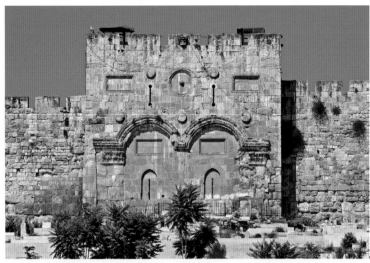

88 top *The Golden Gate, also called the Beautiful Gate or the Gate of Mercy (Bab al-Rahmeh), has Herodian, Byzantine, and Umayyad elements. It was closed by the Muslims during the Middle Ages.*

88-89 *Since the time of King David, the layout of the city wall has changed several times. The current wall, 2.8 miles (4.5 km) long, was built by Suleiman the Magnificent between 1536 and 1542.*

89 left *Two thousand years ago, the area where the Citadel now stands was the site of the enormous palace of Herod the Great, which had three large towers. The current appearance of the fortress can be attributed to the Mamluks and Ottomans.*

89 right *The bullet marks on the Zion Gate (in Arabic Bab Nebi Daud, Gate of the Prophet David) attest to its central location during the 1948 conflicts between Arabs and Israelis.*

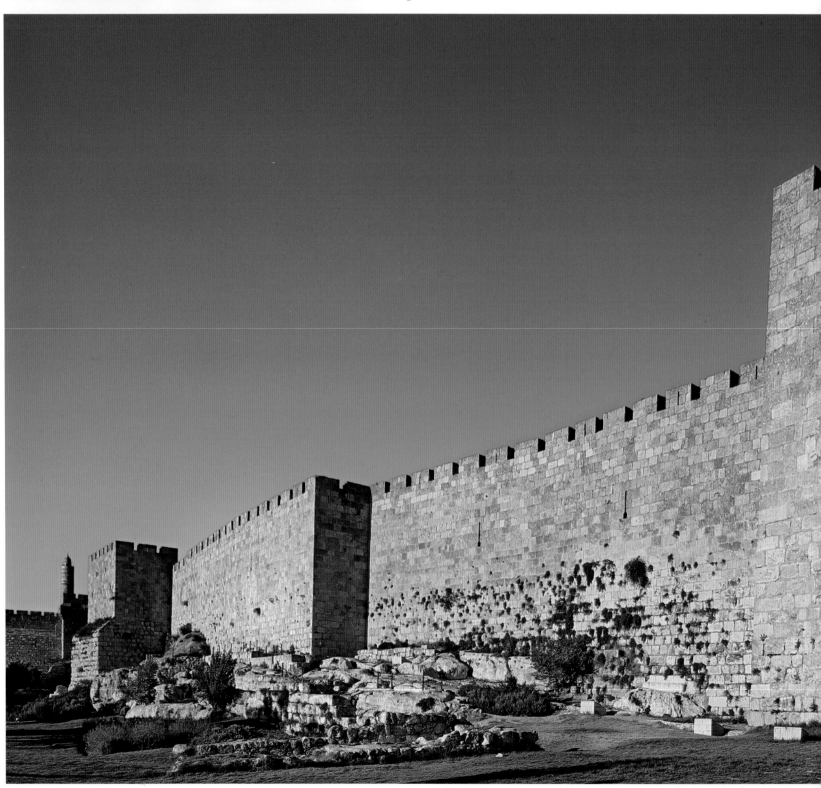

OUTSIDE OF THE CITY WALLS: THE AREA SURROUNDING THE OLD CITY

A PERSON RETURNING TO JERUSALEM AFTER A FORTY-YEAR ABSENCE AND LOOKING AT THE OLD CITY FROM OUTSIDE OF THE CITY WALLS WOULD HAVE DIFFICULTY BELIEVING THEIR EYES.

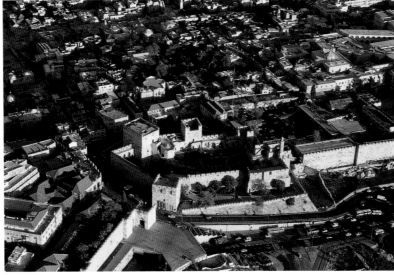

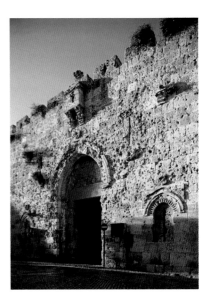

The exterior of the city walls of Suleiman the Magnificent, which were constructed between 1536 and 1542 possibly by the great architect Sinan, are no longer surrounded by refuse, run-down hovels and dry, yellow expanses, but instead by a belt of green. This change has occurred thanks to projects directed by the city's ex-mayor Teddy Kollek, an idealist convinced that "it is not possible to feel an aversion toward people with whom one walks in the same park every day." Toward the south, across from the Hinnom Valley, the Haas Promenade, Trottner Park, the Peace Forest, and the Sherover Promenade allow for strolls through thriving Mediterranean vegetation including olive, cypress, fig, and pomegranate trees as well as rosemary, lavender, thyme and jasmine. Other extremely rewarding views are offered from the top of the ramparts, of which three-quarters of the entire perimeter is walkable. Two distinct routes connect,

one-by-one, each of the 35 lookout towers and the seven beautiful gates that until 1870 were closed every night (the eighth gate, the Golden Gate, has been walled-up since the Middle Ages). Each of these gates may have up to five or six different names. The beginning of both routes along the ramparts is located at the busy Jaffa Gate (in Arabic Bab el-Khalil, Hebron Gate), near the place were executions were carried out during the Ottoman period. An opening in the wall next to the gate was made in 1898 to allow for the passage of Kaiser Wilhelm II's carriage. At the time it was said: "Someone more important than he would enter on foot." For this reason, when British General Edmund Allenby conquered the city in 1917, he descended from his horse and entered the gate on foot; the benefits, he was told by London, would be undeniable.

Beginning from the Jaffa Gate, and following the ramparts in a clockwise direction, the following gates are

encountered: the New Gate, opened in 1889 to allow Christian pilgrims direct access to the Church of the Holy Sepulcher; the monumental and always crowded Damascus Gate (Bab el-Amud or Column Gate); Herod's Gate (Bab es-Zahira or Flower Gate), which the Crusaders broke through on July 15, 1099; St Stephen's Gate or Lion's Gate (Bab Sitti Maryam or St Mary's Gate), through which Arab League soldiers entered in 1948, and Israeli soldiers entered in 1967.

Proceeding in a counter-clockwise direction from Jaffa Gate, the visitor passes the Citadel and arrives at Zion's Gate (Bab el-Nabi Daud or Gate of the Prophet David), the scene of fierce clashes between Israelis and Jordanians in 1948, and then Dung Gate (Bab al-Magharibeh or Mograbi Gate), near which a North African Arab quarter was located until it was leveled in 1967 by Moshe Dayan in order to create open space in front of the Wailing Wall.

90 top The monumental Damascus Gate, an amazing example of Turkish urban architecture, is known by the Arabs as Bab el-Amud or Gate of the Pillar because it stood near a column that held a statue of Emperor Hadrian.

90 bottom left Medieval Christians erroneously believed that Jesus was brought through Herod's Gate by King Herod Antipas. This gate is also called the Flower Gate because of the decorations above the arch.

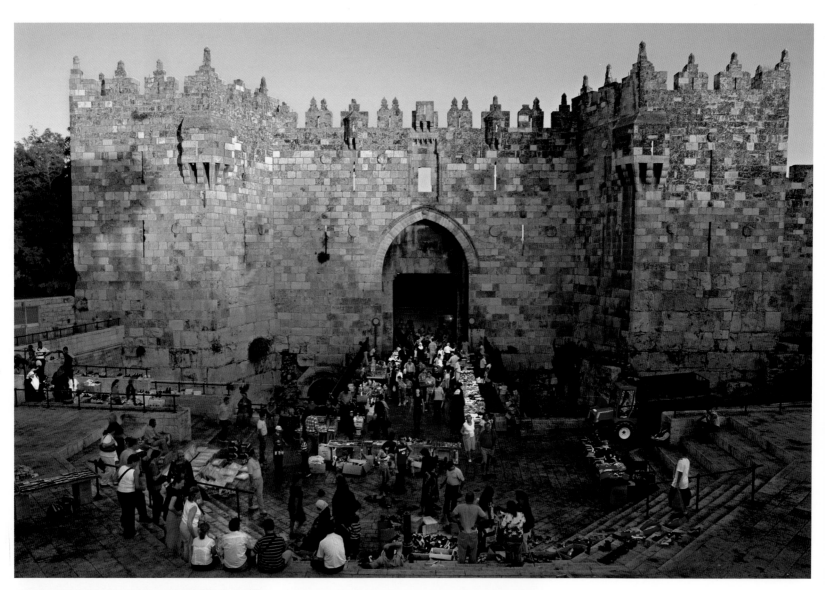

90 bottom right The Dung Gate or the Refuse Gate is the one closest to the Wailing Wall. It is also called the Mograbi Gate because it led to the Mograbi Quarter which was leveled by Moshe Dayan in 1967.

91 Below the Damascus Gate, archaeologists have discovered the foundations of the Gate of Herod Agripas, dating from 44 CE, which at that time was already flanked by two towers (the current Towers of the Women).

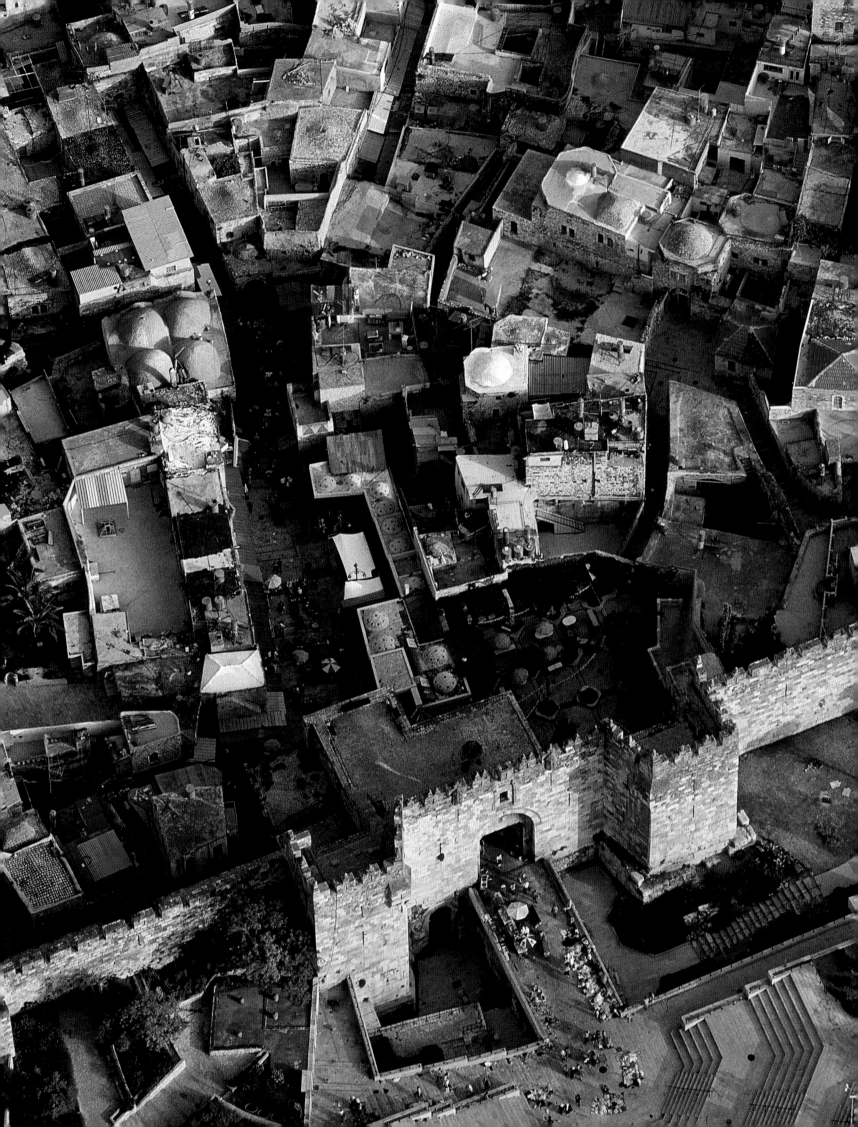

92 top right The Citadel is called the Tower of David due to an old misunderstanding. The tower, whose image is reproduced on so many Israeli stamps, is actually an Ottoman minaret, built by Mohammad Pasha in 1655.

92 top left The triple-arched gate that leads to the Citadel was constructed by the Ottomans in the 16th century. On its steps, British General Allenby accepted the surrender of the Turks in 1917.

92 center left From both the Jaffa Gate and the Citadel one can climb to the bastions and take a panoramic walk along the walls, beginning at the Zion Gate and ending with the Dung Gate.

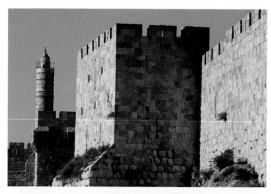

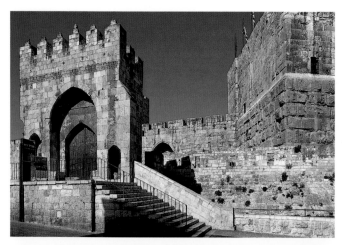

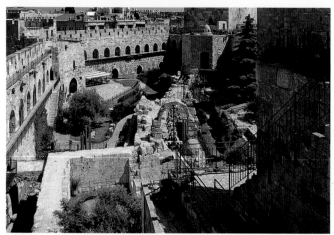

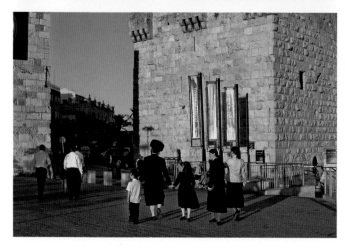

92 bottom left From the Jaffa Gate there is access, inside the Citadel, to the Museum of the History of Jerusalem, where more than three thousand years of the city's history have been recreated.

92-93 The entrance to the Jaffa Gate is located to its side and is L-shaped for reasons of defense. The opening next to the gate was created by the Ottomans in 1898 in order to allow the procession of Kaiser Wilhelm II to pass.

The large Citadel complex, located in a strategic position near the Jaffa Gate, was erroneously christened "the Tower of David" by the Crusaders, but in reality it has no connection to the great biblical king. Instead, the citadel was the residence of the Hasmonean kings, Herod the Great, Godfrey of Bouillon, and Saladin before the Ottomans turned it into a Turkish fortress. The name "Tower of David" was later given to a beautiful 17th-century minaret which, paradoxically, was adopted in the 19th-century as a symbol of the Zionist movement.

Today, visitors to the Citadel can discover the three thousand year history of Jerusalem: sections of Maccabeean walls, an imposing tower that survived the destruction of Herod's magnificent palace, a Roman cistern, Crusader ramparts, Mamluk mosques and domes, striking above and below ground routes. . . . Those things not directly visible may still be appreciated by means of accurate reconstructions in the form of models, displays, holograms, and computer animation on exhibit in the Museum of the History of Jerusalem.

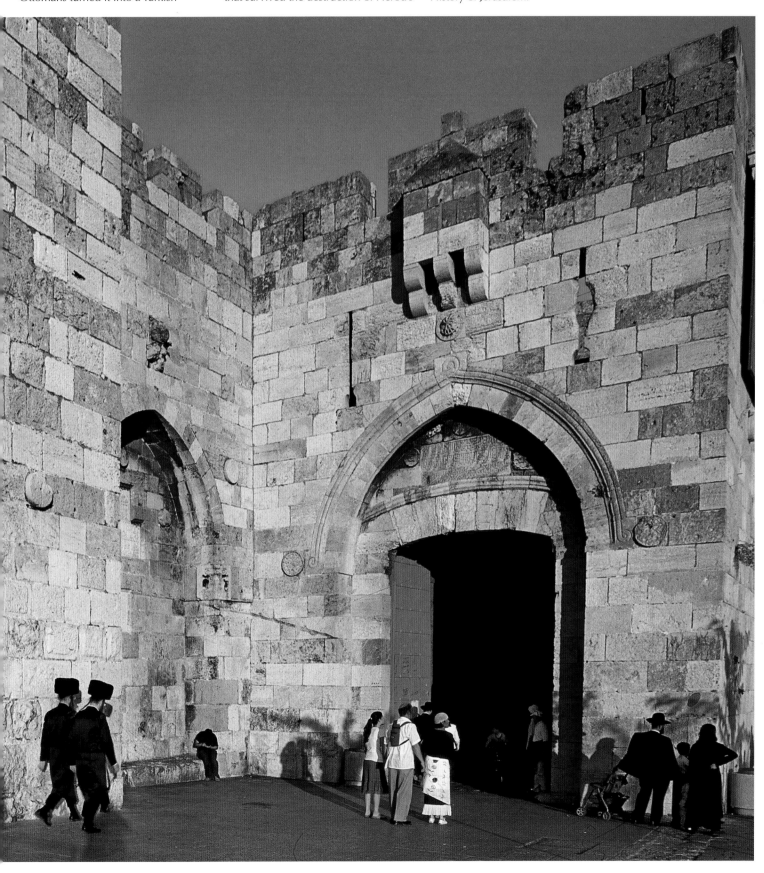

94-95 *After sunset, the Citadel is a theater for light and sound shows, but it is also frequently used by contemporary artists as a background for colorful illuminated presentations.*

95 top right *In the internal courtyard of the Citadel, archaeological artifacts have been discovered from all the periods between the 2nd century BCE and the 12th century CE, from the Hasmonean era to the Crusader era.*

95 top left *The imposing Tower of Phasael owes its name to Herod the Great, who named it after his brother. Demolished by Emperor Hadrian, it was later reconstructed in the 14th century.*

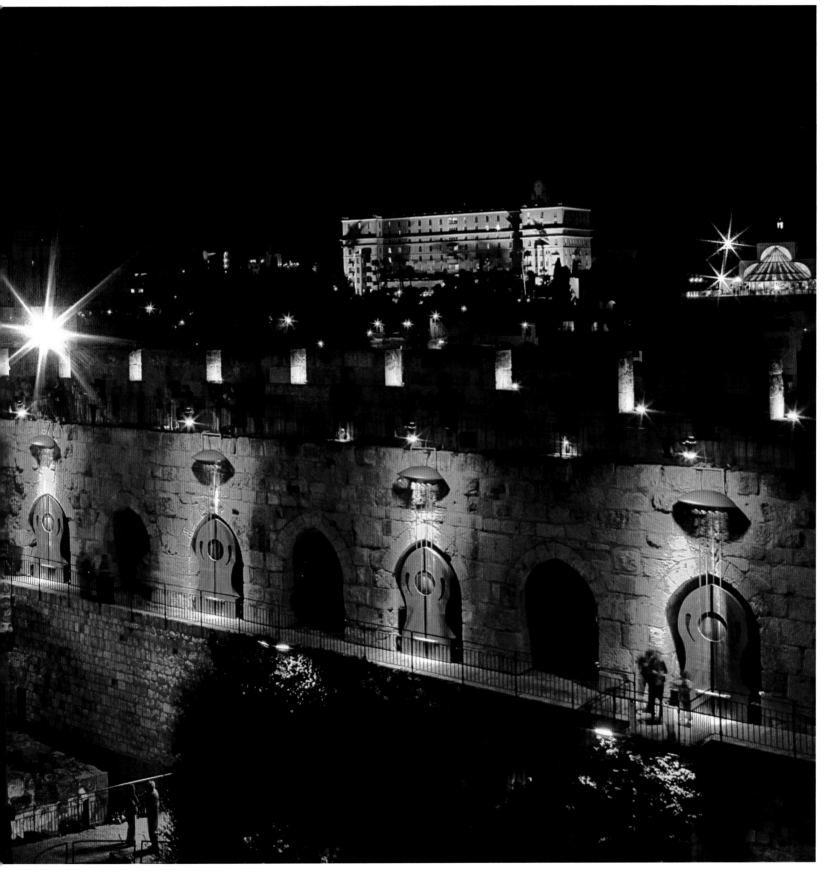

The hill of the Ophel, located at the foot of the southern wall of the Temple Mount, is the oldest part of Jerusalem, the Jebusite city conquered by David. Located near the Dung Gate is the entrance to the Davidson Center, where by means of a series of tunnels, visitors are introduced to the various levels and historical periods of the settlements. The main attraction of the Center is the virtual reconstruction of the Herodian Temple.

Below the south wall of the Temple Mount lies the Jerusalem Archaeological Park, where 25 layers of urban settlements have been uncovered, as well as baths for cleansing, a large stairway that was used by pilgrims to climb to the Temple, Canaanite tombs, houses burned by the Babylonians, buildings of Roman, Byzantine and Umayyad origin, and a Fatimite observation tower. Also on the Ophel, important excavations are currently underway in Area G, as the archaeologists call it, where the center of the City of David (Ir David) was probably located – an area that has been preserved by piles of débris, accumulated after the city's destruction by the Babylonians in 586 BCE, which impeded construction and thereby created a goldmine for researchers. Further to the south, near the Palestinian village of Silwan, are located other sites of great archaeological interest, such as Warren's shaft, the prodigious Hezekiah Tunnel (more than 1640 ft/500 m) long and excavated in 701 BCE by two groups of workers that started on either end and met in the middle) and the connected Pool of Siloam, where the man who was born blind and was healed by Jesus came to wash his eyes (the original pool has recently been discovered, while the one that had been visited up until now is actually Byzantine). All of these were part of a system created to ensure that the Old City would have a supply of water from the Gihon Spring below, even in the case of a prolonged siege.

96 bottom The Pool of Siloam that is visited by tourists is actually Byzantine, as are the remnants of columns from a small 5th-century church. The actual pool where Jesus cured the man who was blind from birth was recently discovered nearby.

96-97 Below the dome of al-Aqsa, to the right of the southern wall of the Temple Mount and the Crusader-era tower, a monumental stairway was discovered that climbed to Huldah Gate, which had been sealed by the Romans.

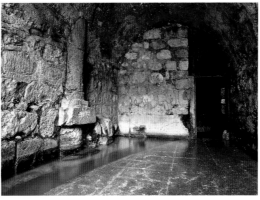

97 top left The Davidson Center has a series of tunnels that display to visitors the remains of 25 layers of urban settlements. Access to the Center is located near the Dung Gate, where sections of the Roman Cardo Minimus have been uncovered.

97 top right In order to pass through the 1640 ft (500 m) tunnel-aqueduct which King Hezekiah had built in 701 BCE to connect the Gihon Spring to the Pool of Siloam, it is necessary to enter water up to one's knees.

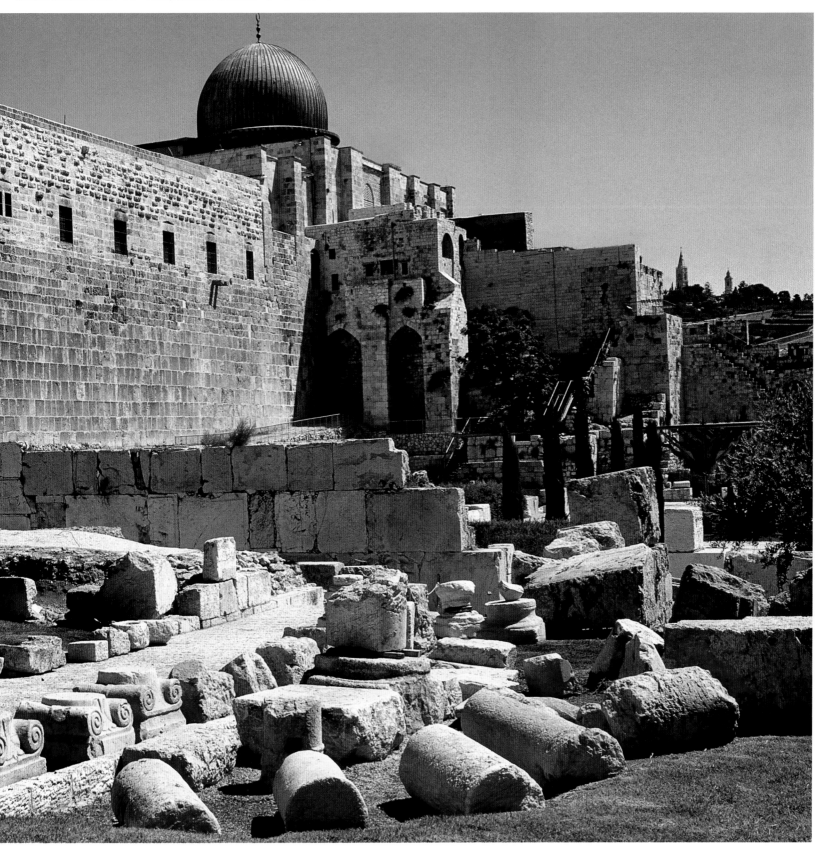

98 bottom right The room of the Cenacle, or of the Last Supper, is located on the second floor of a Gothic building that is the last remnant of a Crusader church. The Franciscans gave the room its current appearance after their arrival in 1333.

98 bottom left The ground floor of the Cenacle building, in addition to having a Franciscan cloister dating from 1335, also holds the Tomb of David cenotaph, which despite the unlikeliness of the claim, is highly venerated by the Jews.

98-99 The Church of the Dormition stands on the site where 2nd-century apocryphal texts assert the Virgin Mary died. The Byzantines had already built the basilica of Hagia Sion in this spot by 390.

Located high in the Valley of Hinnom, or more precisely the terrible Gehenna that symbolizes hell in the Bible, the current area of Mount Zion (no relationship to the biblical Zion), which in 70 CE was still located within the city walls, was the only part of Jerusalem to escape destruction by the Romans. This is the reason that, according to a Christian tradition going back at least to the 4th century CE, it was possible for the Cenacle, the place where the Last Supper of Jesus Christ and his disciples took place, to still exist. The site is especially holy to the Christians, who turned it into the Church of Mount Zion. The building is also holy for the Muslims as well. During the Ottoman period they created a mosque there (a pulpit and a prayer niche are visible under the Gothic vaults), and forbade entry to Christians. Finally, the site is also holy for the Jews, who situate the Tomb of David on the lower floor; this monument, however, has no historical basis. The Israeli authorities, who now own the building, allow people to visit, but in order to avoid problems, maintain the status quo: Christians are not allowed to celebrate Mass in the place where they believe Jesus instituted the Eucharist. In addition, archaeological studies to ascertain whether this site was actually a meeting place for the first Christians, are not allowed to be conducted.

Also located on Mount Zion are two churches that commemorate other key episodes of early Christianity: the imposing Church of the Dormition of Mary, erected in 1910 with funding from the Hapsburgs, serves as a remembrance that the Virgin Mary reputedly died in this area; and the white Church of St Peter in Gallicantu, built in 1931, which commemorates the regret that the leader of the apostles felt after having betrayed Jesus. Nearby, past the small Chamber of the Holocaust Museum, lies a Protestant cemetery where the tomb of Oskar Schindler is located, the Protestant industrialist who saved at least one thousand Jews from Nazi concentration camps.

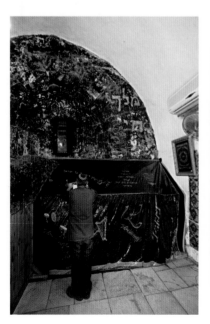

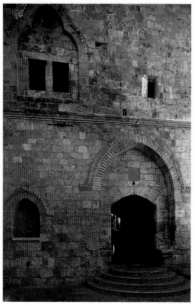

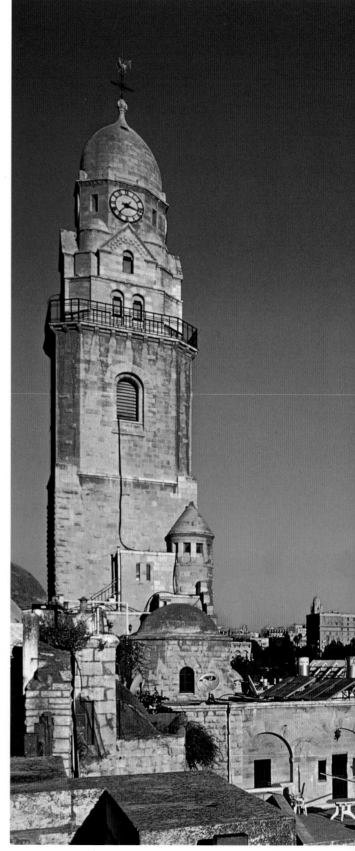

99 top left The room where Jesus began the tradition of the Eucharist, and where the apostles later received the Holy Spirit during Pentecost, is divided into two naves by three columns in 14th-century Gothic style.

99 top right In the crypt of the basilica, a statue of ivory and wood portrays the Virgin Mary lying on her death bed. The surrounding chapels were donated by various countries throughout the world.

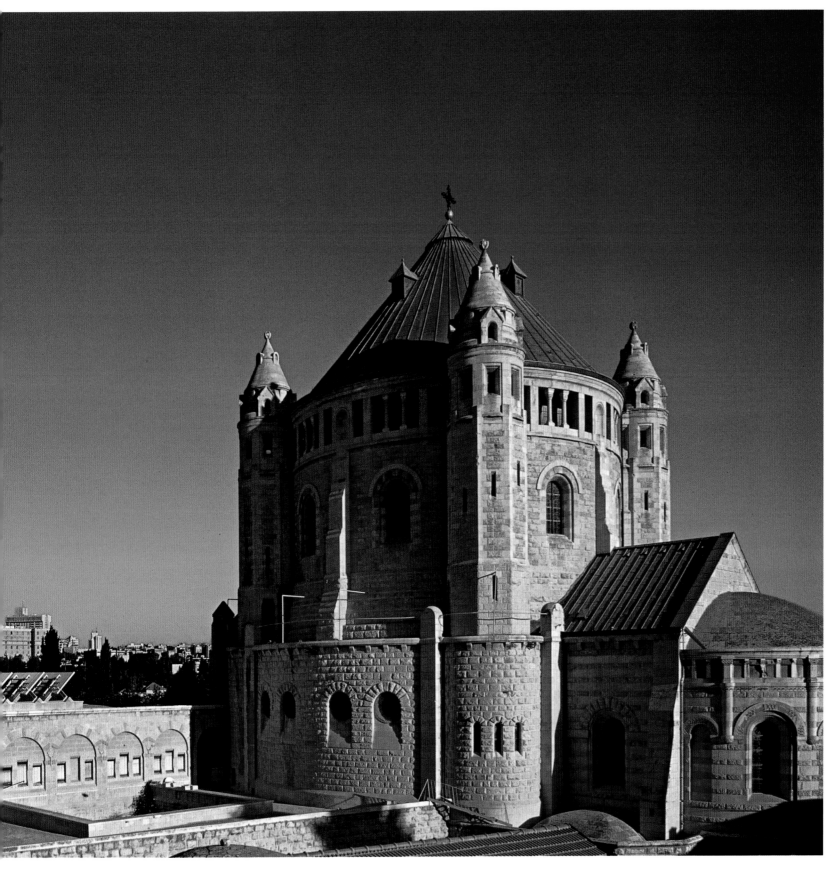

100 top left The façade of the Church of the Assumption of the Virgin, or the Tomb of the Virgin, dates from the Crusader era. In 1757 the church was taken from the Franciscans, who had controlled the edifice since 1363, by the Sultan who then gave it to the Armenians and the Greek Orthodox.

100 top right A large stairway descends to the dark Tomb of the Virgin, venerated as early as the 2nd century CE, which holds a stone block upon which the body of the Virgin Mary was reputedly placed before her assumption into Heaven.

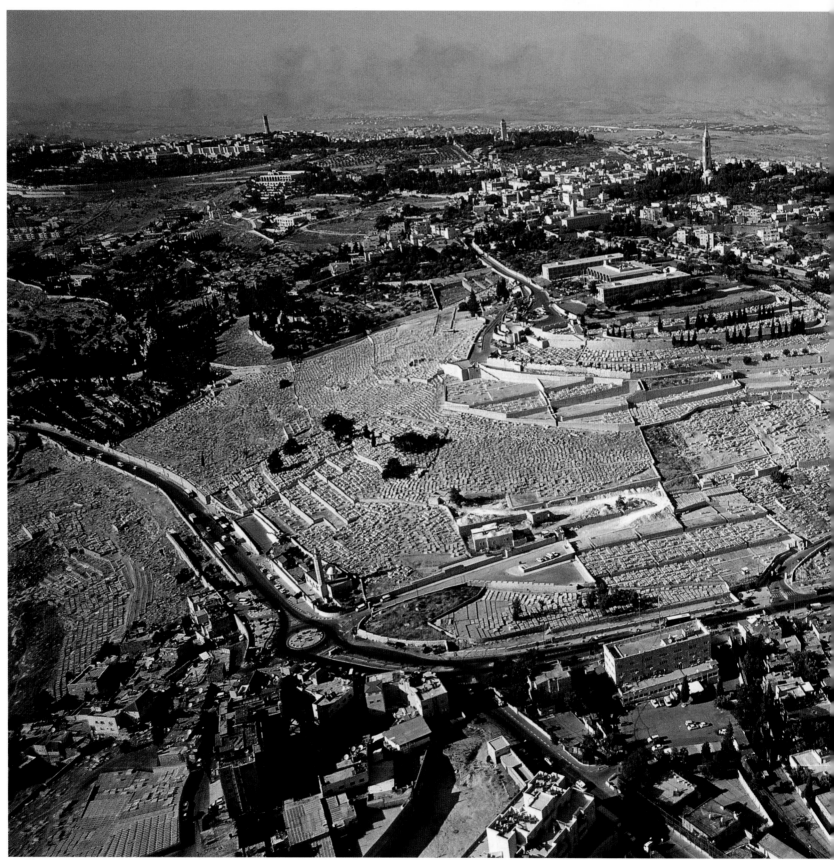

100-101 The Mount of Olives is separated from Jerusalem by the Cedron and Josaphat Valleys. Its slopes, which were already being used as burial sites three thousand years ago, are closely linked to the last days of Christ.

101 The names of the funerary monuments in the Valley of Cedron are deceptive. The "tombs" of Saint James and of Zachary actually belonged to the clerical Hezir family (1st century BCE).

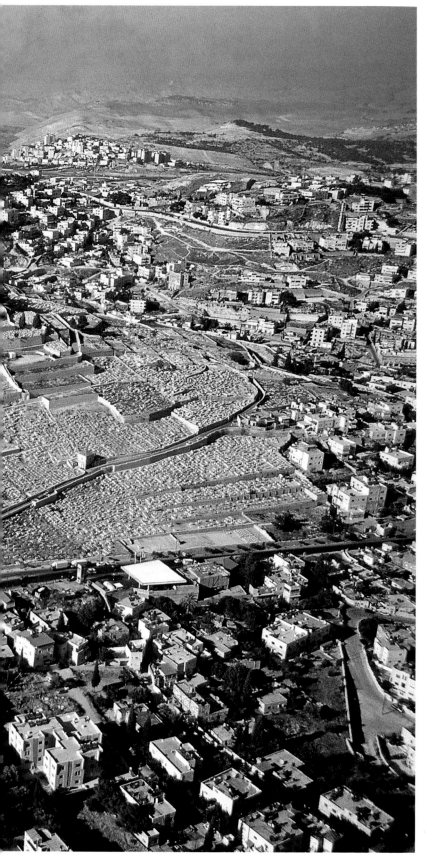

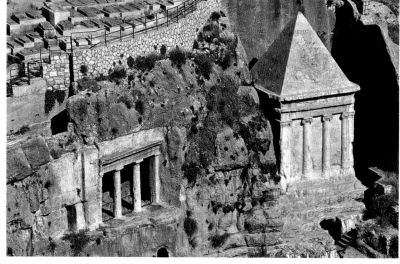

According to widespread tradition, the resurrection of the dead will begin in the Valley of the Cedron Brook (Qidron in Hebrew means dark), the biblical valley of Jehoshaphat that separates the Old City from the Mount of Olives and in which the Prophet Joel situates the Final Judgment. This Jewish belief was also adopted by the Christians and the Muslims, as evidenced by the cemeteries of the three religions that cover part of the slopes; the Jewish cemetery alone contains more than 70,000 tombs. The four great "tombs" of Zachary, St James, Jehoshaphat, and Absalom (that of Absalom is the most interesting, with a cone-shaped covering reaching a height of 66 ft (20 m), located at the bottom of the valley, are actually magnificent funerary monuments dating from the 1st to 2nd century BCE, and have no connection with the persons for whom they are named.

From this valley rises the Mount of Olives, where Jesus was arrested, and from the summit of which he ascended into Heaven. For this reason the area was sacred to the Christians from the beginning, and some of the most notable churches in Jerusalem were erected here. At the bottom of the valley lies the austere Crusader-style façade of the Tomb of the Virgin Mary, which is actually the Church of the Assumption. Spared by Saladin out of respect for the Virgin Mary, the church was Franciscan from 1363 to 1757, and now belongs to the Armenians and the Greek Orthodox. Inside the shadowy cavern is found the rock on which the body of the Virgin was reputedly placed, before God raised her into Heaven. Research conducted by the famous Franciscan archaeologist Ballarmino Bagatti appears to confirm that the tomb dates to the 1st century.

102-103 The Mount of Olives was already covered with churches by the 4th century. Today, the most notable of these are the Church of Agony, the Russian monastery of St Mary Magdalene and the small church of Dominus Flevit.

102 bottom In the Gethsemane Garden there are eight enormous olive trees that according to tradition date to the time of Christ, who spent the night before the Passion here.

103 top right A famous panorama of the Old City is seen from the altar of the small church of Dominus Flevit. The church was built by Barluzzi in 1955 in the shape of a tear, in commemoration of Jesus weeping for His Jerusalem.

103 bottom left The small church of Dominus Flevit was built in 1955 on the ruins of a 7th-century Byzantine church, whose mosaic floors are still visible.

103 bottom right Near the ruins of the Byzantine basilica of Eleona, built by St Helen, is situated the 19th-century cloisters of the Pater Noster Church. Ceramic tiles display the words of the Our Father prayer in dozens of languages.

104-105 The Jews who are buried in the cemetery on the Mount of Olives will be the first to be resurrected at the end of the world; tradition situates the Day of Judgment in the Valley of Josaphat or the Valley of Cedron below.

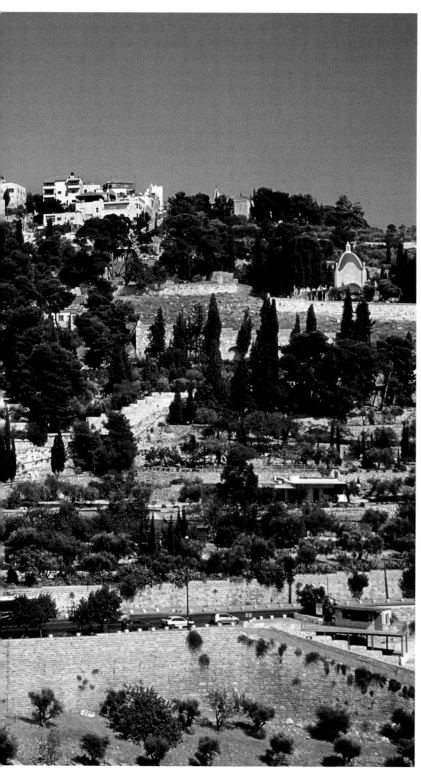

In nearby Gethsemane (in Hebrew "olive press"), is located the grotto where Jesus was arrested and received the kiss of Judas (on the interior there are 4th-century CE mosaics), as well as the Church of Agony that the omnipresent Franciscan architect Antonio Barluzzi erected between 1919 and 1924, upon the rock where Jesus prayed the night that he was arrested. The church is also called the Church of All Nations since the construction was financed by twelve nations. In the orchard stand eight large olive trees which carbon-14 tests have dated to the era of Christ. Upon climbing the mountain visitors gradually pass: the gilded onion domes of the Russian Orthodox Church of St Mary Magdalene, built by Czar Alexander III; the Chapel of Dominus Flevit, also built by Barluzzi, in 1955, with a tear-shaped form that recalls how Jesus wept for the fate of Jerusalem; the 18th-century Church of the Pater Noster, in whose cloister the Our Father prayer is written on tiled plaques in dozens of languages; and finally the octagonal Crusader-era Aedicule of the Ascension, later turned into a mosque by Saladin, and where the Muslims also venerate the impression of His presence that Jesus purportedly left before ascending to Heaven.

The Mount of Olives provides the most spectacular views of the Old City. Another favorable and strategic observation point lies to the north, Mount Scopus, from whose 2722 ft (830 m) height it was not by chance that Sennacherib, Nebuchadnezzar, Alexander the Great, Titus, Godfrey of Bouillon, Allenby and Moshe Dayan studied and planned the attack of the city.

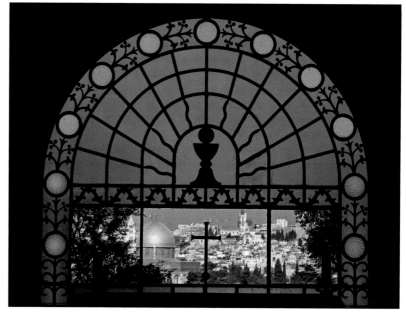

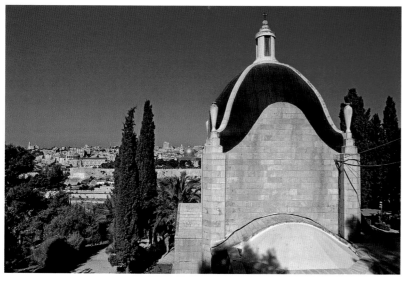

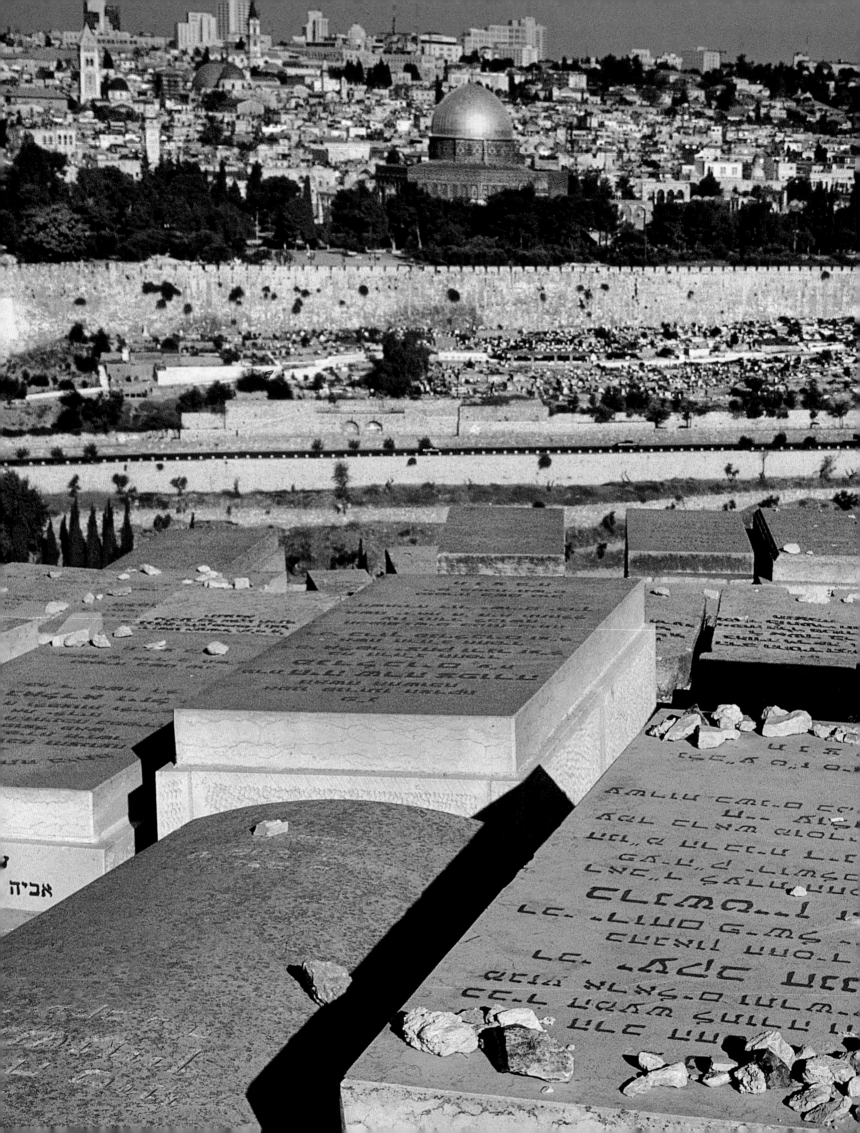

106 top right The Anglican Cathedral of St George, consecrated in East Jerusalem in 1910 and dedicated to the patron saint of England, has both an interior and exterior appearance typical of British churches.

106 top left The Basilica of St Stephen should not be confused with the Greek Orthodox one in the Valley of Cedron. The French Dominican monastery houses the École Biblique founded by Father Joseph-Marie Lagrange, who is buried there.

106 bottom left The Garden Tomb or Gordon's Calvary is a tomb dating from the 9th to 11th century BCE. On this site in 1883, the British General Charles Gordon believed that he had discovered the true tomb of Christ.

107 To the northeast of the Old City stands the late 19th-century Basilica of St Stephen, which contains remnants of the Byzantine church of the same name built by Patriarch Juvenal and Empress Eudocia in the 5th century CE.

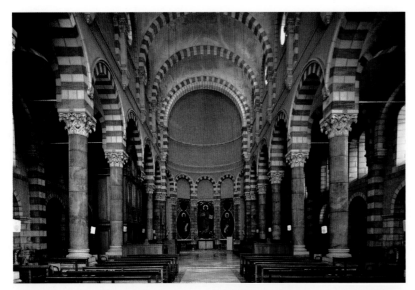

Just outside the Damascus Gate, lies the animated area of East Jerusalem, the Palestinian Arab heart of the city whose atmosphere is very different from that of the western quarters.

By heading north along Nablus Road, the visitor quickly reaches St Stephen's Monastery, which was constructed at the beginning of the 20th-century by French Dominicans in a somewhat eclectic style. This monastery is the seat of the famous Biblical Archaeology School. Nearby is the Garden Tomb where at the end of the 19th century Charles Gordon, a famous British general, and a hero of the war in Sudan, claimed to have located the true sepulcher of Christ based on the observation that the contour lines of a topographical map of the hill outlined the form of a skull (the Golgotha of the gospels); in any event, the pleasantness of the site compensates for the lack of credibility of the theory. In Jerusalem, after all, mistakes and historical jokes are common. Farther along the street another example is found: the elaborate Tomb of the Kings, long believed to be the burial place of David's successors, but which in fact belongs to a Mesopotamian queen, Helena of Adiabene, who converted to Judaism a few years after Christ's death, and whose sarcophagus is now in the Louvre. Nevertheless, the grandiose sepulcher gives an idea of how Christ's tomb might have looked.

Across the street, the Neo-Gothic Anglican Cathedral of St George, built in 1910, appears as if a piece of London has dropped from the sky into the Middle East. Nearby is located the Orient House, a beautiful villa from the late 1800s, which since 1992 has housed the general headquarters of the Palestinian Authority in Jerusalem, and has become a symbol of the demand for Arab autonomy.

Farther to the east, under the northeast corner of the walls of the Old City, where the Crusaders made camp in 1099, the Rockefeller Museum has been located since 1938. This museum was possibly the first large museum opened in the Middle East. Although many pieces from its collection have been transferred to the Israel Museum, its archaeological collection remains vast, covering prehistory through the Middle Ages.

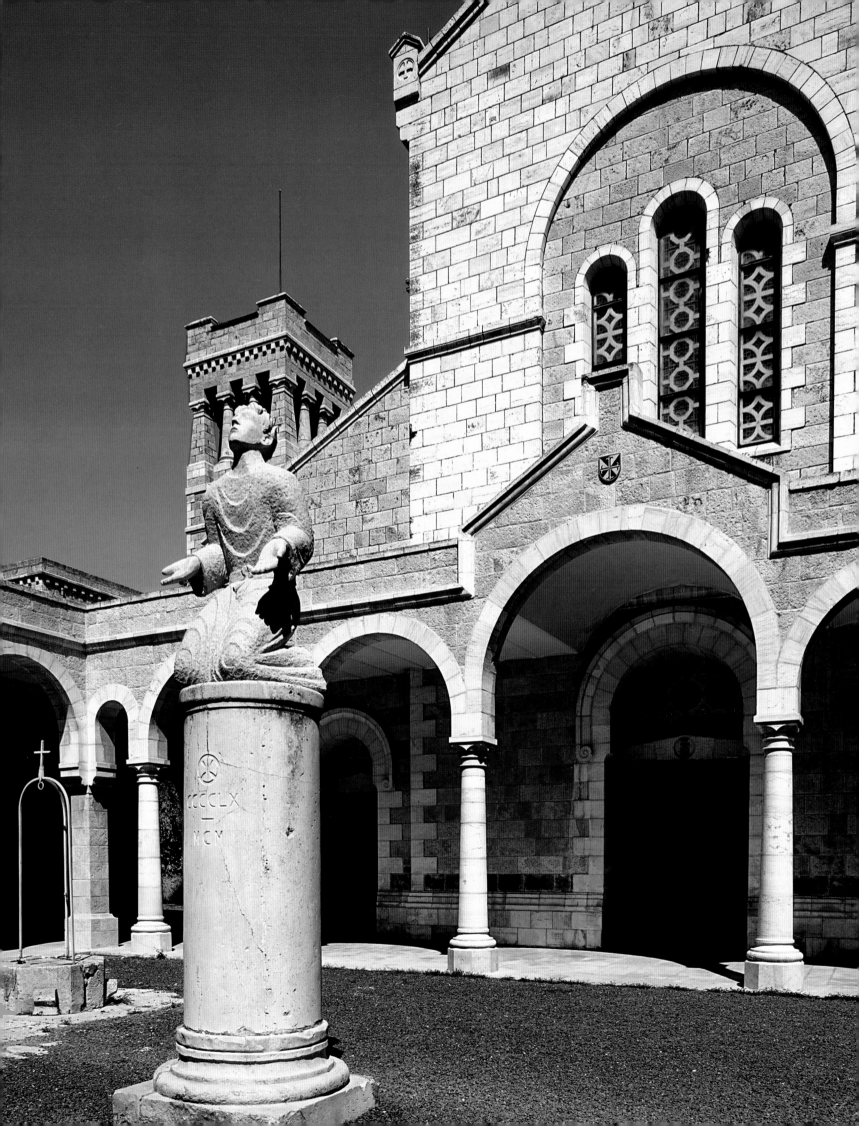

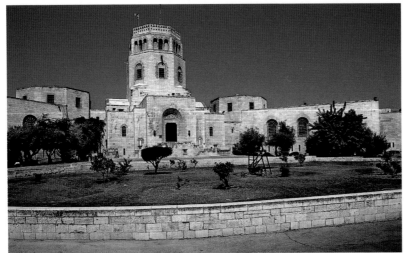

108 top and 108-109 The Rockefeller Museum was financed in the 1920s with two million dollars donated by the American oil-tycoon John D. Rockefeller. The rooms of the museum are arranged around a large rectangular courtyard. For the Rockefeller Museum, the Englishman Austen St Barbe Harrison, the most sought after architect of the British Mandate period, made ample use of the light-colored Jerusalem limestone.

109 top The museum, inaugurated in 1938, displays an extraordinary collection of artifacts which were discovered in Palestine between 1920 and 1948 and which date from the Stone Age up to the year 1700.

109 bottom Below the portico is displayed a sarcophagus which has a spectacular depiction of the Amazonomachia (the mythical battle between the Greeks and the Amazons).

NEW JERUSALEM

*THE LONG JAFFA ROAD (DEREKH YAFO),
THE STREET WHICH THE JEWS WHO DISEMBARKED
AT THE PORT OF JAFFA ASCENDED TOWARD JERUSALEM,
IS THE VERY HEART OF WEST JERUSALEM.*

The numerous buildings, dating back to the British Mandate period, lend the area a touch *d'antan*, of yesteryear. Among these numerous buildings are the Central Post Office, erected by the British who inserted in the façade black basalt stone from Golan; the Bank of Israel, designed in the International Bauhaus style by Erich Mendelson; the Piacenza style Italian Assicurazioni Generali (General Insurance) featuring a large stone St Mark's Lion on its roof; and the Neo-Classical Sansour Building, where the legendary Café Europa is located at ground level – prior to 1948 the cafe was a meeting place for Arabs, Jews and the British.

Indications of architectural renovation are more apparent across from the palms in Safra Square; facing the square is City Hall, that since 1993 has replaced the building the British Administration constructed in 1930 (located nearby, the British building still has marks on its façade where it was struck by bullets between 1948 and 1967). The Post-Modern design of the new City Hall, entirely made of stone, glass, and steel, and with a large copper dome, still manages to incorporate Mamluk influences, which are evident in the bands of red and white sandstone.

Also on the north side of Jaffa Road is the entrance to the enormous Russian Compound, which was one of the very first settlements outside of the Old City. Built in 1860 by Czar Alexander I, it was the largest hotel in the world, capable of housing ten thousand Orthodox pilgrims. Today, however, only the Holy Trinity Cathedral, with its picturesque green domes, belongs to the Orthodox Church; in exchange for periodic supplies of oranges, the communist government of the USSR sold the large buildings to Israel who used them as a police headquarters, a prison, the Prisoners Museum, the Ministry of Agriculture and other offices.

110 bottom The Mamilla Center, finally completed in 2007 with the opening of an exclusive shopping mall, was one of the most lengthy and costly development projects in modern Jerusalem.

110-111 Located between the King David Hotel and Jaffa Gate, the exclusive residential and commercial building complex of David's Village or Mamilla Center was designed by Israeli architect Moshe Safdie.

111 top left Rising to 270 ft (82 m), City Tower is second in height only to the 308 ft (94 m) Crowne Plaza Hotel. It was much discussed at the time of its completion in 1980 because it visibly modified the skyline of the center of Jerusalem.

111 top right After the reunification, in 1967, hotels and commercial buildings began to depart from the monotony of the urban architecture in West Jerusalem. Large edifices such as the Clal Center, the City Tower, the Bank Hapoalim and the Rassco Building appeared to mimic the city centers of the West.

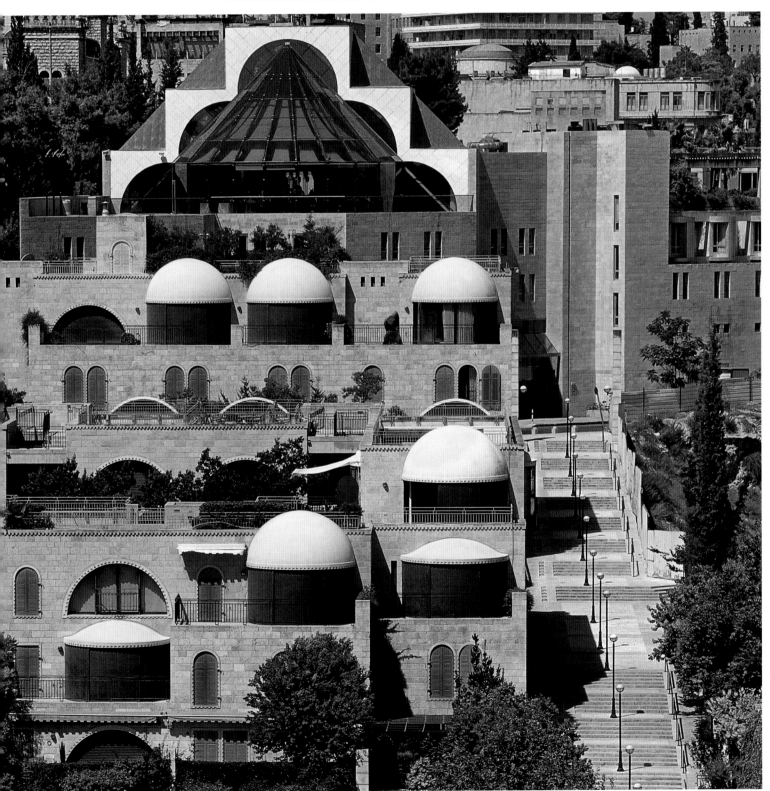

112 and 113 The postmodern structure of the new Jerusalem City Hall, inaugurated in 1993 after 5 years of work, faces the spacious 43,000 sq ft (4000 sq m) Safra Square, which is dedicated to the Brazilian family who financed its construction. The old City Hall, still riddled with bullet marks from the 1948 War, was one of four public buildings constructed by the British (it was designed by Clifford Holiday) during the British Mandate period. In addition to two modern buildings, the new municipal complex includes ten historic buildings that were restored to provide additional space for public officials. In the summer of 2007, the combined show-demonstration featuring the United Buddy Bears, which since 2002 has traveled the world promoting peace and friendship between peoples, made an appearance in Safra Square. At this event, 138 large bears, representing the member countries of the UN, stood with hands touching and proclaimed the slogan "We should know each other better." By request of the local government, the Israeli bear was symbolically placed between the Iran and Iraq bears.

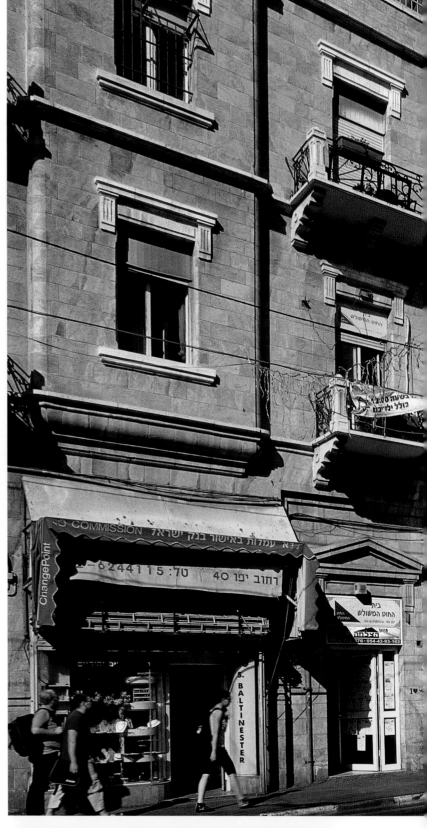

It is also worth visiting the nearby Ticho House, which was the villa of the legendary ophthalmologist Abraham Ticho and his wife Anna, a Viennese painter. In addition to visiting the house in order to see Anna's watercolors and Abraham's collection of Hanukkah lamps, people also gladly come to listen to the concerts and to have lunch at the coffee shop, in a garden that is truly an oasis of peace.

On the south side of Jaffa Road there is access to the *midrahov*, a pedestrian area called the "salon of Jerusalem" for its pleasing exuberance. Here the capital displays an unexpected gaiety worthy of its "rival" Tel Aviv. At any hour, day or night, the small, chic restaurants of Nakhalat Shiva (an historic quarter founded by seven families in 1869 and now beautifully restored) and the small tables on Ben Yahuda Street, are crowded with people sipping a *bliy halav* or *afukh*, or rather a black coffee

or a coffee with cream, or perhaps a Maccabi or Taybeh beer; even on Saturdays there is always a cafe open and a few street artists at work. As a paradoxical contrast between the sacred and the profane, the visitor need only turn the corner to gain access to, in a late-19th-century German ex-hospice, the Italian Synagogue – the most beautiful synagogue in Jerusalem. Perfectly reassembled after being transported in 1952 from Conegliano, in the Veneto, it is furnished with benches and candelabra brought from Ferrara, Reggio Emilia and Florence.

Continuing farther along Jaffa Road, the visitor finally arrives at the Mahane Yehuda Quarter ("the field of Judah") with its chaotic labyrinth of streets; the famous food market known as "the Shuk" is particularly animated on Fridays when residents flock to the stands to stock up on fruit, vegetables, fish and meat due to the Saturday holiday.

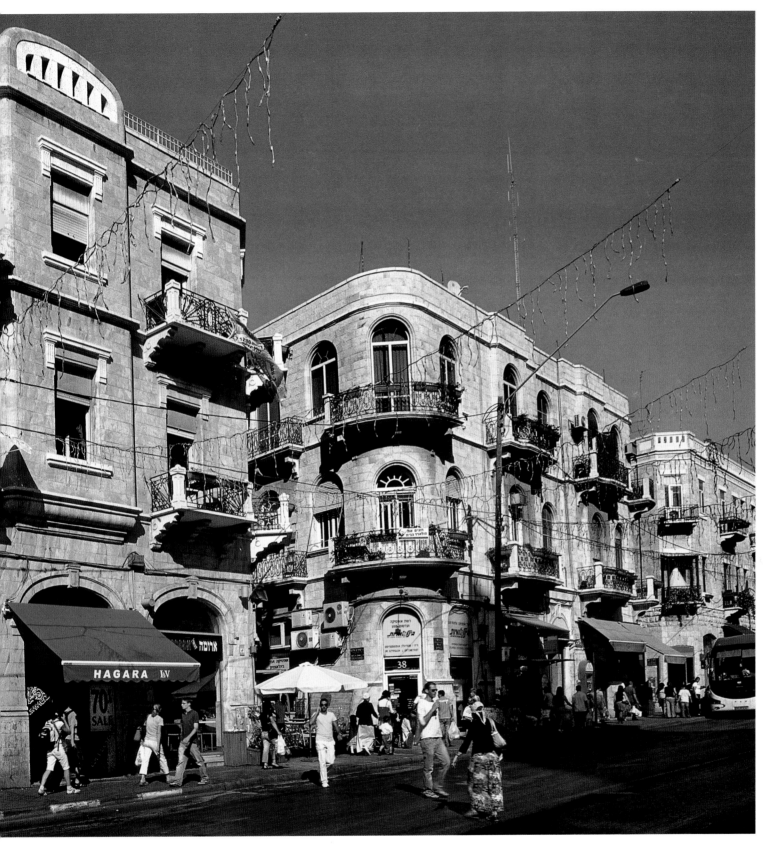

114 top Ben Yehuda Street is the center of Jerusalem nightlife. Together with the adjacent Nakhalat Shiva and Yoel Salomon, as well as Jaffa Road, it forms the largest pedestrian zone in Israel.

114 center The 12-floor Jerusalem Tower Hotel is located near the pedestrian Ben Yehuda Street. It was built as part of a project, that was later fortunately abandoned, to raze the quarter to the ground in order to build the "City" of Jerusalem.

114-115, 114 bottom and 115 bottom The first neighborhoods of modern Jerusalem, as well as large buildings dating from the British Mandate Period, have sprung up along the length of Jaffa Road, which has been paved since 1861.

116 and 117 The Mahane Yehuda ("Field of Judea") Market, located between Jaffa Road and Agrippa's Street, has colorful stalls where any type of fruit, vegetable, spice, meat or fish can be found. The market is most animated on Thursdays and Fridays, when the Jewish residents of Jerusalem do their shopping for the Saturday holiday. Every Friday afternoon before sunset, an Ultra-Orthodox Jew walks through the Mahane Yehuda Market sounding the shofar to remind everyone that the Shabbat is about to begin.

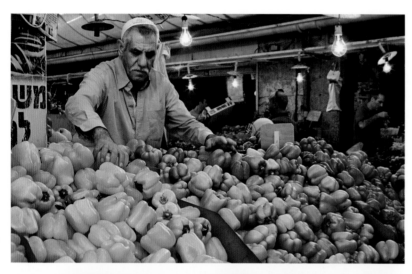

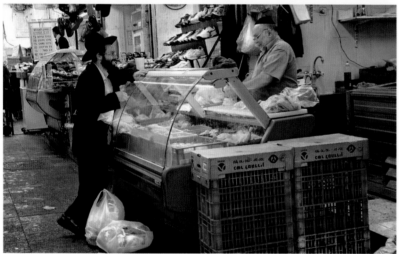

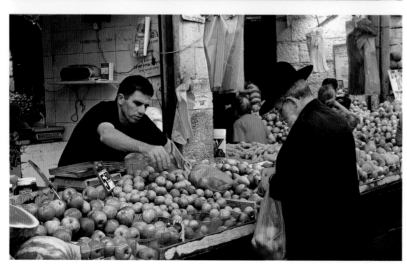

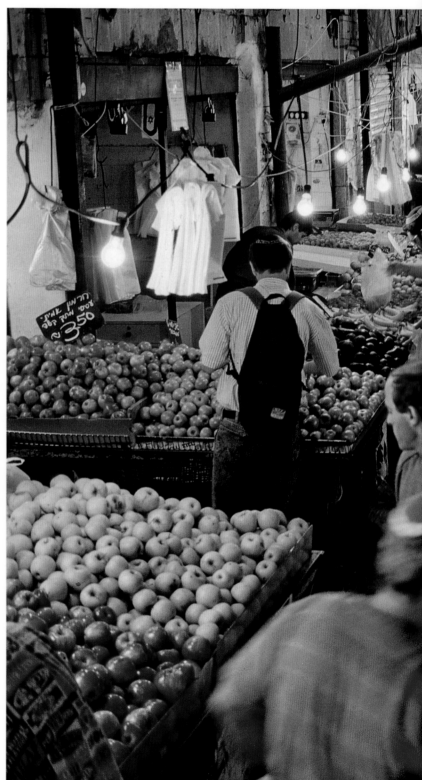

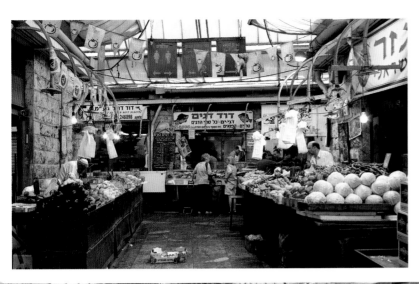

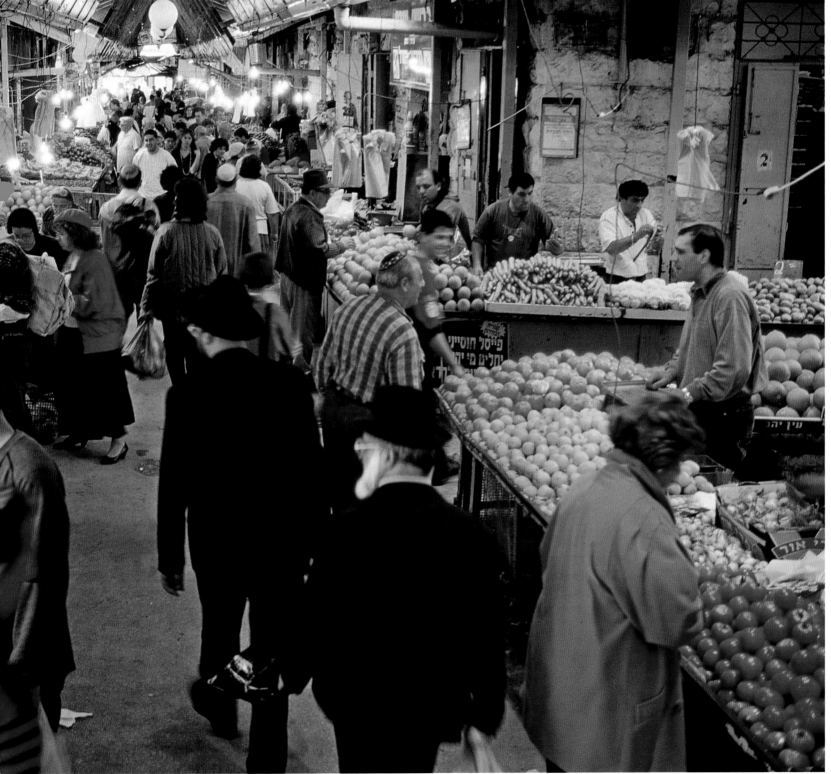

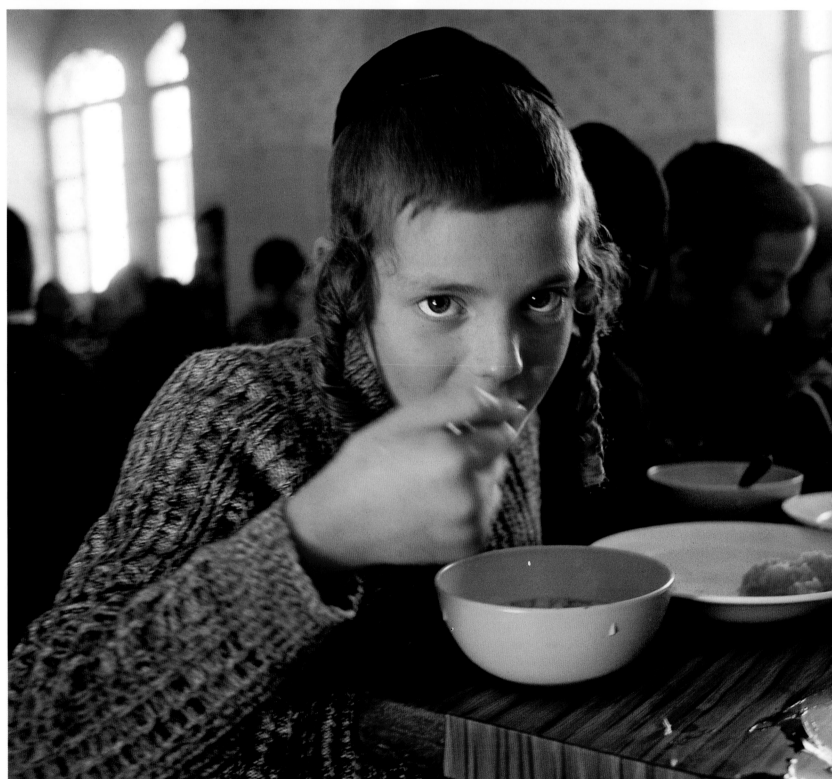

118 top left In Mea Shearim, the Ultra-Orthodox Jewish quarter, every aspect of daily life is laid out by detailed precepts that regulate prayer, dress, study, work and food.

118 top right The rabbis, known also as masters (rav) or sages (chakham), are particularly influential in Mea Shearim, and are the sole authority on ritual issues, which usually pertain to food regulations.

118-119 A student in the dining area of a traditional Talmud Torah school. Created for the purpose of educating poor children, they are a type of elementary school where the basics of Judaism and the Hebrew language are learned.

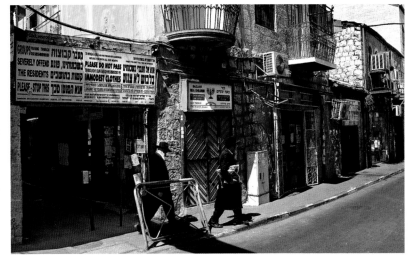

119 top At one time, the four iron gates around the Mea Shearim were closed at night. Although today the gates remain open, the inhabitants have not renounced their desire to remain isolated from the rest of the world.

119 bottom The biblical books of the Pentateuch and the Talmud constitute the main study materials in the Talmudic schools, where Orthodox Jews prepare for high school or for the yeshiva.

It always creates a strong impression entering the urban enclave of Meah Shearim, the Quarter famous not only for its more than one hundred synagogues and rabbinical schools located in less than a mile, but also for its population of Ultra-Orthodox Haredim "those who tremble" (from the fear of God). Always dressed in black, with full hair (*shetraimel*) and long curls (*pe'ot*) that descend from the temples, they are extreme as much for their total dedication to the word of God, as for their intransigence. Within these narrow and squalid alleys lined with overcrowded houses it is impossible not to sense hostile glances, although in reality spit and stones are easily avoided; it is sufficient to not wear shorts and not risk taking indiscreet photos, especially on Saturdays when everything here truly closes and the Israeli police prevent the passage of vehicles.

The fifth Jewish quarter outside of the Old City was started in 1874, Meah Shearim (the name means "a hundred-fold" and brings to mind the Biblical fertility omen), was actually designed by the architect Conrad Schick as an airy quarter with many rows of small houses converging toward a large common area for gardens and public buildings. An ideal city whose realization collided with the housing needs of an ever-growing population. With the end of World War II, there arrived from Europe the Haredim Holocaust survivors who settled precisely in the Meah Shearim Quarter, which gradually became the stronghold of those having fundamentalist tendencies. This Quarter has thereby become a sort of living museum for a type of intransigent Judaism that was once widespread in Eastern Europe. Here the people live and dress as they once did in the Polish and Lithuanian *shtetl* (ghettos) two centuries ago. They speak Yiddish, they decide nothing without first consulting a rabbi, they refuse everything that is modern (including TV, internet and cell phones) and they hate everything secular, as is apparent on the walls in this Quarter, which are covered with posters that insult Reform Jews, the government and, at times, members of their own group who have been deemed traitorous and impious.

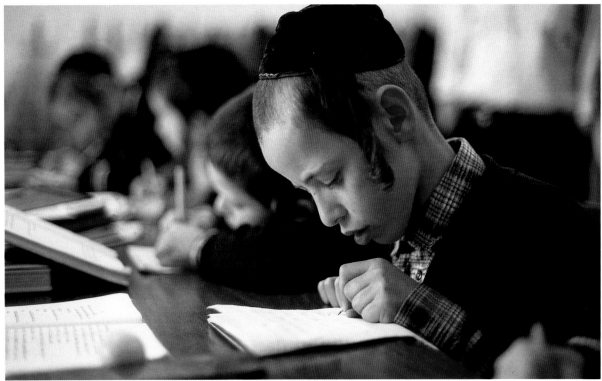

That a Greek style windmill could become the symbol of Jerusalem may seem a paradox, but only to a certain point, as this is a symbol of the Jewish reconquest and the return from the Diaspora. High in the Valley of Hinnom (the biblical Gehenna) and across from Mount Zion, the mill of Montefiore takes its name from the rich English Jew, Moses Montefiore. It was this man who in the 19th-century, with the permission of the Ottoman Sultan, acquired an area to the southwest of the Jaffa Gate and built a block of sixteen small row houses called Mishkenot Sha' ananim ("Tranquil Houses"), which was the nucleus of the Yemin Moshe Quarter. For the first time, after five thousand years of history, Jerusalem expanded beyond its city walls. The mill was intended to provide flour for the inhabitants of the new quarter, but the absence of wind rendered it practically useless. Today, the mill houses the Montefiore Museum, which illustrates the life and work of the English philanthropist, a precursor of Zionism.

To the west of Yemin Moshe Quarter, which with its small Oriental houses reconstructed after the devastation in 1948 is today one of the most chic areas of the New City, runs King David Street. Two hotels standing across from each other on King David Street have become symbols of Jerusalem; the King David Hotel, since its inauguration in 1931, has hosted dozens of presidents and royalty including three sovereigns who have lived there long-term in exile: Alfonso XIII of Spain, Emperor Haile Selassie of Ethiopia and King George II of Greece. The eclectic opulence of the lobby, the large park, and the incredible views of the walls of the Old City from the suites, combine to make this a location of absolute charm. In the Reading Room of the King David Hotel, the Arab leaders who were defeated in 1967 signed a peace treaty with Israel, and in 1977 the kitchen staff prepared a cake in the shape of a pyramid in honor of President Anwar Sadat of Egypt. It is also important to remember that in 1946 Menachem Begin and a Zionist commando of Irgun blew up the hotel, while it was still the seat of the British High Command, causing the deaths of 91 people. Begin, who later became Prime Minister and together with President Sadat was honored with the Nobel Peace Prize, has always maintained that the Irgun warned the British before the attack but that the telephone call was not taken seriously.

Just across the street is silhouetted the soaring tower of the YMCA, the hotel completed in 1933 and designed by Arthur Loomis Harmon, the architect of the Empire State building in New York. The view from the top is vertiginous, but also exceptional is the sophisticated interior design of the building which has been called "the most beautiful YMCA hostel in the world" (YMCA are the initials for the Young Men's Christian Association). The auditorium, places side by side Christian, Jewish and Islamic symbols as an augur of peace.

Along these same pacifist lines, the Artists' House, located a bit farther north, frequently organizes combined shows of contemporary Palestinian and Israeli artists. At the beginning of the 20th century, this was the first Art Academy in Jerusalem. Today, more than being a showroom for avant-garde art, it is an animated cultural laboratory committed to building bridges between cultures, religions, and people.

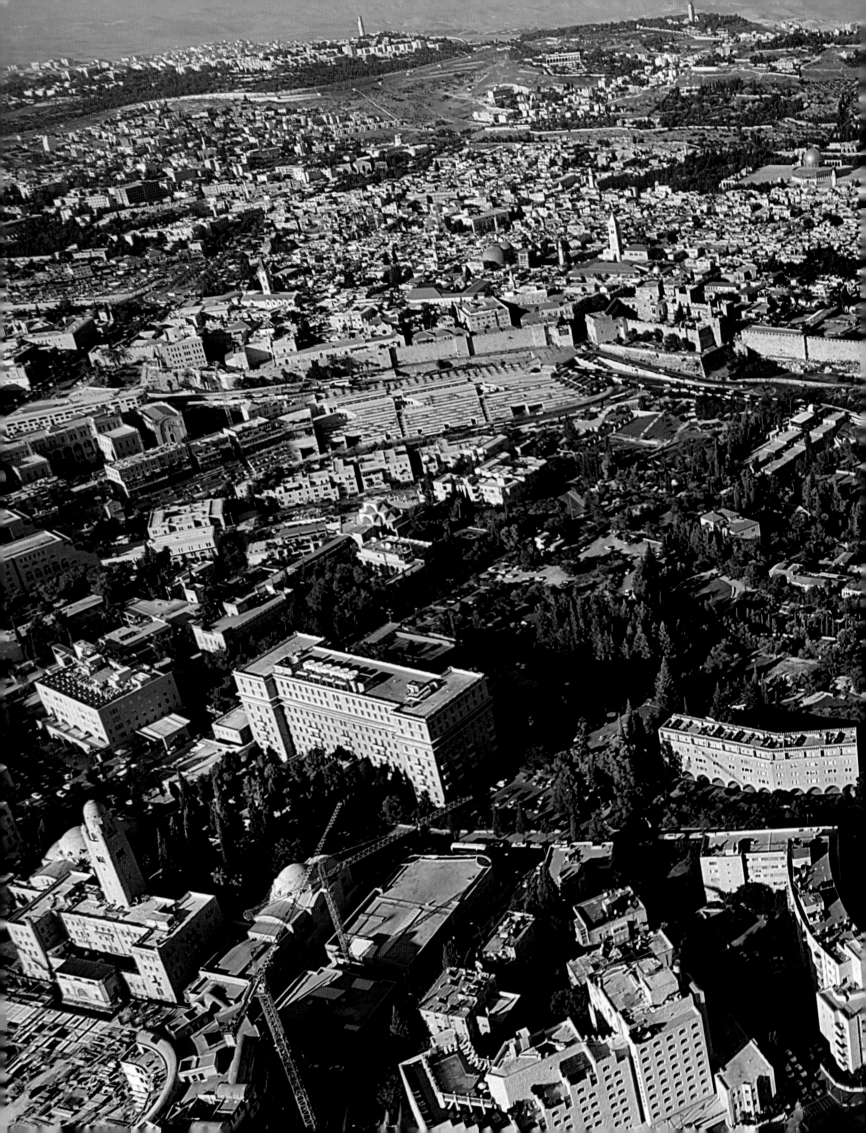

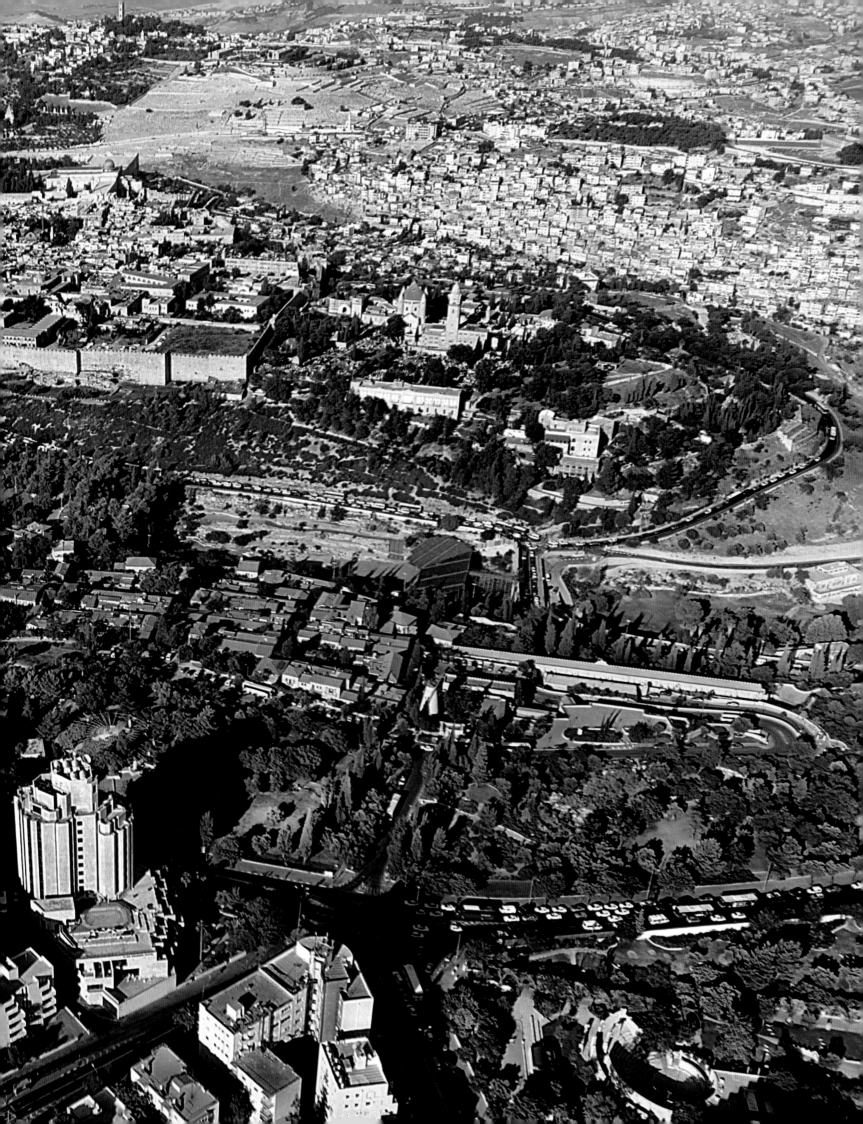

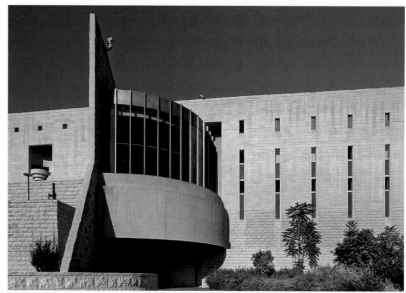

124 top The design of the Postmodern Supreme Court building juxtaposes new and old, interior and exterior, lines and circles. The center of Jerusalem can be seen from its panoramic windows, which face Sacher Park.

124-125 In front of the entrance to the Knesset stands a distinctive gift from the British government, a large seven-branch bronze menorah upon which sculptor Benno Elkan depicted 29 scenes from Jewish history.

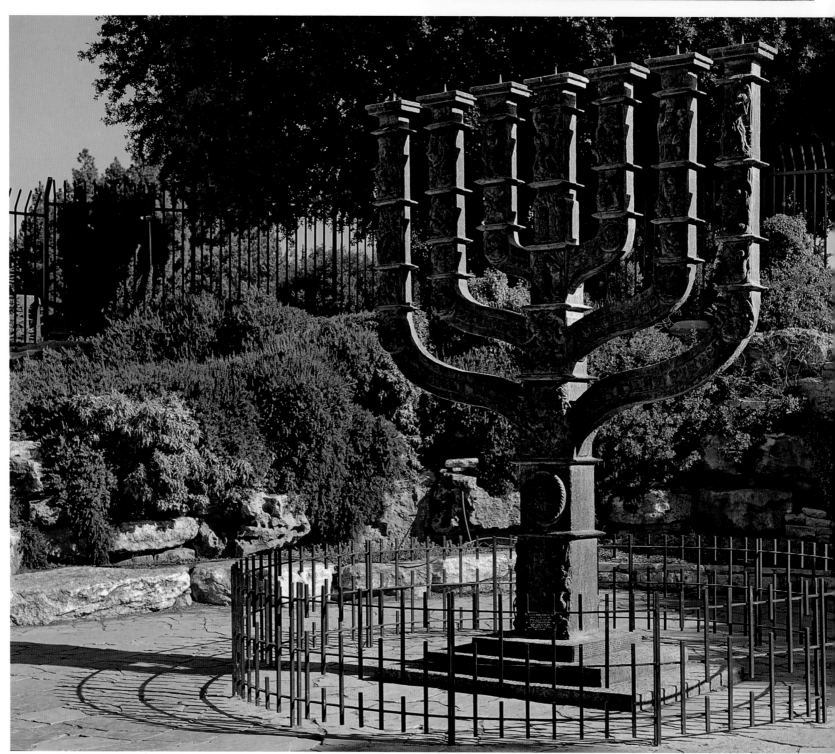

125 top Located within Wohl Rose Park, which lies between the Knesset and the Supreme Court, the Garden of Nations is a mosaic of gardens donated by different countries. Modern sculptures are found among the plants and flowers.

125 center The functional architecture of the Knesset (the unicameral Israeli parliament) demonstrates classical influences; the pillars that sustain the roof are reminiscent of Greco-Roman columns.

125 bottom The Ornamental Pool in Wohl Rose Park reproduces an authentic Japanese garden, including a small cascade, pools, rocks and a stone lantern.

The green hill of Giv' at Ram, located about a mile west of the Old City, comprises a series of state buildings and museums, some of which have become symbolic of the New Jerusalem. Here, a large rectangular edifice designed by Joseph Klarwin and which appears to be inspired by the Parthenon in Athens, has been the seat of the Knesset since 1966. The Knesset is the single legislative body of Israel and has 120 parliamentary Members (each serving four years), the same number of Members as the Great Assembly (Knesset Hasgedolah) that convened after the return of the Jews from Babylonian exile. In front of the Knesset is prominently displayed a large bronze menorah, the candelabra emblem of Judaism and of the State of Israel. The menorah, sculpted by Benno Elkan and donated by the British Parliament, illustrates 29 events from Jewish history, beginning with the Bible and ending with the Warsaw Ghetto, and has seven branches, as did the one that Moses placed in the tabernacle of the First Temple and also the one that in 70 CE Emperor Titus profaned by taking from the Second Temple as booty to bring to Rome. The Hall of the Knesset displays a series of three tapestries, created by the great Russian artist Marc Chagall, which represent the Creation, the Exodus from Egypt and the City of Jerusalem.

The Knesset, similar to the White House in Washington, DC, has located behind it a large rose garden, Wohl Rose Park, whose 600 varieties of roses form a type of "botanical library" of existing species, including the most rare. Across from the garden was erected in 1992 the most beautiful example of Post-Modern architecture in Jerusalem: the new Supreme Court. Designed by a brother and sister from Tel Aviv, Ram Karmi and his sister Ada, the complex successfully renders, in architectural and symbolic terms, the idea of justice that is apparent in Jewish history and tradition. The stone courtyard divided by a mirror of water, for example, is inspired by the verse of Psalms "Truth shall spring out of the earth; and righteousness shall look down from heaven," while the courtrooms are inspired by Talmudic synagogues, the pyramidal library brings to mind the tombs of the Valley of Jehoshaphat, and finally the coarse walls are reminiscent of the Western Wall.

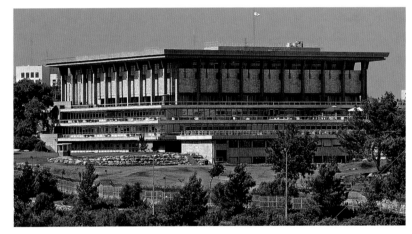

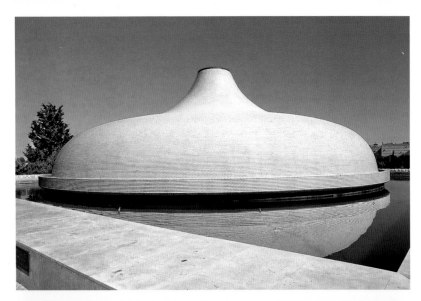

126 top Beneath the white tiled dome of the Shrine of the Book, designed by the American architects Frederic Kiesler and Armand Bartos, are conserved eight of the most complete biblical scrolls ever discovered.

126 bottom At the center of the Shrine of the Book is displayed a copy of the Great Scroll of Isaiah, which was discovered in the caves of Qumran; it is the only Biblical book found intact and dates from 100 BCE.

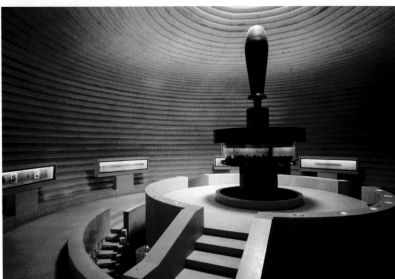

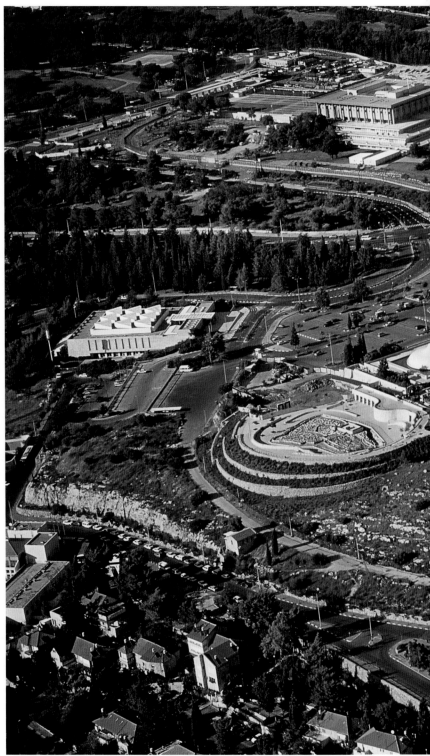

Located not far from the Knesset is the country's most prestigious and important cultural building – the Israel Museum, inaugurated in 1965. Its archaeological, artistic, numismatic and ethnographic collections are all exceptional. The Judaica Pavilion contains the largest collection in the world of Jewish objects, including splendid ceremonial pieces, Hanukkah lamps, Medieval illuminated manuscripts, and even three entire reconstructed synagogues: one Indian, one Italian and one German. The museum dedicated to Impressionist paintings and 20th-century art displays masterpieces by Van Gogh, Modigliani, Matisse, Chagall, Gauguin, Renoir, Cézanne, Monet, Degas, Picasso, Dalí, De Chirico and Klee.

The archaeological museum is impressive for both the quantity and the quality of its Middle Eastern civilization pieces, which are exhibited in chronological order (notable is the antique glass, the Samarian ivories, and the Treasure of the Judea Desert, 429 pieces that go back more than 5000 years).

Leaving the building, the visitor pass through the Billy Rose Sculpture Garden, interspersed with dozens of statues by important artists such as Rodin, Moore, Mestrovic, Turrel and Oldenburg, to reach the main attraction of the museum: the Shrine of the Book. Conserved here are the famous Dead Sea scrolls, discovered in 1947 by a Bedouin in the caves of Qumran. The original white dome of the building is a reminder of the earthenware vessels that contained the parchments for 2000 years. On the central platform, in the rolled form of a Torah, is exhibited a copy of the 23 ft (7 m) long parchment that contains the entire book of Isaiah: the oldest biblical manuscript ever found.

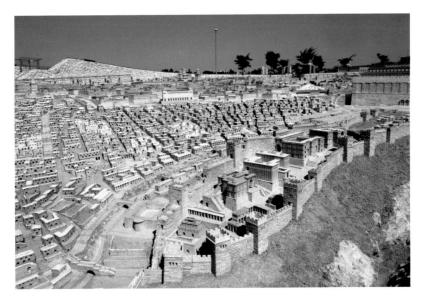

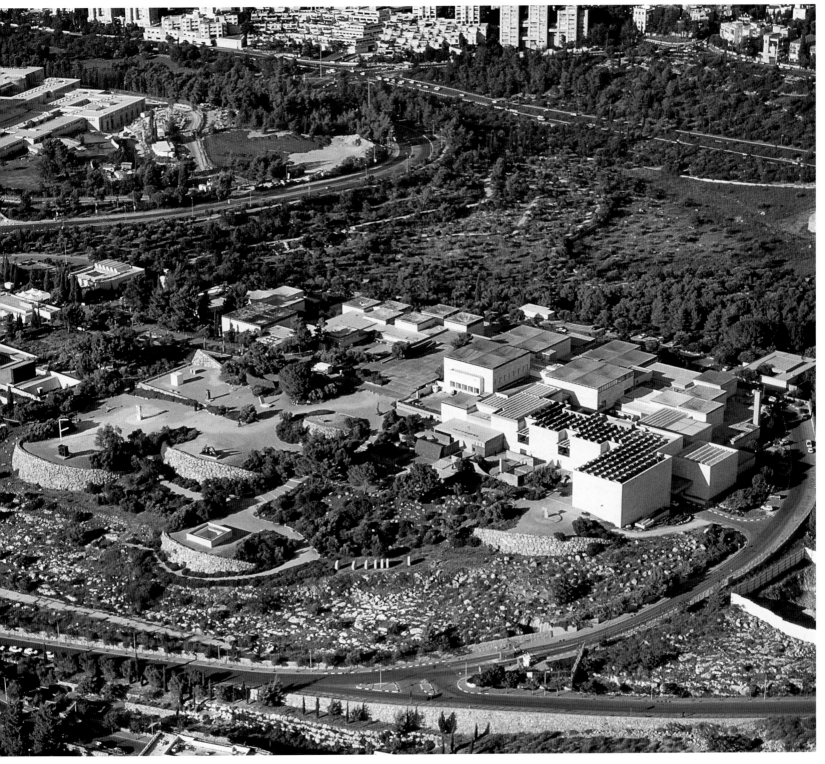

128 left While masterpieces of 20th-century sculpture predominate in the Billy Rose Sculpture Garden, works by great 19th-century sculptors such as August Rodin, Émile-Antoine Bourdelle and Aristide Maillol are also present.

128 top right The sculpture Woman Combing Hair (1914) by Alexander Archipenko welcomes visitors to the Sculpture Garden. The Japanese-American Isamu Noguchi designed the Sculpture Garden in the form of a Japanese Zen garden where plants and sculpture, concrete and water, alternate.

128 center right The Israel Museum could not be without a provocative work by the acclaimed and ubiquitous pair of artists Claes Oldenburg and Coosje van Bruggen: Apple Core from 1992.

128 bottom right Vertabrae (1968), the bronze sculpture by the important British artist Henry Moore, is situated in one of the most panoramic terraces of the Sculpture Garden, near a sculpture by Pablo Picasso.

If the Western Wall is the religious heart of Israel, the civil and political heart can be found in the hills on the periphery of Jerusalem; here are located highly symbolic sites dedicated to the memory of both those who conceived of the idea of a Jewish nation and to those Jews who lost their lives in war or in the Nazi concentration camps. The new Herzl Museum, inaugurated in 2005 on the site of a previous museum, celebrates Theodor Herzl (1860-1904), the father of the Zionist movement, through multi-media presentations and a visit to an accurate reconstruction of his study in Vienna. Behind the museum is access to the green park of Mount Herzl: within a block of black marble rest the remains of Herzl himself, brought here from Vienna in 1949. Also found on the slopes of Mount Herzl are the tombs of former Prime Ministers Golda Meir, Menachem Begin and Yitzhak Rabin as well as, in the military cemetery, the graves of six thousand Israeli soldiers who died in war. On the other side of Mount Herzl is located another cemetery: the cemetery has no tombs, yet it is the most sorrowful place in Jerusalem and in the entire nation. The memorial park of Yad Vashem (literally "a memorial and a name," from a verse in the Book of Isaiah, 56:5) does not have graves, but instead preserves the memory of the six million Jews who were victims of the Holocaust. At the entrance, the visitor passes through the Garden of the Righteous Among the Nations which, among the trees, has plaques that honor the approximately sixteen thousand gentiles who helped the Jews during World War II. The new Holocaust History Museum (designed by Moshe Safdie and inaugurated in 2005, at a cost of $40 million), presents through the use of multi-media techniques, the history of the

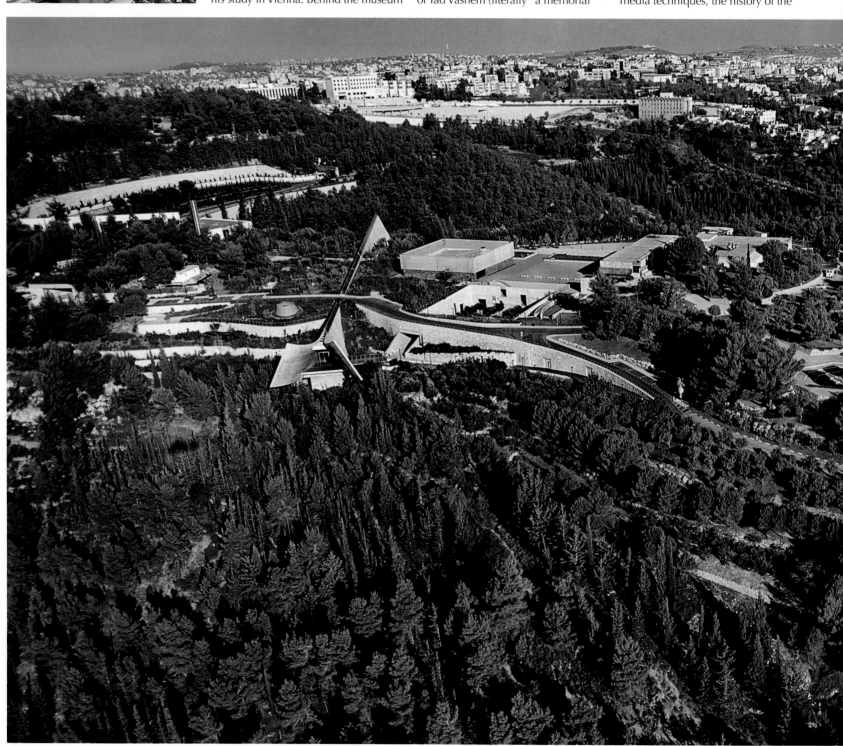

130

Holocaust, making ample use of the personal testimonies of survivors. The dark Hall of Remembrance holds the names of the 21 extermination camps, which are inscribed upon slabs of black basalt. The Hall of Names is a memorial to each and every Jew killed by Nazi savagery: three million "Pages of Testimony," also now in digital form, are like symbolic *mazevoth*, or headstones that relate the biographical data of each person. Numerous other memorials are scattered throughout the park: the most distressing of which is the Children's Memorial, placed in a subterranean cavern and dedicated to the million and a half children who were exterminated. The reflection of the candles on the vault of the cave give the impression of being under a starry sky, while the names of the young victims are repeated in a heart-rending chant that can leave no one unaffected.

From the Yad Vashem stretches the Forest of Jerusalem (Ya'ar Yerusahalayim): six million trees were planted to remember the victims of the Nazi extermination, an enormous reforestation project to affirm that the life of a people will continue, stronger than those who desired to uproot it.

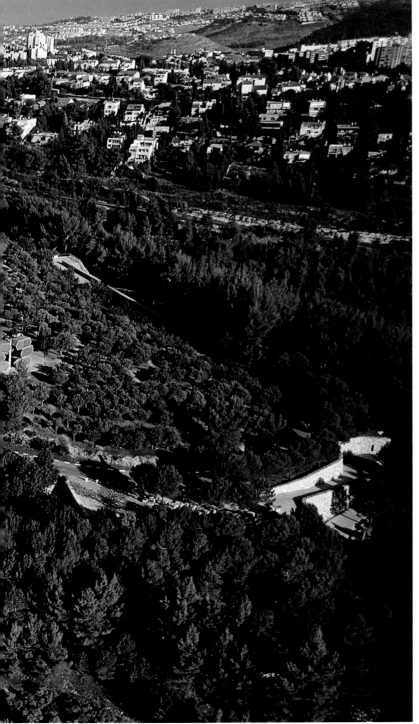

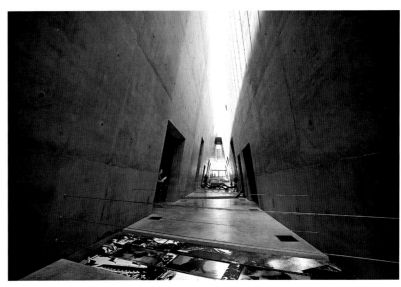

130 top In addition to holding the tombs of the most illustrious Israelis, from Theodor Herzl to Yitzhak Rabin, the pines of Mount Herzl are also the setting for the most important military cemetery in the nation.

130-131 and 131 The vast Yad Vashem complex , the Holocaust memorial, is located on the western periphery of Jerusalem facing the Jerusalem Forest, which covers the slopes of Mount Herzl. To enter the new Yad Vashem complex, one passes through the minimalist "Wall in Tribute to the Survivors," built by Safdie as "a line between everyday space and sacred space, a border." On the interior, one sees that the story of the Shoah is explained personally, through the presentation of 2500 objects that belonged to victims and ninety individual stories that are projected on the panels of the room.

To discover that Jewish Jerusalem can be joyous and optimistic, it is important to visit the Hadassah University Medical Center, beyond the western suburb of Ein Kerem (the village where John the Baptist was born). On entering the large hospital and crossing the threshold of Abell Synagogue the visitor is unable to stifle an exclamation of amazement: here the tears of the Wailing Wall and the anguish of Yad Vashem feel as though they are a thousand miles away. The credit goes to the genius of Marc Chagall, who created this chromatic wonder: twelve large stained glass windows, each dedicated to one of the twelve sons of Jacob and the twelve tribes of Israel (each blessed by Moses), fill the room with a warm and brilliant light that instills a sense of peace. Each window is obviously inspired by the Bible, but is also a microcosm of the poetic world of the great Russian artist, where nature and dreams, reality and fantasy all combine, inseparable from the history of this ancient people. The prohibition against the representation of the human figure did not limit the creative capacity of Chagall: feathered birds, doves of peace, fruit, angels, horns, asters, and stars of David float in the air above donkeys and deer, grazing sheep, slithering snakes, lions of Judah, small houses, tables of the Law, and candelabra, all in a message of universal love. Chagall had a clear idea of what he wanted to create: "my modest gift to the Jewish people, who have always dreamt of biblical love, of friendship and peace among all people; to that people who lived here, thousands of years ago, among other Semitic people." He also added: "All the time I was working, I felt my mother and father looking over my shoulder; and behind them were Jews, millions of other vanished Jews. . . ." Chagall carried this history, his world, with him, but redeemed it in dazzling light, exalting the land of Israel: the windows of the tribes of Reuben and Dan are azure, Simeon and Benjamin blue, Judah and Zebulon red, Naphtali and Levi yellow, Asher, Issachar and Gad green, and that of Joseph is orange. For this original tribute to the history of his own people, it was necessary to invent a new technique: each window is dominated by a single color, but the panes of glass that comprise it are not monochromatic. In fact, thanks to a process invented by Chagall's assistant, Charles Marq, each pane can contain three distinct colors. The effect is brilliant and radiant.

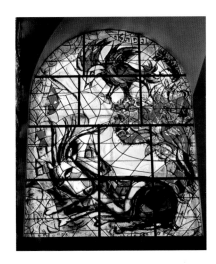
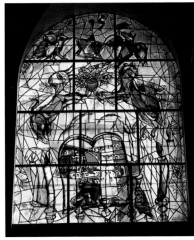
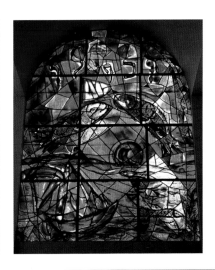
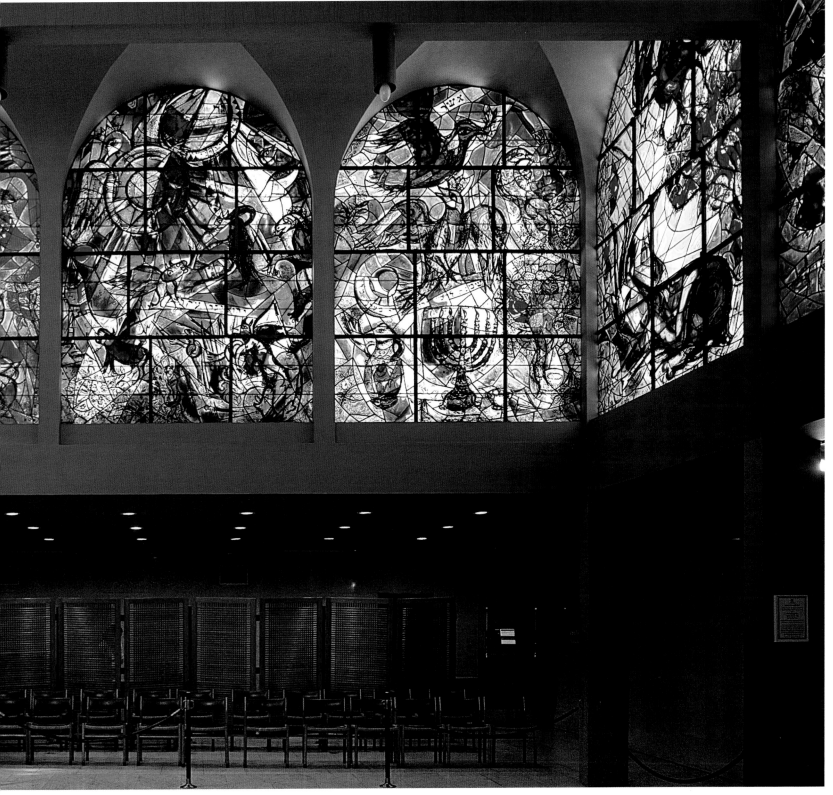

INDEX

PHOTO CREDITS

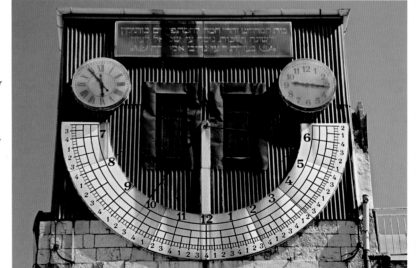

136 On the Jaffa Road, near the Mahane Yehuda market, stands the three-story Sundial Building, erected in 1908 by the American Rabbi Shmuel Levi to house a yeshiva and a synagogue. A 16.5 ft (5 m) semi-circular sundial on the façade indicated the time of prayers, which are connected to the rising of the sun. The two clocks were used on cloudy days.